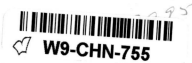
CRAIG BLACKLOCK

THE

LAKE SUPERIOR

IMAGES

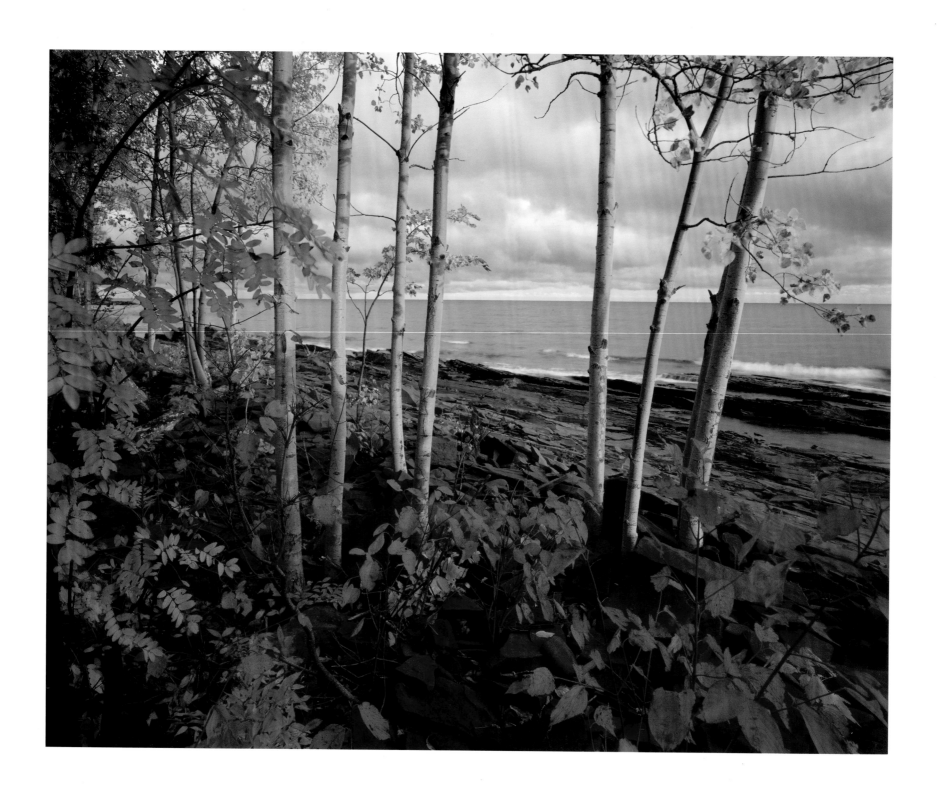

Plate 1

Aspen trees, Porcupine Mountains State Park, Michigan. October, 1991

CRAIG BLACKLOCK

THE
LAKE SUPERIOR
IMAGES

BLACKLOCK NATURE PHOTOGRAPHY

Printed in Korea by Dong-A Publishing & Printing Company, Ltd.

98 99 00 01 02 03 5 4 3 2 1 SECOND EDITION

Blacklock, Craig 1954-

The Lake Superior Images / Craig Blacklock

Published by
Blacklock Nature Photography
P.O. Box 560
Moose Lake, MN 55767

Distributed by
Adventure Publications, Inc.
P.O. Box 269
Cambridge, MN 55008

DEDICATION

For my wife Nadine who grasped the sometimes taut string keeping this project grounded to reality, and provided the love and support that made it possible.

ACKNOWLEDGMENTS

I would like to thank Kris Aas-Larson for being the best paddling partner and friend a person could hope to have. And for writing an epilogue that clearly distilled the essential meaning from both discussions and silences during our time together.

I was extremely fortunate to have Linda Benedict-Jones, Curator of the Polaroid Collection, agree to not only write the introduction for this book, but to co-curate the accompanying exhibit at the Tweed Museum of Art, and to offer her suggestions during the final sequencing of photographs. I am indebted to her, and to the Polaroid Corporation for their support of her participation in this project.

I am pleased that *The Lake Superior Images* will debut at the Tweed Museum of Art. My thanks to Martin DeWitt for arranging for the exhibition, and for his contributions as co-curator of the show.

My thanks go to John Green for helping me to understand the geology of Lake Superior and for reading that section of text for accuracy, to Meg Aerol for her editing, and David Garon at Digital Ink for his masterful job of graphic design.

No acknowledgment could adequately do justice to the efforts that my wife Nadine put into this book. During the last two years of the project, the book consumed nearly as much of her time and energy as mine, allowing her little opportunity for her own photography. During my hundred-day circumnavigation she ran our business alone, shuttled supplies, unloaded hundreds of sheets of 4x5 film I'd shot, and later filed that film - something she'd *never* do for me if we were both home! Later, she edited uncountable drafts of the text, worked with me in editing and sequencing photographs, and in designing the book. Aside from this help she accepted my absences away from home, and then my time in the darkroom, with an understanding few spouses would muster.

Publication of the first edition of this book was made possible in part through purchases by Minnesota Power, Potlach, and Target Stores.

CONTENTS

ABOUT THIS SECOND EDITION

MAY, 1998

When I look through this book I clearly recall making each image — even those photographed as long ago as 1984; the type of day it was, what my technical and aesthetic concerns with the image were, how long I had to wait for wind to stop blowing leaves. All these things seem like they took place recently.

Yet, in past years I have taken my kayak, the Kingfisher, back to many of these locations and seen the marks of time on the lake. The most obvious is the lake level, which is currently higher than during some years I was working. Part of a particularly colorful cliff face in Pictured Rocks National Lakeshore (plate 120) has fractured and fallen into the lake. But nature's changes are small and slow compared to what we have done to the shoreline.

The lakeshore development I wrote about in 1992 seemed to speed up geometrically; not only on the shoreline and islands, but on ridges and headlands, where developments are visible for miles in either direction. On the positive side, the Canadian government is now considering establishing a National Marine Conservation Area, giving some added protection to parts of their shore. With the help of groups like the Minnesota Parks and Trails Council and The Nature Conservancy, the Minnesota Department of Natural Resources has added a few key parcels of lakeshore into its state park system. Around the lake, paddlers are working on a water trail to ensure this ancient transportation route remains viable, with public rest areas and campsites accessible to kayakers and canoeists.

So, time *has* gone by, and things *have* changed. Printing technology has also dramatically changed since this book was first published. The presses themselves still work in virtually the same way, but how the images get to press is another story. When the first edition of *The Lake Superior Images* was published in 1993, Nadine and I boxed up the 154 original transparencies and shipped them off to the printer, who had only the transparencies and a few notes from us to guide them as to how we wanted the images to look. We received back press proofs, marked our corrections on them, and after three rounds of this, oversaw the printing. The printing company did a great job with the available technology, and we were elated with the book.

So what is different now? For this edition the transparencies were drum-scanned by EverColor Fine Art, in Worcester, Massachusetts, at 100 or 200 megabytes per image. Instead of the printer doing the color correction work on a very large and expensive computer, I am doing it on my desktop, using a Power Macintosh 8500/180 . Within the software program Adobe Photoshop, the images are corrected for color and contrast, dust and scratches are digitally cloned out and selected areas are sharpened or softened.

The current version of Adobe Photoshop offers several tools that were not available even to big printing companies in 1993. The biggest advantage, however, is being able to personally fine-tune the digital images. No longer is it a struggle trying to define how much the contrast should be increased, or how much magenta should be subtracted. Now the image is simply adjusted until it looks right on the computer screen. Ansel Adams compared the negative to a music score. It has the information — but how it is interpreted makes all the difference. This technology allows the user to play the same pieces on a brand new instrument. The expanded possibilities for personal interpretation are not unlike the difference between playing a harpsichord and a piano.

In darkroom work, most corrections are applied universally, or only crudely isolated. With Adobe Photoshop the user precisely isolates small areas of images, only certain colors, or only certain values, and works within those areas without altering the rest of the image. For instance, to make the orange lichens in plate 47 brighter, cyan was subtracted only from the yellow — the rocks remained neutral, and the sky and water bright blue. Perhaps the most noticeable result of this technology is the ability to enhance contrast in shadow or highlight areas, giving the images a crisp look with saturated colors. This is much closer to the way we perceive the world with our eyes since our pupils adjust when we peer into shadows or look up at clouds.

When I received the scans back from EverColor, I worked on the files in the color space of red, green and blue (RGB) — the primary colors of light. (These same files can be output as museum-quality color prints as large as 37 x 46 inches. This technology has rendered my darkroom obsolete.)

The files were then reduced in size to what was needed for the book printing, and converted to cyan, magenta, yellow and black (CMYK), the colors of ink on the printing press. A final color-correction (while viewing the photographs on a high-end monitor), and placement into the layout was done at Digital Ink, in Duluth, Minnesota. The images were sent to the printer on digital audio tapes (DAT). The printing company output separation film from these files, made proofs for our approval, and then printed the book with our guidance on press.

Having the opportunity to re-interpret these images has been very rewarding. I hope you enjoy this new version of these photographs, and that they also bring you close to your own memories of being on the shores of this incredible lake.

DIRECTOR'S STATEMENT

THIS BOOK IS PUBLISHED UPON THE OCCASION
OF AN EXHIBITION OF PHOTOGRAPHS BY
CRAIG BLACKLOCK AT THE
TWEED MUSEUM OF ART, DULUTH, MINNESOTA
JULY 10 THROUGH AUGUST 22, 1993

The role of art museums in contemporary society must evolve to reflect the metamorphosis of culture – transformation of attitudes toward the political, social, psychological, and spiritual issues of daily living is the challenge we all face in preparing for the new century. As well, new perspectives on issues such as public health, education, ethnicity, sexuality, the economy, and environment, reveal just how complex this planet is – and the delicate balance we must maintain to participate in and assure global well-being. The role of Creative enterprise serves as a vital, if not essential, component in the process of maturation toward a truly effective new world consciousness.

Whether literary, performing, or visual, all the arts offer knowledge about the world and ways of experiencing it that contribute to an understanding that is unique and different from any other discipline. Art is perhaps humanity's most essential, most universal mode of expression – certainly not a frill, but a necessary part of communication.

Even before the process of creative expression was coined *arté*, humanity's response to the experience of daily living found realization through perception, conception, and physical manifestation in not only functional form (manipulating stone tools) but also through expressive symbolization – witness the 40,000 year old cave paintings of Lascaux, France.

In the Lake Superior region, and along the rocky shorelines of many lakes in the Canadian Shield, pictographs created much more recently by indigenous people seem to signify innate expression of response to experience of daily survival through symbolic imagery, revealing abstract and figurative references. The very act of mark making, of carving or manipulating stone, metal, or wood, is in all reality, an extension of self – an affirmation of identity and bridge between the world that we know and the mysteries of the unknown. Language systems, whether gestural, written, or verbal, relay essential messages, communicate meaning, and offer diverse modes of opportunity for understanding. The creative process, though often ambiguous, is an essential language system, a basic mode of communication.

The Tweed Museum of Art continues to be responsive to these complex issues of cultural evolution. Opportunistic in a sense, the Tweed utilizes to the fullest the creative process in a visual art context to deliver information directly to a diverse constituency.

The mission of the Tweed Museum of Art is two-fold: maintain and develop the museum's significant collection of art, and broaden University and community access to, participation in, and understanding of culturally diverse art forms and
the creative forces that generate them. Basic to the mission is the belief that direct experiences with significant, original works of art can serve as a rich resource of ideas, which may have the potential to expand each person's perception of the world as well as themselves.

The Tweed Museum of Art has made a conscientious effort to identify and recognize the creative vision of contemporary artists on a regional, national, and international level. In the past ten years, the Tweed has not only established a developing photography collection, but also has organized exhibitions of photography that have received regional and national recognition. This commitment to the photographic medium has been extended to include Tweed's recent Contemporary Photographers Series – featuring in 1992 solo exhibitions of recent work by Dean Chamberlain, Gloria DeFilipps Brush, and Lynn Geesaman. It seems only natural to conclude this year's Series in celebration of native Minnesotan Craig Blacklock's major accomplishment, *The Lake Superior Images*.

Developed over nearly a ten year span, Blacklock's Lake Superior photographs offer a unique perspective on vantage points rarely accessed by weekend visitors to the big lake. His devotion in capturing one-of-a-kind images reveals characteristics of Lake Superior literally not seen or experienced before – unique to this artist's intention. Blacklock has taken the notion of nature photography to the extreme – while maintaining conventional production processes and essential imagery considerations, his color photographs heighten accessibility – and possess a content strength understandable to all. The environmental message is clear, yet Blacklock's images have evolved to consider formal aesthetic issues beyond content deliberations. Yet, how can we not respond to the inherent beauty of nature and through the power of these images have reinforced the idea of the ongoing need for conscientious stewardship of our natural resources?

The exhibition features a selection from the one hundred and fifty-four images included in this volume, and is also titled *Craig Blacklock: The Lake Superior Images*. For expediency's sake in touring the exhibition regionally and nationally, the exhibit was limited to sixty photographs. Their selection was based on strength and uniqueness of image, and above all else, to maintain the intent of the total project concept.

Organizing the exhibition has involved extensive collaboration. My personal thanks go to Linda Benedict-Jones, Curator of the Polaroid Collection, for her perceptive response to Craig's work in helping select photographs for this exhibition. Almae Larson has provided the logistical support to make the exhibition and tour possible. To other Tweed staff members, recognition is due as well: Larry Gruenwald, Kimberlee Galka, Kathy Sandstedt, Merlyn McMann, Susan Headly Keller, Alison Aune, Jana Pastika, Rick Fairchild, Julie Mason, and Carol Huber – their combined expertise has brought the exhibition to life.

The Lake Superior Images exhibition has received considerable support. I would like to thank Richard Durst, Dean of the School of Fine Arts, for his interest and support of this project; and to Gloria DeFilipps Brush, Professor of Art, and Head of the UMD Department of Art, for her enthusiasm and commitment to the exhibition from the onset.
Our thanks go to Robert Bruce, Executive Director, and to the Board of Trustees of Duluth's Lake Superior Center for encouragement and support of educational programming.

Without a sound financial base the exhibition could not have been feasible – and is made possible through generous contributions from the Alice Tweed Tuohy Foundation, Tweed Patrons and Subscribers, and friends and supporters of Craig Blacklock. Enduring cooperation and support is received from the Tweed Associate Volunteers and Advisory Council.

Concluding acknowledgment must be directed to Craig Blacklock himself – for his insightful exhibition proposal, cooperative spirit, and profound and unwavering dedication to the concept of stewardship of this country's great natural resources, particularly those of the Upper Midwest.

Together with Craig we thank Nadine Blacklock, for without her enthusiasm and support, the total project, let alone the exhibition of *The Lake Superior Images*, would not have been possible.

Martin DeWitt
Director and Curator, Tweed Museum of Art

The lake both inspires and humbles, reminding us by comparison how insignificant we humans are in the grander scheme of things.

Arend Sandbulte
CEO Minnesota Power

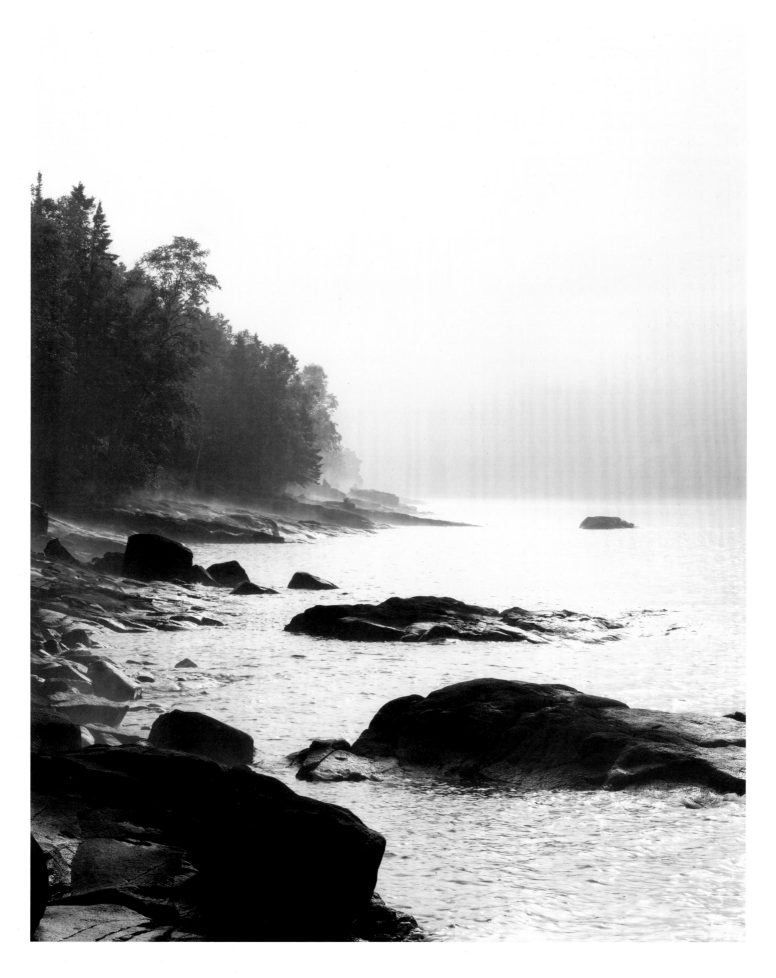

P l a t e 2

Cascade River State Park, Minnesota. July, 1984

When the image mirrors the man
And the man mirrors the subject
Something might take over

Minor White

INTRODUCTION

One could say that camera pictures of lakes and land pre-date the medium of photography itself. Sir John Herschel, preeminent British scientist of the nineteenth century, used the "perspective machine" known as the camera lucida to create detailed drawings of his extensive travels. In 1821, while sailing near Interlaken, Switzerland, Herschel made a delightful sketch of Lake Brienz from Iseltwald - eighteen years before the official announcement of the invention of photography. Recent research indicates that early camera lucida landscape drawings had a significant influence on photographers in later decades.

The second half of the nineteenth century offers us rich confirmation of this notion. Photographers captured both land and water principally using the laborious process of albumen prints made from negatives of wet collodion on glass. Notable among them were seascapes from the 1850s by French photographer Gustave Le Gray. He, and others, often had to expose two negatives - one for the water and one for the sky - due to the limitations of the early processes. He combined the two negatives during the printing stage, with the point of juncture always being the horizon. One unfortunate result was that he occasionally attached stormy skies to glass-like water surfaces. One of Le Gray's favorite skies, in fact, made numerous appearances in his celebrated combination prints. Scottish photographer John Thomson rendered lakes like traditional Chinese paintings in his four-volume 1860s study, *Illustrations of China and Its People*. Many expedition photographers of the American landscape during the era of westward expansion focused on waterfalls and lakes, along with breathtaking images of mountains and canyons. Carlton Watkins and Eadweard Muybridge made stunning images of the Valley of the Yosemite; Timothy O'Sullivan recorded bizarre rock formations of Pyramid Lake; photographer/painter William Henry Jackson composed mirror-like reflections of Elk Lake, Colorado. Further north, Henry Hamilton Bennett, a less-renowned commercial studio photographer, helped to "tame" the wilderness in his photographs of canoeists on the Wisconsin Dells.

Ansel Adams, the indefatigable conservationist whose pristine photographic prints now fetch commanding sums at photography auctions, dominated American landscape photography in the twentieth century. His images are known to more than just photographers and collectors, of course; they also grace walls across the country as compelling poster images and fill volumes of carefully edited and meticulously crafted books. Adams did not work in a vacuum, however. Others, such as Edward Weston, Minor White, Eliot Porter and Paul Caponigro - to name but a few - all contributed their own signatures to the landscape genre; their unique visual statements would, in turn, influence generations to follow.

In the 1970s, new voices in landscape photography came forward that contrasted thoroughly with the longstanding traditions. These were the New Topographical photographers, and their mission was to show what earlier image-makers had generally tried to avoid: the man-altered landscape. Robert Adams, Lewis Baltz, Stephen Shore and others presented stark views of everyday American landscape, including shopping malls, industrial parks, and planned housing developments. They sought to impart a more truthful picture of the evolution of the land's appearance.

Today, millions of picture-makers worldwide document the landscape with easy-to-use handheld cameras. Yet, in the United States there are comparatively few who sustain a vision and a regional focus as noteworthy as their predecessors. Mark Klett is one who imaginatively explores his adopted southwestern terrain of Arizona and Colorado. A trained geologist, Klett has for years photographed and re-photographed many of the same locations as the legendary nineteenth century survey photographers. William Christenberry is another; he travels the same territory of Hale County, Alabama, as did the memorable Farm Security Administration photographer Walker Evans five decades ago. Christenberry narrows his focus to the unfettered landscapes and humble building facades of his boyhood home. His strength is his dedicated exploration of the place and time that shaped him.

Craig Blacklock, whose love of the Lake Superior area is palpable, is yet another whose vision and regional focus are inter-connected. I first became aware of Blacklock's images at roughly the same time as I was reading Holling Clancy Holling's children's classic *Paddle to the Sea* to my sons. The book is the story of a carved Indian figure in a small, wooden canoe made by a young boy in the Nipigon country north of Lake Superior. The boy named the carving "Paddle to the Sea" and placed the canoe on a melting snowbank. From there Paddle was eventually carried down a mountain and on a long journey around each of the Great Lakes, down the Saint Lawrence River, and finally to the Atlantic Ocean. It is an enchanting and engaging tale that introduces an appreciation for both nature and geography. Children have loved it since it was first published in 1941, and I later learned that, not surprisingly, it was Craig Blacklock's favorite book as a child.

Blacklock was somewhat less ambitious than Paddle. This is not to say, however, that circumnavigating *only* Lake Superior in a kayak was lacking in courage. This massive lake is the largest in the world in terms of surface area. And, as Paddle's journey informs children through the marvelous means of illustration and narrative, Blacklock's one-hundred-day kayak journey informs all viewers with the more detailed regard of a photographic lens. Through the ground glass of his camera, he lends us his searching gaze, providing us with expansive views and detailed studies. We marvel at the sand patterns seen through crystalline waters; we witness blankets of ice that camouflage the rocks below. We enter caves that we would otherwise fear and experience the texture of dawn that we would otherwise miss.

Occasionally we lose ourselves in these images, only to later delight in where we have been. Consider for a moment an image that was made near Speckled Trout Creek on the eastern Canadian shore (Plate 97). It is an image constructed entirely with the colors of *feuilles mortes,* or autumn leaves, yet it is not a picture of foliage. It has bold vertical shapes the color of sand and crushed shells, broken by needle thin lines of criss-crossing amber. The scale and the graphic impact within the frame suggest that we are possibly looking at the results of photo-microscopy, and we momentarily ponder what we might be seeing. Is it a mysterious laboratory culture or maybe a cross-section of human tissue visible only through magnification? Then again, with its strong, simple lines, perhaps this shape is a metaphor of some amorphous character, some looming, thick-bodied stick-figure in full stride, whom we have encountered elsewhere, or are still to meet. Soon, our eye catches the clue, a white horizontal, identifiable wave near the top of the rectangle, and we proceed to correctly read the image as the patterned bottom of the lake. Suddenly we are transported from our reverie to reality and perhaps back again to the dream. Nature, it seems, can always be counted on to fulfill that need; photographs of nature which accomplish this are far more rare. The possibilities for interpretation of this and many of the Lake Superior images are seemingly endless, affording ample contemplation by the curious mind.

On another level, Blacklock's imagery recalls the work of Eliot Porter, the first photographer - and some would argue the only - to be adequately celebrated for his use of color in depicting the landscape. Porter's work is best known for the way he gently traced patterns of grasses, branches and foliage, always with a delicate palette. Blacklock readily admits his admiration for Porter's pioneering work and, along with others in the latter part of this century, he is trying to further the vocabulary established by Eliot Porter in this arena of pictorial exploration. Like Porter, Blacklock's work is characterized by the specific rather than the spectacular, the minuet rather than the opera. Also like Porter, Blacklock was born and raised in the mid-west, far from the Grand Canyon, Niagara Falls, or other extraordinary accomplishments of nature. Perhaps that is why images from both of them are predominantly tranquil and particular: When we sense the wind, it is a breeze that rustles; when we hear the water, it merely laps the shore. For Blacklock, as with Porter, there is as much respect for ordinary pebbles and lichen as for thundering waterfalls. The beauty and the mystery of the quiet water is captured by Craig Blacklock as an expression of his awe and reverence for Lake Superior. He has known the lake since childhood and goes there in search of universal truths. The images in this book mirror the spirit of the photographer and, as such, they often serve as portraits of his thoughts, hopes and feelings.

Still, the question nags: Can these Blacklock pictures really be from just one lake? How is it possible to find oneself in both the Aegean Sea and the Arctic Ocean when viewing these images? Indeed, some of them seem to have more in common with tapestry and the textile arts, so rich are their colors and details, than they do a lake. Some remind us more of painting from the Abstract Expressionists, so sharp and two-dimensional are their edges. We even find poetry, some sort of visual Haiku it must be, in the form of great blue heron tracks.

To some of us, a lake is a lake. It has fresh water, loons if we're lucky, and comes complete with mosquitoes. We are never there long enough to appreciate the layers of the rock, the hue of the ice, the nuances of the seasons. Blacklock is there for us and gradually, in these images, we come to feel comfortable in the places where animals dwell. We sense deer, bear, moose and beaver. There are birds of varied call here, too. The photographer's accompanying journal confirms their presence; we don't have to see them to know they are there.

Craig Blacklock carries with him a deep respect for Lake Superior. He grew up in the Minnesota of 10,000 lakes, has a perfect view of a small one from his home, yet has a magnetic attraction to the greatest of them all. He doesn't have to travel far to reach Lake Superior, and he is driven to share it with others. As an occasional teacher, he feels compelled to take his students there and delights in seeing other photographers crouching behind tripods, precariously communing with nature. His love of Lake Superior is such that he is angered that viewing platforms were erected in a Minnesota state park, detracting from the natural character of the shoreline, and that a modern church in Duluth was built on a hill with a commanding view of the water, yet was designed with only small,

stained-glass windows. If you visit him, he will take you to this special inland sea and coax you to try your hand in its crystal-clear, frigid water - with a temperature, even at its autumnal warmest, that will numb a human within minutes. You will learn the names of many wildflowers – mountain ash, cinquefoil, and birds-eye primrose – and how to distinguish between aspens and birch. You will marvel at the richness of names that dot the periphery of the lake, rhythmic Native American names like Michipicoten, Ontonogan, and Keweenaw; colorful French Canadian appellations like Bête Grise and Le Pâté; or declarative English language offerings like Split Rock, Bark Point, and Miner's Beach. If you visit the photographer by way of his pictures, you will experience all of this vicariously, but you will experience it.

Craig Blacklock's life is in many ways an extension of the ecosystem of Lake Superior itself. As much as possible, he lives at one with nature. He and his wife Nadine, also an accomplished photographer, mined the slate for the floor of their woodland home. They built the passive-solar, wood-stove heated structure with much of their own labor. As a former potter, Blacklock crafted the plates and bowls from which they eat wild rice casseroles and other often vegetarian fare. Recycling is of the first order: every lettuce leaf and tea leaf is offered back to the earth via the compost heap. Binoculars sit on windowsills, always ready to catch a passing hawk; they are unnecessary for the local bears, which come to press their noses on the panes of glass. This information is pertinent only because it establishes his relationship to his subject matter: he is connected to it. His contemporary existence is not like that of many in this country. He does not have to deal with rush hour traffic or crime in the neighborhood. Yet, the stresses in his life are inconceivable to most of us: He bunks down in a sleeping bag housed in a small fabric tent, surrounded by snow and howling wind in temperatures down to 30 degrees below zero, to make photographs during the winter months. What is hardest for him to endure is being witness to the loss of wild places he has come to love. Being a nature photographer is a job that also has occupational hazards, but Blacklock freely admits that he feels safer on the lake than he does on the road.

There is a tremendous diversity in the landscape photography being created today. Photographers add color with tints, with computers, or by the trusted and repeatable means of relying on manufactured films. Images emerge that are both pocket-shaped and room-size with subjects ranging from populated urban areas to barren nothingness. The pristine wilderness that Blacklock offers us, therefore, is one that some of his contemporaries find difficult to reveal. He avoids the developed shoreline where some of his peers conscientiously choose to highlight its frightful ugliness. Like the New Topographical photographers in the '70s, many image-makers today prefer to not shield us from toxic waste centers or land devastated by military experiments. Yet, like Blacklock, other photographers of the Nineties continue as environmental advocates without abandoning the glory of nature in their picture-making. While the immediate concerns of all of them may be the vantage point of their view cameras, or the application of the Zone System, their mutual long term interests are for clean air, clean water and perpetuation of the forest and fauna of our world. In increasing numbers, they will collectively carry us into the next century as photographers whose concern for their subject actively extends to its preservation.

One of the specific wishes of Blacklock and other environmentalists is that the remaining undeveloped lake shoreline be kept for open access. When he silently glides for months on end around the periphery of the lake, he does it with the hope that his pictures will convince others to appreciate the lake as he does. Lake Superior is simply too profound as a spiritual resource to be guarded by a privileged few. Should these last open stretches be developed, they will forever be out of reach by the general public. We have learned precious little from the examples set for us by the Navajo, the Dakota and the Anishinabe. We all know that Native Americans lived in harmony with the earth and believed that land could be neither bought nor sold since it belonged to all. Perhaps it is not too late to apply their wisdom to relatively small, yet hugely important, areas of land bordering the Great Lakes. Perhaps these Blacklock photographs will help preserve public access to Lake Superior's shores, as certain photographic efforts of his 19th Century predecessors helped to convince Congress to establish national parklands of the Yosemite, Yellowstone, the Grand Teton and others. Such lofty aims often seem impossible. But then, the little hand-carved canoe named Paddle did make it to the sea.

Linda Benedict-Jones
Curator, Polaroid Collection

Plate 3

Ice Shards, Shovel Point, Tettegouche State Park, Minnesota. March, 1984

THE LAKE SUPERIOR IMAGES

The Lake

Whether we are walking barefoot over soft sand on the South Shore, or gazing down at the water from atop the Sleeping Giant, almost everything we appreciate about Lake Superior relates in some way to its geology.

The story of the lake's creation begins on what is now the Canadian shore during a period of volcanism and mountain building around 2.7 billion years ago. Volcanoes, some above and some below the sea, erupted and built up thick layers of lava and ash. Deep below the surface, magma intruded upwards, then solidified as huge batholiths of coarse-textured granite. This granite formed the core of the Algoman mountains, a range that may have rivaled the present-day Rockies.

For the next 700 million years an interval of erosion took place. It was during this time that the granite batholiths we currently see along the Canadian shore were first uncovered. Following this, about 2 billion years ago, a sea flooded the region and sediments were laid down on top of the eroded bedrock. In places, these sediment layers contained high concentrations of iron-bearing minerals. Taconite and other iron ores in several iron ranges near Superior's shores are evidence of this deposition. The youngest layer of sediment from this time period is the Rove Formation. A thick layer of sedimentary rocks, it underlies much of the low area around Thunder Bay and Grand Portage.

A little over 1.1 billion years ago basaltic lava poured out of a great mid-continent rift that stretched from current-day Lake Superior to Kansas. Collectively known as the Keweenawan volcanic rocks, these flows are exposed not only on Michigan's Keweenaw Peninsula and Isle Royale, but at several locations on the Canadian shore, and almost the entire Minnesota shore. Hundreds of individual flows make up the North Shore Volcanic Group, stretching from Duluth to Grand Portage. While most of the flows were basaltic, some were rhyolites, such as the flow that formed Palisade Head and Shovel Point in Minnesota's Tettegouche State Park. The lava contained gas cavities that later filled with minerals. Several of these *amygdules* (including agates and thomsonites), having been released from their lava molds by weathering and erosion, are sought after by rock hounds. Along this same shore are two prominent gabbroic intrusions: Silver Cliff sill and Lafayette Bluff sill. Minnesota Highway 61 passes through tunnels beneath both of these high headlands. Further northeast, intrusions of basic magma penetrated the lava flows and the Rove Formation sediments to form more diabase dikes and sills. Two-hundred-foot-thick diabase sills cap the Sleeping Giant on the Sibley Peninsula and Pie Island where these relatively hard cap-rocks have protected the softer shale of the Rove Formation from erosion.

The spewing out of great quantities of material from beneath the present-day bed of Lake Superior eventually caused the crust to sag, leaving a depressed trough. For millions of years, sediment was deposited into this trough from the surrounding uplands. Remnants of this deposition make up the sandstone found along the South Shore, where ripple marks and crossbedding patterns have preserved the history of long-extinct streams and seas.

Events that gave final shape to Lake Superior also shaped early populations. Those of us with a northern heritage have ancestors who hunted mastodon and wooly mammoth, and perhaps ate fish from huge glacial lakes. During the Ice Ages, that began about two million years ago, ice covered the Lake Superior region at least four times. The last episode, the Wisconsin glaciation, began about 75,0000 years ago and continued the scouring process of prior glaciations, removing vast quantities of rock. The Superior Lobe of the glacier advanced from the northeast down the trough created after the Keweenawan lava flows. Scooping out much of the softer sandstone that overlay the volcanic rocks, the glacier sculpted the basin of present-day Lake Superior.

Around 13,000 years ago the climate began to warm and the ice growth could no longer keep up with melting and sublimation. As the southwestern tip of the Superior Lobe melted, Glacial Lake Duluth filled the basin. The remaining ice still dammed the natural outlet to the east, creating a temporary flow out of the basin to the southwest. During the time it took the ice to completely melt, the lake was much higher than at present, but when the outlet at Sault Ste. Marie was uncovered, the water dropped nearly two hundred feet below the current level. Once the weight of the ice sheet, which had depressed the land, was gone, the outlet at Sault Ste. Marie slowly rebounded. This gradually raised the lake level to its present state, reached about 4,000 years ago. Though the lake has not changed dramatically since then, the relentless process of erosion continues. Some erosion takes a lifetime to notice – like a clay bluff disappearing from beneath a home once far back from the lake. Sometimes it is as swift as a cliff breaking along a fracture, sending tons of rock plunging into the lake like a glacier calving icebergs.

Lakes are among earth's most evanescent features. Superior and tens of thousands of smaller bodies of water born of the glaciers will be but a momentary flash of silver on the face of our planet. How fortunate we are that their existence and ours have coincided in time.

To comprehend Superior we must change our concept of what a lake is. Lake Superior has more surface area than any lake on earth: 31,280 square miles, roughly the same size as South Carolina. Its three quadrillion gallons, ten percent of the world's fresh surface water, could flood all of North and South America to the depth of one foot. This water washes against 2730 miles of shoreline. So large a mass easily tempers the climate near the lake, cooling shores and islands in summer, and warming them in winter. Lake effect snow, created by warm, moist air over the lake condensing when blown onto the cold mainland, contributes to more than sixteen feet of snow that falls on Michigan's Upper Peninsula each winter. Climatic differences and the variety of soil types from north to south produce deciduous forests with a smattering of conifers on the south shore and boreal forests on the far northern shore.

We know the facts, yet not know the lake. To understand the lake, we need to live with it. Over the years, Superior worked its magic on me in ways that cannot be quantified, put into words, or captured in photographs.

The Journey

What lies around the next point? How far over the horizon is the next shore? I asked myself these questions so many times about Lake Superior that I became obsessed. I went to the lake again and again, distilling its substance into photographs. The process took time. I made many trips of one or two weeks over a number of years, and then a long, one-hundred-consecutive-day journey circumnavigating the lake by kayak. This concentration of energy created an existential existence for me within the lake environment and my photography. I was sequestered with my subject. I listened to its voices and silences, felt its calm and stood in the fury that can follow its slightest change or expression. I saw its wholeness, its wounds, what is healing, what isn't. I stayed with Superior from pre-dawn till dusk, in moonlight and darkness, in all seasons, until pretenses fell away and truths were revealed on film.

1984

The first photographs for this book were made in May on Palisade Head along the North Shore in Minnesota: spring thunderstorms billowing up behind the massive cliff face and bright green, newly formed birch leaves; cubist patterns of sunlit and shaded rock. I made several more trips along the Minnesota coast during the rest of the year. Each time, I learned a little more about my subject. I knew Superior's waters were cold, but I did not know the power of that cold until I stood in waist-deep surf for a few minutes. An instant sensation of my body imploding was followed by agony. Back on shore in dry clothes, I could not warm up and ached for hours. I still recall this experience as I decide if it is safe to paddle.

1985

A canoe trip to the Susie Islands, just off-shore from Grand Portage Indian Reservation, gave me a totally new perspective. From a cliff on Lucille Island I looked over lower islands to the high terrain of the mainland. Water among the islands stays relatively calm even if rollers roar on the open lake. Although the islands are close together, each has a distinct character in rock type, terrain, and vegetation. Some have not burned for centuries. So, in places the cushion of moss is very thick. Others are mostly bare rock, covered with gull rookeries.

As much as I was fascinated by the Susies, I remember the images of winter most vividly. In February and again in November, I worked with intimate subjects along the Minnesota shore. Near the Witch Tree, lichen-covered rock glowed beneath a fluted veil of ice. At Gooseberry Falls State Park I was intrigued by a frozen puddle. Looking down into the ice was like peering into the infinite cosmos. From Shovel Point, abstract patterns of broken ice shifted under the force of the wind, the grating panes sounding an eerie echo from the ice ages. In December I explored remote Canadian shores. Many mornings were in the minus-thirty-degree Fahrenheit range. Heavy, smoke-like fog rose from the lake. Each wave released a white band of steam when it broke, as if forbidding spirits were escaping from a smoldering caldron. Superior delivers death quickly and easily this time of year. On the eastern shore I came upon a boat I later learned belonged to missing fishermen. The large aluminum hull, twisted and torn, resembled a stepped-on soda can. But amidst this cold, unforgiving environment, I also found much beauty. The finest crystal cannot come close to matching the ice formations I saw along the shore and streams flowing to the lake. Snow as dry as powder blew off spruce tops, caught the sun and blinked like fairy dust.

1986

After two trips up the Minnesota shore in early winter, I moved on to Wisconsin's Apostle Islands. Here I used a small sled to transport my gear over the ice along Houghton Point. My snowshoes occasionally broke through a thin layer of ice, and sometimes sank through five inches of slush before hitting a second layer of ice. I took each step with caution, never completely confident the second layer

would be there. After poking into several small caves, I found an ice falls enveloping a small shrub. It remains one of my favorite compositions.

A few days later I hiked to Squaw Bay and had my first look at Devil's Island Sandstone arches and sea caves. Icicles were everywhere. Some were clear, others milky, some smooth, some jagged as fish teeth. All decorative, all with character. Inside the caves, massive ice pillars stretched from ceiling to floor.

The remainder of 1986 and all of 1987, *The Lake Superior Images* was put on hold while my wife Nadine and I photographed the Boundary Waters and Quetico for a book called *Border Country, the Quetico-Superior Wilderness.* My sabbatical from Lake Superior gave me time to let my feelings about Superior gestate. I returned to work on the lake with a crystallized vision of what I wanted to express.

1988

To gain access to the rest of the lake, I purchased an expedition model Sea Otter kayak. I named it the *Kingfisher.* It is light blue and white, like its namesake. Also, like the bird, I expected to be making short excursions over the water with frequent landings. I learned basic paddling skills at a sea kayak symposium in Bayfield, Wisconsin, then returned home to refine my Eskimo roll, a self-rescue technique for righting an overturned boat. In late August I took my first trip with the *Kingfisher* to the north end of Oak Island in the Apostles. As I began my crossing a strong wind nearly blew the paddle from my hands. I turned back. My boat could handle the wind and whitecaps, but I was still a novice on these waters. I did get out to the island later that evening, and then was wind-bound for most of a week. The continual metamorphosis of a small stream meandering through the sand beach near my camp was my only subject. A few weeks later I paddled to Stockton Island. It was late enough in the season that the only tracks on the beach were those of geese, gulls, coyotes, and bears. What a pleasure it was to have this paradise virtually to myself.

Two experiences stand out from that trip. It was so dark the night I photographed a full moon rising over Balancing Rock I could barely see to assemble the camera, and I could not get the necessary light meter readings. I guessed at four exposures. The longest, about 30 seconds, produced what I wanted. The other challenge on that trip was working chest-deep in the lake to photograph waves washing through a honeycomb of small sandstone arches. Wearing a dry suit (a

waterproof one-piece garment worn over insulating pile), I tethered the kayak to my waist and waded out. Each wave coming in lifted me off the bottom. After I set up the tripod and 4x5 camera, I made one exposure before a large swell grabbed the focusing cloth off the camera and carried it away. Not being able to continue shooting without the focusing cloth, I switched to a 35mm camera. The precise moment the waves came through the openings was unfortunately the same moment they hit me and the tripod. All but a few exposures were ruined by that vibration.

1989

In January and again in March, I worked with ice formations at Cascade River and Split Rock Lighthouse State Parks in Minnesota. When the weather warmed, I returned to the Apostle Islands.

In June, I paddled out to Sand Island and entered a series of sea caves at Swallow Point. Their womb-like vestibules, with reddish walls, humid air, and slurping noises, had a tactile intimacy. Inside the largest one, I beached the *Kingfisher* on a ledge and, wading, explored several adjacent rooms. My favorite room had over a dozen windows looking out on the lake, and others beneath the surface. Pillars of stone had eroded into the shape of Grecian urns.

Whenever I wanted to photograph the caves or shoreline from a point too deep to wade, I stayed in the kayak, and added extensions to the bottoms of my tripod legs. This worked in up to twelve feet of water. Once the tripod was set up, I would hang onto it to keep the kayak in position. This may sound simple, but in practice was quite awkward. One time it took more than an hour just to get the tripod set up on a boulder-strewn bottom. During the process I kept drifting under a ledge where dripping water gave me unwanted showers.

The next month I paddled out to Devil's Island to work with the larger sea caves at the north end of the island. These caves do not have the intricacy of those on Sand Island, but in several instances the rooms are connected, offering the opportunity to photograph through one room into the next. The sandstone ceiling in at least one cave has a rippled pattern – a casting of sand patterns from a billion years ago, revealed when the lower layer dropped away.

In the Apostles I found subjects that needed midday sun, lighting I had avoided for years. The high sun brought out bright green in the water and texture in the cliff faces. That same lighting worked well in Michigan's Pictured Rocks National Lakeshore in September when I worked the colorful ramparts between Miner's Beach and Chapel Beach.

I had seen the massive undulating walls of sandstone at a distance from a tour boat, but paddling along them in the kayak brought me within inches of the mineral staining that gives the area its name. It was like being in a modern art museum. I needed only to frame the paintings I liked best. As I was drifting along composing photographs in my mind, a little sand spilled over the ledge two hundred feet above me and landed on the kayak. That should have been ample warning, but I simply covered my head until it stopped. A second later a large section of rock ledge landed in the water two feet to my right. I did not spend a great deal of time under overhangs after that.

On the same trip I had my first experience with waves so large the crests blocked my view of the horizon. While working in water near shore, I noticed waves building and decided I should pack up and head in. The kayak had been perched well above the water on a rock, but by the time I finished putting the camera away, waves were reaching the boat. I slid the kayak down on the lee side of the rock and hopped in. Just as I did, a wave lifted the bow and deposited it back on top of the rock, leaving me at a steep angle, bracing with my paddle until the next wave floated me free.

I paddled hard through waves breaking on rocks in shallow water. Once away from shore I actually enjoyed the roller coaster ride until I noticed the wind getting stronger and blowing me sideways towards the cliffs. For the next mile and a half I struggled to keep the kayak in deep water, as I angled towards Miner's Beach. When I got there six-foot waves were breaking far out from the sand. To avoid surfing uncontrollably towards shore, I back-paddled each time a wave hit me, letting it wash over my stern rather than propelling me forward. Finally, I rode the back of a wave up onto the sand. The next wave turned me sideways, filling the cockpit with water as I stepped out. I lay in the sand for a few minutes, exhausted and somewhat amazed I had safely negotiated the churning surf. The images from that trip were exciting and vastly different from any others. I wanted to do more at Picture Rocks and planned to go back the next year.

In September I hoisted the *Kingfisher* aboard a ferry to Isle Royale and got off at Rock Harbor, on the northeastern end of the island. For several days I paddled, hiked and camped among the small islands that lie just off Isle Royale. I chose my compositions, then waited for weather that never came. The sky remained cloudless most days, and the wind blew almost constantly. I left with only a few usable transparencies and a handful of Polaroids for future reference.

1990

I returned in June to Pictured Rocks to refine some photographs from the previous year and to work on the Grand Sable Banks and Dunes – the largest sand dune complex on Superior. The sand rises up from the lake in a continuous bank five miles long and nearly 300 feet high. Behind this precipice, soft dunes blend one into the other in graceful curves, their precarious shapes anchored by deep-rooted grasses. I was at first overwhelmed by the landscape, but soon found myself walking with eyes focused at my feet, searching the sand for simple patterns and tracks.

The next trip was to Ontario. Putting in at the tiny town of Silver Islet on the southern tip of Sibley Peninsula, I paddled east into the labyrinth of islands beyond Black Bay. My base camp on a small island near Loon Harbour gave me access to high cliffs, quiet protected coves, and rugged shores of the outer islands. The predominant weather was afternoon thunderstorms over the mainland, clear sky overhead, and fog rolling in from the lake. The edges of these systems moved back and forth like a tide.

A thunderstorm caught me on the paddle back across Black Bay. It was still pouring when I reached the mainland shore, but the sun soon broke through. A family of four otters popped up in front of the kayak, back-lit in rain-pocked water. One had a fish they all wanted. When they noticed me, the fish became secondary for all but the one who possessed it. They dove and resurfaced, coming closer and closer. Soon I noticed only three otters swimming around me. The one with the fish was on shore having lunch – smart otter.

After that trip, I felt I had the kayaking experience needed to paddle the Pukaskwa coast from Hattie Cove to the Michipicoten River – a distance of one hundred miles along a rugged wilderness coast with few islands for protection. I made the trip in August. The landscape was incredible. Most amazing of all was the rock! Tortured, twisted, folded metamorphic rock like nothing I had ever seen. One small island in Oiseau Bay had zebra-striped black and white rock with pink veins snaking through it. Elsewhere, giant dikes cut through cliffs, and quartz veins meandered over islands and under crystalline water. Between the headlands, coves were lined with white cobblestones. But the clear blue sky, filled only with jet trails instead of thunderheads, was a disappointment. I contented myself with reference photographs and marks on the map. I hoped conditions would be better my next trip.

On my way home I stopped at Lake Superior Provincial Park to photograph the tremendous gallery of pictographs on Agawa Rock, a cliff facing the lake. The iron oxide paintings have a simplicity and beauty unmarred by time.

From my earliest childhood visits to Superior I have been fascinated by the border between water and sky. Sometimes the horizon is a sharply defined straightedge, other times it is indistinguishable, a line to be imagined. As I grew up, this boundary came to symbolize a clear demarcation of where my knowledge of the lake ended. What lay beyond my vision, beyond my personal experience, beyond the horizon, was cloaked in mystery. My photographic trips gradually pushed this horizon farther off, but many gaps remained. I had a desire to put all the pieces together, to see the shore as a complete circle, encompassing the horizon – real and symbolic. I made plans to circumnavigate Superior by kayak during the summer of 1991.

1991

On May 19th Nadine dropped my cousin Chris Jordan and me at Split Rock Lighthouse State Park forty-five miles northeast of Duluth. Chris would accompany me as far as Grand Portage, just south of the Canadian border. What a great feeling to be on the water with the planning behind me and the whole lake before me. For the first time, I paddled beneath cliffs I knew well from land: Split Rock, Gold Rock Point, and Palisade Head. For many who love this shore, these headlands embody the essence of this part of the lake.

We camped the first night at the mouth of Palisade Creek, a lovely site with a beach of gravel and sculpted bedrock. Palisade Head rose up from the lake to our southwest, Shovel Point to the northeast. Two days later we reached Temperance River State Park. Along the way we heard oldsquaw ducks calling, frequently saw loons, and glimpsed an otter. Perhaps the most spectacular sight was the Manitou River plummeting into a bay surrounded by cliffs and a sand bar.

The 22nd brought heavy fog and thunderstorms. I walked the shore and photographed tiny, pink bird's-eye primroses growing around small pools in the bedrock. In the next couple of days I took the camera out only once to photograph shoreline southwest of Grand Marais. Chris and I had just commented on how nice it was the area had not been developed, when we met a woman clearing land nearby for a future home site. Seeing it saddened me greatly.

At Horseshoe Bay I made several photographs of the jumbled boulder shore and a small island as heavy fog moved in. I knew this might be my last chance to photograph the harbor. It was divided into lots with surveyor's tape, and has been talked about as a site for a marina.

When we reached Grand Portage Bay we visited the reconstructed fur trading post at Grand Portage National Monument. I tried to imagine Voyageurs arriving here after paddling the length of the lake, but the presence of other tourists and the sounds of their cars broke the mood. Over at Grand Portage Lodge we met Nadine. She brought me supplies and took Chris home the next day. For me, the trip to this point had been a shake-down for the part now beginning. In the next month I would be traveling alone through wilderness, much of it new to me. I said good-bye to Chris and Nadine and rounded Hat Point, stopping to pay my respects to the Witch Tree, a four-hundred-year-old white cedar held sacred by many Anishinabe who still live on the reservation land that surrounds it. Although the day started out sunny, I got no further than the base of Pigeon Point before a thunderstorm forced me ashore. The next day I put on only two miles before thunderstorms stopped me again. Waves smashed against the barren shore at the end of Pigeon Point, the pounding muffled by fog. I hiked inland to an old elevated beach. Stones encrusted in shells of polychrome lichens crunched beneath my boots. How many centuries had it been since waves tumbled these stones, polishing them clean and smooth?

When I finally moved on, it was in a low-lying fog bank. Everything was white and silent. I had the weird sensation of being stationary. It seemed as if the water came to me. Floating sticks approached me as if I were reeling them in on a fishing line. So clear was the water, I felt suspended three feet above the surface. Pine Point appeared out of the fog as a castle in a fairy tale. Mirages made tall anvils of the islands, and thunderstorms rumbled over the mainland. This was the Superior I had looked forward to: wild, vast, a landscape rich in mystery and illusion.

At the south end of Mink Point twin moose calves disappeared into the woods and, as I rounded the point, a beaver slapped the lake surface with its tail. I thought a high cliff to my left rear would provide a good vantage point and turned back to land. I headed up the hill, bush-whacking about a half mile through the woods to the overlook. The panorama before me included a beaver pond, Mink and Sister Islands, and Sturgeon Point. Thompson and Pie Islands were hidden somewhere in the fog.

On the 31st I experienced my first seiche of the trip, a phenomenon caused by changing air pressure. During the seiche, the lake sloshes like liquid in a cup and creates tide-like conditions. As I passed between the mainland and Dog Island I had to paddle up a six-inch rapids in an otherwise calm lake!

While camped at Flatland Island I visited with some fishermen, the first people I had seen since Grand Portage. Later that evening as I watched clouds disappeared over Pie

Island a loon surfaced in front of me and a mink poked out from an alder only five feet to my right. I squeaked, enticing it back for three inquisitive looks before it bounded away. Thin strands of fog settled over Thompson Island like cobwebs. A string of five cormorants passed by at dusk. They rose up when they saw me, then settled down to fly low over the water.

After crossing over to Pie the next morning, I waited on a beach for the afternoon sun I wanted for photographing Le Pâté, the high bluff on the west side of the island. A flock of common goldeneye ducks flew by, their approach signaled by a rising whistle of wind rushing over their feathers. Other goldeneyes were fishing. Males courted females by stabbing their bills up and forward repeatedly, making a call similar to a creaking hinge slowly opening. This beach, like several others I had seen, was covered with black spiders. I slapped mosquitoes and put them down near the spiders, which immediately pounced on them. In mid-afternoon I photographed a cloud over Le Pâté. At one point it formed a giant wing, complete with detailed feathers.

Upcoming events can loom large in one's imagination. Ever since conceiving this trip I had dreaded the crossing from Pie Island to Sibley Peninsula. The distance is only seven miles, but unpredictable winds in Thunder Bay, frequent fog, and having to cross shipping lanes, provided enough uncertainty that I was never comfortable with the idea. My worry disappeared when the morning of June 2 dawned calm and partly cloudy, and I got a perfect weather forecast. The crossing was beautiful. Sun peeked through clouds above the Sleeping Giant and smooth water reflected the whole scene.

I spent four days in Sleeping Giant Provincial Park on the Sibley Peninsula and found a lot to work with there. I photographed high cliffs on the west side from the kayak, and hiked up to the top of the Sleeping Giant from Tee Harbour. Bunchberries were in bloom. The weather couldn't have been better.

A few days later, on Moss Island, it was raining when the alarm went off at 5:30 a.m. Still tired, I went back to sleep for an hour. The next time I peered out things had changed. Sun touched the beach and trees. The sky looked as if it had been daubed on in oil paint with a stiff brush. The zenith was dark indigo, the horizon robin's-egg blue. Clouds with luminous white tips had coarse, purple undersides. I jumped from the tent, grabbed the camera and ran. Just as I set up, a cloud erased the sun from the beach and trees. I waited impatiently, begging the sun to come back, all the while helplessly watching every cloud disappear *except* the one shading my foreground. Success in nature photography comes from anticipation of events such as this, and I cursed myself for sleeping in.

Later that day I fought two-foot whitecaps in Blind Channel, I appreciated finding protection near Owl and Paradise Islands. Their park-like shores had open areas of pink gravel covered with lichens and low shrubs. As I approached the east side of Bowman Island a deer bounded away over sharp rocks. How it managed to run without breaking a leg amazed me. I later took a stroll down the same beach and felt razor edges even through my heavy leather boots.

I made camp that night on Hope Island. The morning of June 12th was dry, cold, and extremely clear. Shaded cliffs in Armour Harbour contrasted with back-lit spruce and birch trees. Near Woodbine Harbour I entered a section of columnar jointed basalt. The six-sided ribbons of black rock, some curved and some straight, were set in bundles at every angle.

On the 13th I paddled in to Rossport to pick up supplies previously shipped to the Rossport Inn, and to leave off my exposed film. Owners Ned and Sheila Basher greeted me and for the next couple of days I enjoyed good food and company. Ned introduced me to Merce Romanec, and we spent the day together walking along spectacular waterfalls on the Gravel River.

On the 15th Merce decided to join me for a stretch of paddling. At Worthington Beach we explored an old mine and found a small pictograph – evidence of two very different cultures that had both found something important to them there. Further on, I climbed to the top of one of the small islands that make up Les Petit Escrits. Fog flowed through the channels below me and occasionally up over the islands, filtering through the trees. We made camp on the mainland by a small stream. Moose and wolf tracks decorated the sand. I left Merce the next day at Terrace Bay.

On the afternoon of June 19th I made the crossing to Pic Island. High and rugged, Pic dominates this part of the shore. To make a photograph that would show this, I needed a perspective some distance from the island. A cliff on tiny Allouez Island south of Pic served perfectly. The following morning, with the hope of seeing caribou, I went to the beach on the northwest side of Pic. Though I did not see any animals, tracks covered the sand.

That night I camped a short distance away on Foster Island. Glaciers had sculpted the island into smooth fingers, as if a hand had been drawn over wet clay. In places, grooves etched in the rock are still clearly visible. Tadpoles swam in the pools. White Labrador tea and mountain ash blossoms dotted the woods. The morning of the summer solstice purple clouds fanned out above Pic to the west. Strong wind blew from the east most of the day, and I decided to remain on Foster; I still had some compositions

in mind to shoot. In late afternoon the wind died for about thirty seconds, then switched to the west and built to white caps within a minute! I was glad to get this terrifying demonstration of Superior's quick-change artistry from land rather than in the middle of a long crossing.

Just before sunset that evening a man in a solo canoe paddled by, struggling to make progress into the wind. He was a couple hundred yards out and never saw me. What a strange, lonely feeling it gave me! I wanted to know where he was from and where his adventure was leading.

The following day I paddled north to the entrance of Port Coldwell. At the north end of the bay, the Canadian Pacific Railway goes through two tunnels. As I watched and listened from out in the lake a train snaked its way along the shore and through the tunnels. Railroads follow the low and level routes. At several locations, they come close to the other great means of moving people and industrial goods – water. The combination, especially where raw materials of industry like minerals or forest products are close at hand, led to the development of several towns on the shore of Superior.

Marathon is one of those towns. Within thirty minutes of paddling I left the wilderness, passed a belching smoke stack and landed at a boat ramp in the center of an industrial complex. I hiked up the hill, through the backs of businesses lining the highway, and over to a shopping mall. Minutes later I was back in the wilds; the excursion into the bustling community seeming a strange daydream except that I now had a bag of produce wedged between my knees.

At Hattie Cove I checked into the campground for the night. I called Nadine to let her know I was at Pukaskwa National Park a week ahead of schedule. Hattie Cove was where I would rendezvous with Kris Larson who had just graduated from college and was going to finish the trip with me – his last great adventure before settling into a job. The next morning I moved to a small island in neighboring Pulpwood Harbour where I could continue to work while waiting for Kris.

The morning of June 26th the sun shone a little while, but by 9:10 a.m. low, dark clouds blocked the light. Thunder crashed in the west, and breakers driven by a strong southwest wind splashed up on islands at the mouth of the harbor. The air was heavy and humid. I battened down my tent and waited for the storm to hit. At 9:40 the first splatters of rain turned into a downpour that lasted until after 11:00. As the rain lessened, the wind (now easterly) increased, popping the tent fabric, and twice yanking stakes from the thin soil. I climbed an outcrop and could barely stand against the wind. A red-breasted merganser took off into the wind, beating the air. Not making progress it veered off to the south. A gull glided over, side-slipping. It was visibly buffeted, constantly making slight adjustments to remain in control. Then it, too, circled away, zooming on a careening course along the far bank.

By noon the wind switched back out of the southwest and calmed to ten miles per hour. Around 2:00 p.m. I paddled to the Hattie Cove Visitor's Center to call Nadine. At 3:00, a strong seiche began in the cove, and by 3:30 thunderclouds were again rolling over. The south sky turned pink and the north an ominous green-black. Tremendous rain and wind came, and the drop in air pressure created a seiche stronger than anyone in the area had ever seen. It produced waves six inches high across the cove, and three feet high at the bay entrance. Normally quiet, the bay became a river with a strong current reversing course every fifteen to twenty minutes. The sand beach advanced and retreated twelve feet. Logs floating near shore were alternately left high and dry, then lifted and carried by the current. A tornado cut through the campground, toppling over one hundred trees and cutting electric power. I did not want to paddle back to my camp under these conditions, so the park naturalist gave me a ride to a motel in Marathon on his way home.

When he picked me up the next morning the thunderstorms resumed, but with less ferocity. Back at Hattie Cove, I waited for the moment the seiche equalized, then paddled out into the swells and around the corner to my camp. A large spruce tree had blown over, pulling its mat of roots and soil away from the bedrock. I was relieved to see that my tent, with extra guy-lines tied to rocks, had withstood the storm.

Midday it became still and foggy. I took a camera to the east end of the island and photographed the seiche. It flowed into the harbor for five minutes, then out to the lake for the same length of time. Twenty vertical inches separated the high and low water levels, creating a small waterfall between rocks off of my island.

On the morning of June 28th I was down to one sheet of 4x5 film which I had saved to record the sand beach near the Pic River. When I first saw the beach four days earlier it was covered with all-terrain vehicle tracks. Knowing the storm would have wiped those tracks away, I wanted to get to the beach before any new tracks were put down. I got there at the perfect moment. A fog bank lay just off shore, and a layer of purple clouds was edging out over the lake. There was no wind blowing the grasses! Then, to my dismay, I discovered part of my tripod was still in the kayak, and spent five minutes retrieving it. Fortunately, conditions held and I got the photograph.

Kris and his fiancée Christine arrived the afternoon of June 30th. We had a champagne toast to their recent engagement, followed by a feast of fresh food and sweets. Most of the gear was readied that evening, and we finished packing early the next morning. Kris and I were on the water by mid-morning. Christine continued home around the lake by car.

Our first campsite was on an island that was home to millions of what looked like house flies. They dove into our cooking pot, got inside my cameras, covered all plastic and nylon surfaces – especially the underside of our tent flies, where they were so thick they blocked out most of the light. The next morning we stopped at the mouth of the White River in search of Pukaskwa pits. We found several of the shallow depressions, where someone had "dug" into the beach stones long ago. The function of these pits remains a mystery. Scattered across the northern reaches of Lake Superior, they were probably made by Native Americans.

A little ways beyond the White River I photographed a diagonal vein of black rock in a gray cliff. This scene was a prelude to the distinctive rock of Oiseau Bay. We arrived at Oiseau early in the afternoon, quickly set up camp, and paddled to the island I fell in love with on my previous trip. I was anxious to get Kris' reaction to the rock, and pleased when he seemed as excited by it as I was.

On July 3rd I got the weather and lighting I wanted. A dark sky filled with thunderheads was the backdrop for sunlit black-and-white striped rock. I felt great satisfaction getting images I visualized a year before. Returning from the island I spotted a beaver swimming, diving, and slapping the water hard with its tail, signaling its alarm. I paddled above it and watched it zig-zag beneath me.

A monarch butterfly escorted us out of the bay the next morning. Now the shoreline was steep with only a smattering of beaches. Rocks were pink, gray, or white. I hoped the light fog would hold until we reached Simons Harbour, because I wanted to photograph fog-shrouded islands from a cliff there. We paddled extremely hard but the fog lifted just as we arrived.

That evening, though, the fog returned as we hiked to an overlook of Hideaway Lake and English Fishery Harbour. I photographed the vista, then we ran through the woods to a north-facing cliff, arriving just as the wall of fog was swallowing up the islands and starting to flow over the mainland. I had previously visualized photographing the scene with a long lens, but had only a wide-angle with me. Almost frantic, I searched for a composition that would work with the short lens. The moment was quickly passing, and I had only two exposures left. I lowered the tripod to waist-height to use rock as the foreground. It looked good.

Focus. Light reading. Click. Check everything. Click. It was over. I could almost hear the adrenaline flow slowing like an electric motor winding down after the power is cut. Kris was ecstatic. He told me this was one of the most impressive natural phenomenon he had ever witnessed.

A couple of days later we stopped to photograph Cascade Falls, then Pukaskwa Pits at Richardson Harbour before camping at the mouth of the Pukaskwa River. Just after lunch on July 7th we spied a group of wood lilies and shrubby cinquefoil growing fifteen feet above the water in a jumble of angled rocks. We hauled the camera equipment through the woods and out on the ledge overlooking the flowers. Lily blossoms glowed in soft light and the sun flashed off waves below. It seemed to take forever to get the camera positioned far enough out to see all the flowers without it, or me, falling over the ledge. Once I was set up I made a number of exposures, hoping all the flowers were holding still in at least one.

We spent the next two days wind-bound east of Le Petit Mort Rocks, within sight of Michipicoten Island. I was working on the islands out from our camp when I noticed a hummingbird gathering nectar from lilies near me. Suddenly she buzzed over to my red pants and tasted me. Then she landed on my leg for a few seconds! She tried my backside, landed on a branch a few feet away, then went back to the real flowers, undoubtedly terribly disappointed.

By the 11th we had picked up supplies in Wawa and were kayaking south of the Michipicoten River. The lake was still. We floated in a blanket of low fog, the sun occasionally visible as a silver disk. As we paddled beneath cliffs the scene took on the qualities of an underwater world. Gulls perched on ledges retreated at our approach like schools of fish. I made over one hundred exposures of the shoreline from the kayak on our way to Old Woman Bay, where we made camp.

The following day we began to see red and white pines – the first I had seen since leaving the western part of the lake. We got to the Devil's Chair at Cape Gargantua early afternoon, explored a bit and set up camp on a black sand beach overlooking the Devil's Chair to the west. A small sea stack a little ways from camp would provide a good foreground.

On July 13th, the sun, followed by a crescent moon, set directly behind the Devil's Chair. This region, with its legends and ocher mines, remains one of the most sacred on Superior for many native people. Both Kris and I were touched by the aura that emanates from this stretch of coast. I made several photographs in the Cape Gargantua area before we headed south to Agawa Rock. We camped south of Agawa Bay, where I worked for two days.

As we continued around the east side of the lake we saw terrain with a soft quality entirely different from the harsh landscape of the Pukaskwa region. Hills were lower and further from shore. There were more beaches – first cobble, then sand mixed into fingers of black rock; then the huge, sweeping sand beach at Pancake Bay; and the flat gravel of Corbeil Point.

On the southwest side of Batchawana Island, we camped on a sand and gravel beach beneath a maple tree! In just a few days we had passed from the spruce forests of Pukaskwa, through the pines of Lake Superior Provincial Park, and entered a hardwoods not unlike my home in central Minnesota. The forest floor hosted red and white baneberry, rose twisted stalk, and blue bead lily, all of which were in fruit. I was two months into the trip, and at the furthest point east.

We were wind-bound July 19th, but on the 20th crossed Batchawana and Goulais Bays over unrippled water. As we rounded Gros Cap on the 21st the wind picked up again. We continued southeast a couple of miles before crossing four miles of water to the Point Iroquois Lighthouse. We were back in the United States, but the most visible change was the sight of the South Shore sand country.

Battered by a choppy surf we got soaked, then chilled. At Big Pine Picnic Area in Hiawatha National Forest, we stopped to fix lunch and warm up. Afterward we paddled to Pendills Bay, where a long sand beach is backed by sea grasses and pines. It was such a magnificent place I felt we should wait to photograph it in late sunlight.

After making camp we went for a long swim in luxuriously warm water entering the lake from Pendills Creek. Blueberries and Juneberries were at their peak, and we each picked large quantities. It was a relaxing afternoon that felt more like a vacation on a tropical beach than an outing on Superior. For supper, we sopped blueberry/Juneberry pancakes in maple syrup. A fog bank moved in just as the evening light was richest, adding a mysterious background to my photographs of the beach.

Early into our paddling on the 22nd it started raining, and a starboard wind rose from the southeast. We fought breaking waves in water so shallow our paddles often touched bottom. The entire area showed signs of shoreline erosion. Where homes had been built too close to the lake, owners placed bedsprings, junked cars, washing machines and other debris along the shore in futile hope of preventing further erosion. It was one of the saddest sights of the entire trip.

The surf got bigger. We modified each paddling stroke to meet each breaking wave. The larger waves, splashing us chest high, trickled down inside our spray skirts. We were exhausted and knew we should get off the lake. At Paradise, we drove the kayaks up onto the sand beach below a bluff. After climbing up to the road we looked left and saw the Birch Hill Cafe; it promised much-needed warmth and food.

The next day we again struggled with strong winds all the way to Whitefish Point. Part of the time we walked in shallow water, pulling our boats along behind us. For two days we could not travel.

As we approached Grand Marais, Michigan, on July 26th, we stopped at several locations to photograph driftwood and tracks. The most unusual tracks were large imprints left by a cougar, but my favorite photograph features great blue heron tracks. Composed vertically, they look like human figures quickly drawn with a Japanese brush. Once in Grand Marais, we hiked along the beach below the Grand Sable Banks. Every breath of wind started tiny rivulets of sand cascading down the dune face, creating continually changing frost-like patterns. At the top of the dunes I set up my camera in a ghost forest – skeltons of trees killed by shifting sands. Brilliant white thunderheads were streaming along over the mainland, and Kris took his camera further inland to photograph the dunes against the clouds. I now regret that I did not go with him, because the sky over the lake remained cloudless.

We left Grand Marais the morning of July 30th. Delayed by storms, we didn't reach Chapel Beach until the next afternoon. On August 1st I photographed Grand Portal Point both from an overlook on land and from the kayak. Even though I had photographed this stretch of cliffs between Chapel Beach and Miner's Beach extensively in past years, I love the colored sandstone formations so much that we stayed in the area for four days.

After leaving Miner's Beach, we rounded the lake side of Grand Island and continued on to the Sand River. The next day we walked along the streets of Marquette. It had been over two months since I had been in a city of any size, and I found the experience exhilarating and rather jarring at the same time. My first inclination was to take it all in. But as soon as our errands were done, I was anxious to return to the lake.

We paddled northwest to Little Presque Isle and got our first glimpse of the next section of the lake. The land was hilly, the rock a brown conglomerate. We were only two thirds of the way around the lake, and yet I felt the trip was nearly over. This section, including the Keweenaw, was the last one I needed to photograph. Having the end in sight prompted thoughts of home. I continued to enjoy the trip, but was not well-focused. I found myself playing mind games to rebuild enthusiasm, to try to slow my pace.

On August 7th we met two kayakers traveling counterclockwise around the lake. The encounter played into one of my dreams that night. I crossed a long, one-way bridge in Minneapolis and was trying to get back, but each road I turned onto was a one-way coming at me. I had to take a secondary road far to the east of St. Paul, then north and west to get back to the start. In a second dream, my kayak paddle splintered away when I used it as an ice pick to climb a frozen waterfall. On several occasions during the trip I made fiberglass repairs to a crack in my paddle blade and to a break in the shaft. So it was easy to understand my subconscious concern about the paddle, but where did that frozen waterfall come from?

On the morning of the 8th we made our longest open-water crossing of the trip: from southwest of Point Abbaye we paddled nine miles to the north side of the Keweenaw Waterway. During the next couple of days we paddled north along sandstone cliffs, then towering hills near Bête Grise Bay. On the 11th, we made our way around Keweenaw Point. We spent the 13th working at the west entrance to Copper Harbor. The sunrise there was the most intense of the trip. Kris broke camp while I made photographs, and soon we were paddling west into a strong wind.

For several days we worked our way down the west side of the Keweenaw Peninsula, stopping to photograph on islands east of Eagle Harbor. On the night of August 17th we camped a little ways south of the Keweenaw Waterway on a stamp mill tailings beach. I envisioned taking photographs of the beach and headland in late sunlight. The light cooperated, but the sky was disappointingly pale and clear. We were about to experience a bit of Superior's mischievousness.

Before turning in, we pulled my boat up twenty feet from the water and tied it to a partly buried tree root. Kris' boat was pulled up twelve feet further. Our gear was put between them. My last comment to Kris was it would take a hell of a storm to create waves that could reach the boats. I heard Kris milling about early the next morning, and called out for a report on conditions. He reminded me of my parting comment the night before, saying we had gotten the storm we joked about. He said my paddle was missing, as were the pot lids, and my tripod was buried up to its head in sand. I thought he was kidding. I couldn't recall hearing wind or waves that powerful, but when I looked out, I saw he was in earnest. My boat had been washed up sideways against the root. The cockpit was flooded and my radio floated in water. Kris found my water bottle and our pans down the beach. Waves had reached the stern of his boat, but had done no damage. My paddle had been tied to my boat, and I had the feeling that it might have been buried before the tether broke, I took a stick and started digging grooves in the sand. Almost immediately I hit it. It was under fourteen inches of sand!

The high waves stirred up bottom sediment, and getting water became a problem. We decanted it twice before filtering by filling a pan, letting the sediment settle, then slowly pouring the "clean" water into another pan and repeating the process. Even so, the filter kept clogging, needing frequent cleaning to keep it functioning.

Low scud clouds were racing in from the northwest. Four to six-foot whitecaps, dark and gray, kept pounding the beach. My radio survived its bath, and we learned the weather was supposed to be bad through the night, but improve the next day. At dusk I got my photograph of the beach with lavender clouds above it.

The next morning we paddled past red sandstone headlands and sand beaches, some white and some black. As on the east side of the Keweenaw, we ran into long stretches on sandstone cliffs with no shore access. We sighted several eagles, and watched a doe and twin fawns run along the shore for a quarter of a mile. At a beach south of Elm River we discovered a snack stand in a township campground. Down to a handful of change, we had just enough to buy ice cream. The woman who sold it to us rather prophetically announced she could hear the onset of Autumn in the crashing waves. With that added incentive to put on the miles, we cut across Misery Bay and Sleeping Bay, and went all the way to Ontonogan. Our paddling distance for the day was forty-two miles. At the mouth of the Ontonogan River, I passed the one thousandth mile of my trip. An eagle perched atop a dead spruce served as an appropriate mile post.

We picked up supplies the nest morning, then paddled on to the Porcupine Mountains. The shoreline changed abruptly from low and sandy to rugged brown sandstone sloping down to the water. I made mental notes of areas that I wanted to return to during a fall trip – the shoreline just west of Union Bay seemed to have the most potential.

The shore became less interesting the next day as we paddled towards the Black River. Beyond the river, red clay bluffs were riddled by erosion. We camped that night about two miles east of Little Girls Point. I was sleeping on rocks near the shore without a tent when waves hitting my bag woke me up. Northern lights were flashing, and I watched them for quite a while before falling asleep again.

On the 21st we reached Bayfield, Wisconsin, after a thirty-mile day. Nadine drove over to meet us on the 22nd. She brought supplies and took my 4x5 equipment home with her – lightening my load for the last few days of the trip. Kris spent the day fixing some slow leaks in his boat.

Kris and I left Bayfield the morning of the 23rd in stormy weather. Stopped twice by thunderstorms we

reached Squaw Bay just before sunset. I quickly went from one rock formation to the next, photographing familiar caves and cliffs from the kayak.

The next morning we had a fairly strong south head wind. Once past Bark Point, we were again in red clay country. Heavy rains washing the fine clay into the lake had turned the water brown. We didn't even want to try to filter the lake water, and were grateful when a family of picnickers gave us a half-gallon jug filled with ice water. Feeling good, we kept on paddling – partly because there was no place to camp on the wet clay. We arrived at Wisconsin Point at sunset with a full moon rising in the east and Duluth's lights twinkling on the hillside across the bay. The lake calmed and I found that the water away from the shore was clear, so I refilled our water bottles, enjoying the view and winding down during the process. We had put on forty-six miles, much of it into a head wind. If the trip had started in Duluth, I think we would have finished it that night by moonlight.

We were back on the lake a little after six the next morning. The moon was settling, and thunderheads picked up the first rays of sunshine. A strong wind blew from the southwest. We joked that with the wind, we might be able to make it all the way to Split Rock by eight that night – fifty-five miles. We stayed in the lee of Wisconsin and Park Points until heading northeast along the Minnesota shoreline. The wind died for a while, but then came back strong. We made great time, and began to think seriously about continuing on to Split Rock. Most of the shoreline was saturated with cabins, limiting photography opportunities. We were on a final sprint, and had a chance to put on more than fifty miles, a distance we often talked about.

To pass the time we talked: about Kris' career plans, the first things we would do when we got home (primarily regarding eating foods we craved), and the future of Lake Superior. Would Superior's remaining wilderness be protected, or was the shoreline we were now paddling be a preview of what much of the rest of the lake would become? With the realization that we seldom win environmental battles, only delay losing them, we wondered how long we could postpone the demise of what we cherished so deeply.

In the afternoon the tail winds picked up even more. I kept catching waves, surfing a hundred feet at a time, my bow cutting into the wave in front of me as my stern rose up, propelling me forward. Kris wasn't able to catch the waves, and later told me how frustrated he grew as I sprinted effortlessly away from him. We decided to time ourselves between Knife River and Two Harbors. We put on an incredible eight miles during one hour of paddling.

At Gooseberry Falls State Park we stopped for water and a bite to eat. Our tail wind died, but we felt confident we could complete the trip. To our dismay, a fifteen mile per hour wind came up from the northeast. We quickly got back in the boats and dug in, hoping to put on the miles before the wind got any worse. About two-thirds of the way there it began to calm. The wonderful cliffs at Split Rock Lighthouse State Park towered above us as we crept around the last point. The lighthouse stood against the sky to our right, and we paused to appreciate the moment.

The cliche "coming full circle" came to mind, yet I no longer thought of the trip as a circle, but rather a spiral. The place I returned to was different than the place I left. Two seasons had elapsed. The lake is a dynamic environment. Each cycle – a day, a storm system, a year – engraves its mark on the lakeshore. My perception of Superior was also different. I had "paddled around the horizon." I now knew what lay around the points and across the water. I could comprehend the size of the lake; appreciate the diversity and continuity of its shores.

If my awareness of Superior had changed, had my awareness of myself changed too? Probably. The photographs I made were as much a self-portrait as they were a portrait of the lake.

Kris and I pulled the boats up onto the beach at 7:54, six minutes ahead of the arrival time we estimated that morning.

That October I returned without my kayak to the Porcupine Mountains. Based out of Union Bay Campground, I concentrated on the half mile of shoreline to the west. For several days Superior was whipped by storms, but it calmed during an interlude of warmth and sunshine. After my travels of the summer I relished the chance to stay in one place. Many things caught my eye: fingers of rock reaching into a lake that mirrored the clouds of a sunrise, early sun highlighting wave patterns in sandstone, fallen leaves floating on a pool recently filled with rainwater.

Early that winter I made a first attempt at a layout for this book. In addition to returning to Isle Royale, I needed images from the islands north of Pigeon Point.

1992

Once again the *Kingfisher* was aboard the ferry bound for Rock Harbor on Isle Royale. Having paddled around Superior's perimeter, I symbolically returned to its center. From the island I could look north to the high hills of the Canadian shore, west to Minnesota, and, during rare moments, see the Keweenaw which appeared as a mirage floating over the southern horizon.

My photography went much better on this outing than on my previous trip to Isle Royale. From campsites at Merritts Lane, Tookers Island and West Caribou Island, I explored the entire string of islands between Blake Point and Middle Island Passage, and returned to those compositions I had chosen my last time in the area. A full moon and several days with wonderful clouds enhanced the landscapes I photographed. After a couple of warm summery days, the temperature dropped and stayed cold. Frost covered my kayak the morning of the summer solstice!

At West Caribou Island, a cow moose brought her gangly young calf through the campsite early in the morning. Great blue herons flew to and from tree-top nests on an island in Middle Island Passage. Gulls, cormorants and loons were seldom out of sight, and red fox wandered through camp, ever vigilant for a chance to scavenge unguarded food.

Many of the islands off Isle Royale are little more than rock outcrops, often treeless, covered only with a thin crust of lichens. Like rings surrounding a giant planet, these strings of rock are individually inconsequential, yet together they add much to the character of the body they surround. These islands are, for me, the heart and soul of Superior. They are what draws me to this lake – a place I can find solitude, and time for contemplation. Against these tiny islands beats the rhythm of the lake, carrying the energy of the sun – a pulse rate determined by factors we have analyzed and formulated, yet not mastered.

We can feel free here, because nature here is beyond our control. We are not responsible for anything besides our own existence, just like any other creature we may encounter. When we cannot change things, we are able to enjoy them for what they are. It is only when we return to a world where we have the ability to make change, that we desire to do so, and then must bear responsibility for our actions.

Superior connects me to an environment beyond my immediate surroundings. Events anywhere on the lake reverberate here. Waves created in storms hundreds of miles away can send swells crashing upon Isle Royale's shores. But subtle, more ominous things have also reached this remote island: lake trout contain PCBs and other pollutants;

algae flourish in shallow water near a summer home with a failing septic system; and the sounds of wilderness are often masked by the white noise of outboard motors, sea planes, and throngs of hikers.

Some of these things exist here, in large part, because of what we have done to the mainland. Thousands come to Isle Royale in search of what we have destroyed elsewhere. But they discover there is no escape over the horizon on Superior, no frontier waiting beyond our vision, no infinity to absorb abuses. It is a lake, after all, bound by a finite shore. It gathers what we discard – our run-off and airborne wastes – and is diminished by what we take away.

After hundreds of years of extracting Superior's resources, we are now consuming one of the few that cannot be renewed – her shoreline. The construction of private homes, whose owners pay taxes to counties responsible for managing the shore, is changing Superior's wild character. Parks like Isle Royale, set aside under public protection, become increasingly overcrowded as the remaining private land is developed. The next few years will determine how private lands surrounding the lake are treated. Our current course of road construction and development does not have to continue. But to change, we must first recognize that Lake Superior is a global resource. Acknowledging that we are a part of a larger Superior community obligates us to practice good stewardship and to share this resource with the rest of the world.

By the time I arrived at Canadian Customs on August 8th, I was tired and cranky. My less-than-benevolent feelings resulted from fighting bumper-to-bumper traffic north on Minnesota Highway 61, and from seeing new development that will add to the traffic problem and further diminish natural shoreline available to the public. The continuing shortsightedness and provincialism of those responsible for managing the Minnesota shore of Lake Superior put me in a bitter mood. This was going to be my last kayak trip on Lake Superior for this book. I would search not only for photographs, but for a personal equilibrium.

I headed towards an area of Superior where people seem satisfied with visiting the lake, sharing it with others, then leaving it is a near-natural state. Crown land is open to public use, but not available for private development, with minor exceptions. Few rules exist that intrude on the visitor, yet the land is well cared for by those who use it. In a handful of natural harbors, crude docks and saunas have been erected for the communal use of any who come.

Otherwise the land appears as wild and untouched as any on Superior. Even islands mined or logged in the past have regained a wilderness patina.

A half dozen miles north of the Minnesota border, at the end of a two-rut road, I put the *Kingfisher* into Cloud Bay. An hour's paddle away lay the string of islands I had come to photograph: Victoria, Jarvis, Spar, Slipper, and Thompson. Before long I was gliding in calm water along the northwest side of Victoria Island. Lichen gardens covered the cliffs, and I stopped to photograph a cluster of harebells growing in a crevice.

Continuing northeast past Jarvis to Spar Harbour, I pulled up beside a dock and was welcomed by boaters who come out to the island from Thunder Bay almost every summer weekend. They maintain the small dock, cabin and sauna tucked into the bay. I hiked the trails they had cut up to the "Top of the World" – a cliff-top vantage point with spectacular views to the north and west. Seeing that the light would be best in the morning, I picked out my camera location, made a Polaroid for reference, then headed back down where I was invited to join the boaters for a sumptuous, Thanksgiving-style supper, complete with pumpkin pie. Here, in a small group surrounded by the wilds of Superior, the virtues of each person shone. Here was happiness and contentedness. Here indeed was the balance I sought.

I returned to the Top of the World in pre-dawn darkness. As the sun cleared the horizon I was ready. Looking northwest, toward Mink Island and the high hills of Mink and Sturgeon Points, I waited to shoot until sun light glowed on the cliff face and a thick layer of blue fog drifted up the flanks of the hills. The wind that had risen with the sun died completely. It was a moment I would gladly have waited a dozen mornings to witness – that I was able to photograph it the first morning gave me great hope for the rest of my trip.

My optimism could not have been better founded: I continued to find the types of images I was looking for on Slipper and Thompson Islands. The lake was calm the final morning of the trip. The moon, just past full, set over my bow as I paddled back toward Cloud Bay. An eagle lifted into the air ahead of me, disappearing over the Cloud Islands. As I entered the bay, an osprey dove unsuccessfully for a fish. Shaking water from its feathers, it circled back up to scan the lake again. A great blue heron, perched on a driftwood root near my car, let out a coarse squawk as it flushed and settled down into the reeds only a hundred feet away. My travels on the lake had come to an end for the time being.

Superior goes on: following eternal rhythms, a lake vast and powerful, yet finite and fragile.

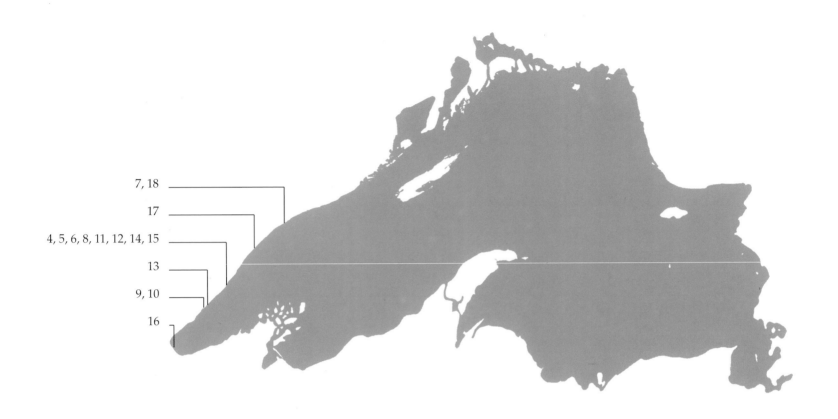

DULUTH TO GRAND MARAIS

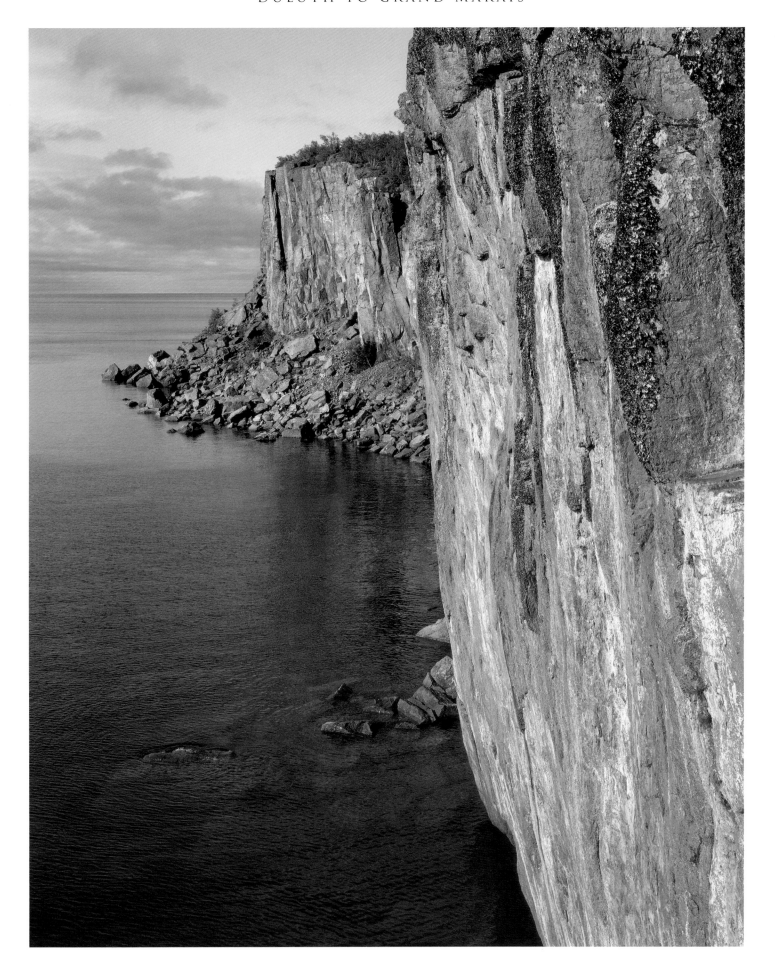

Plate 4

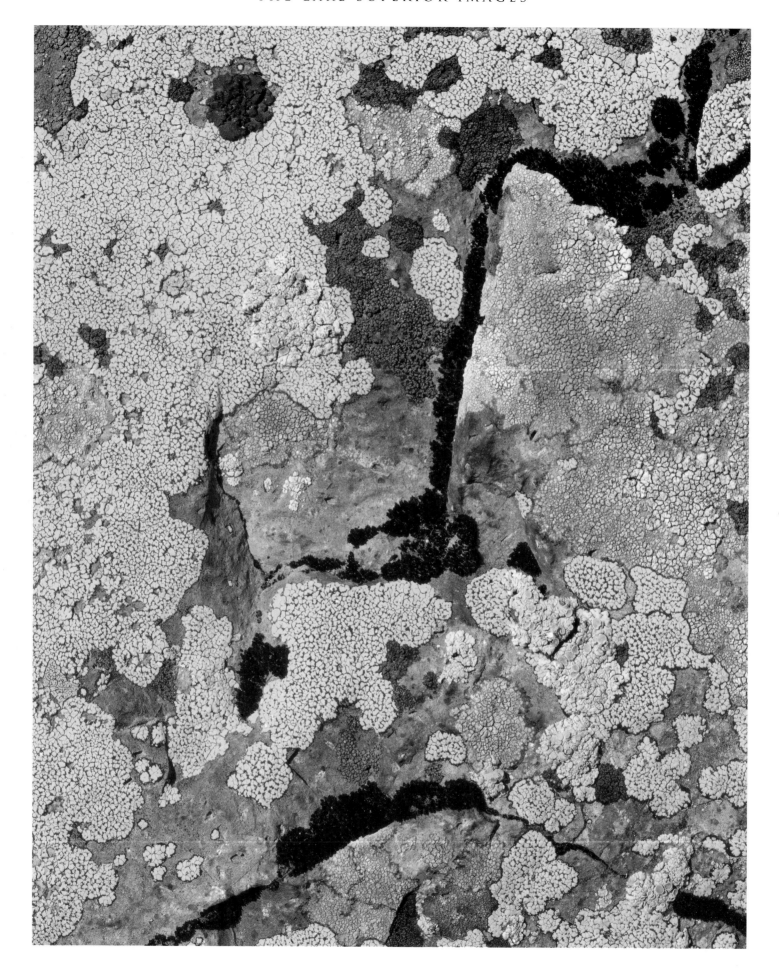

Plate 5

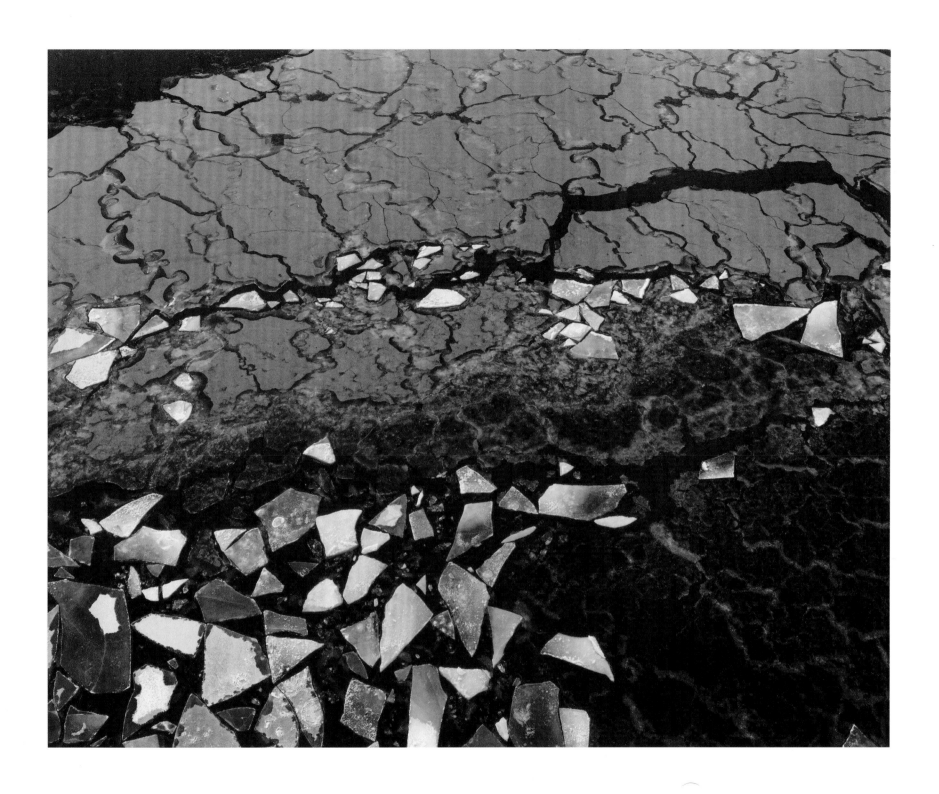

Plate 6

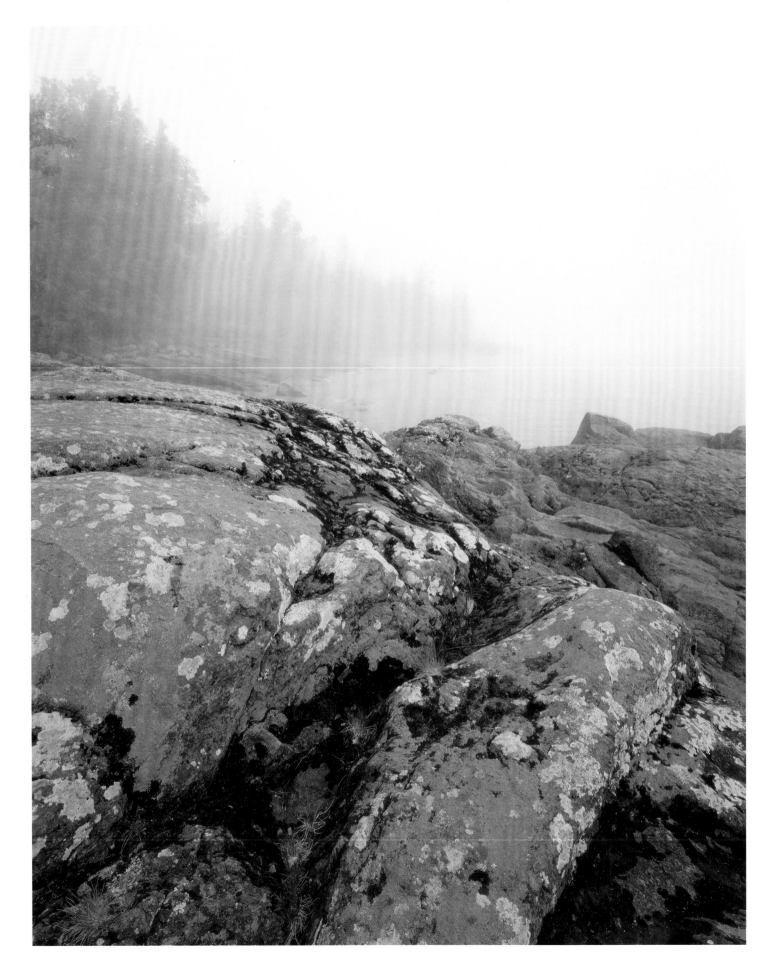

Plate 7

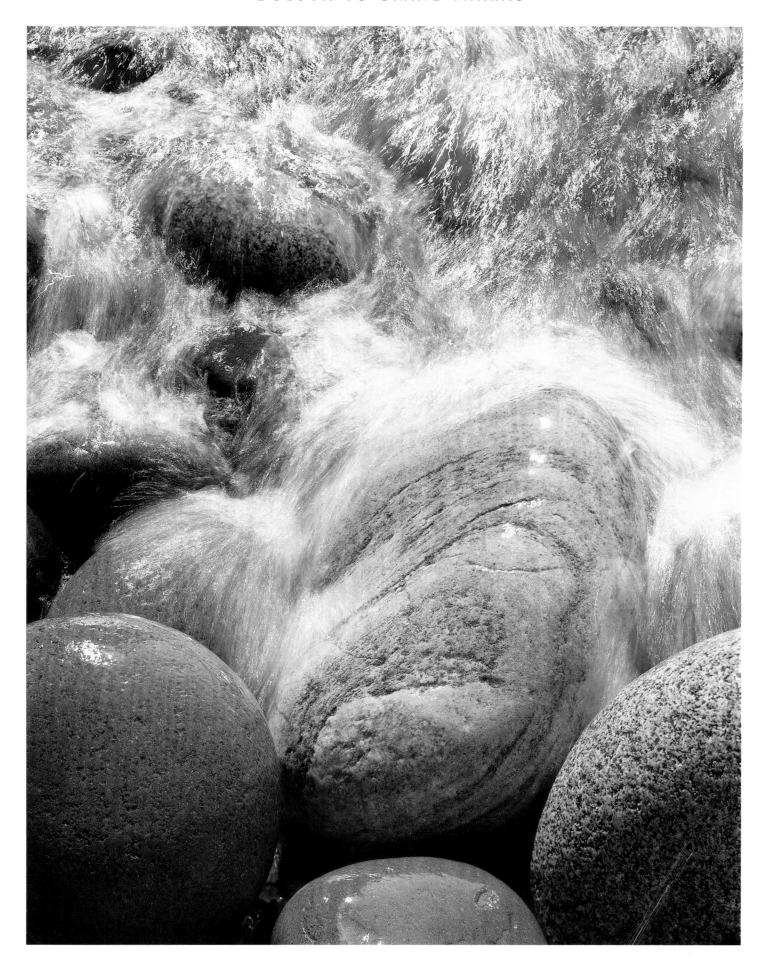

Plate 8

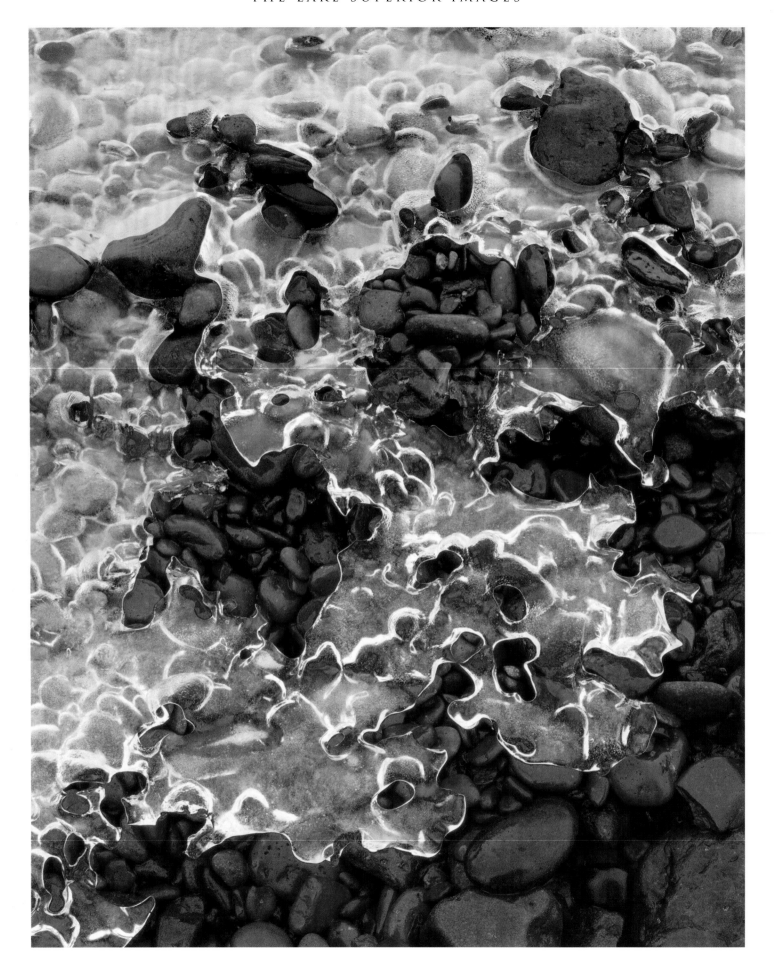

Plate 9

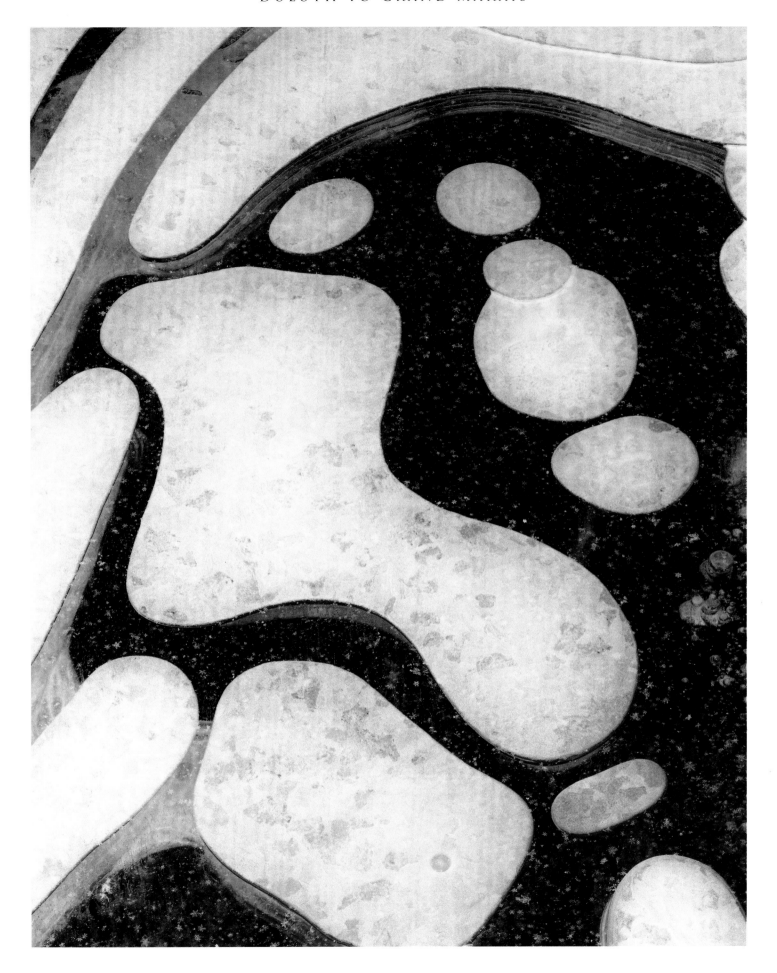

Plate 10

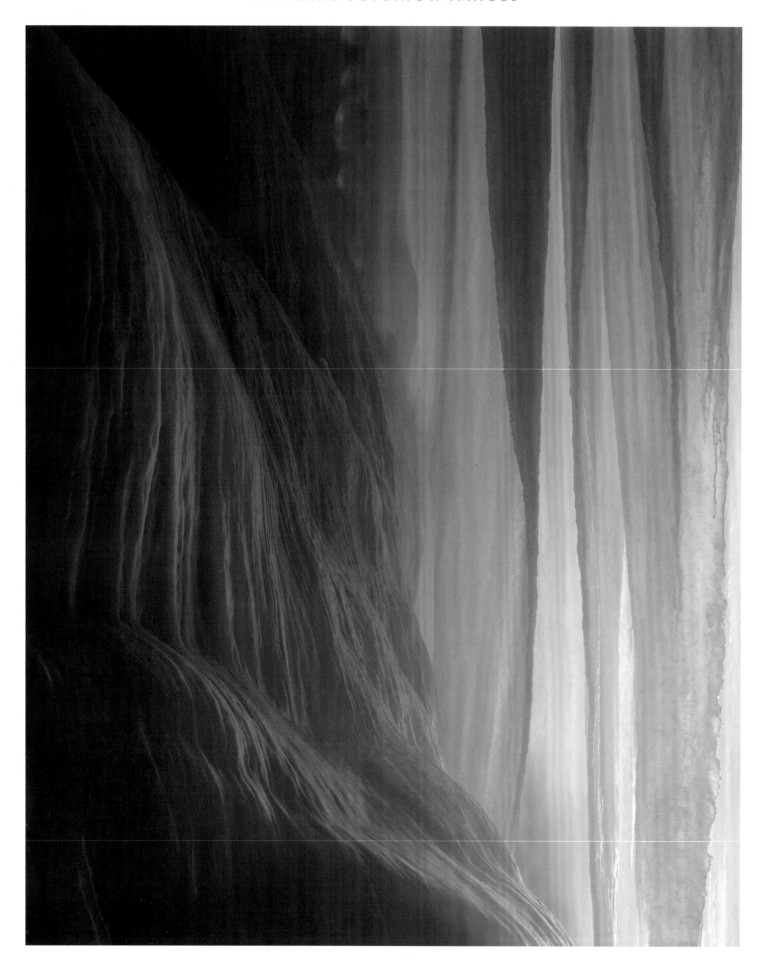

Plate 11

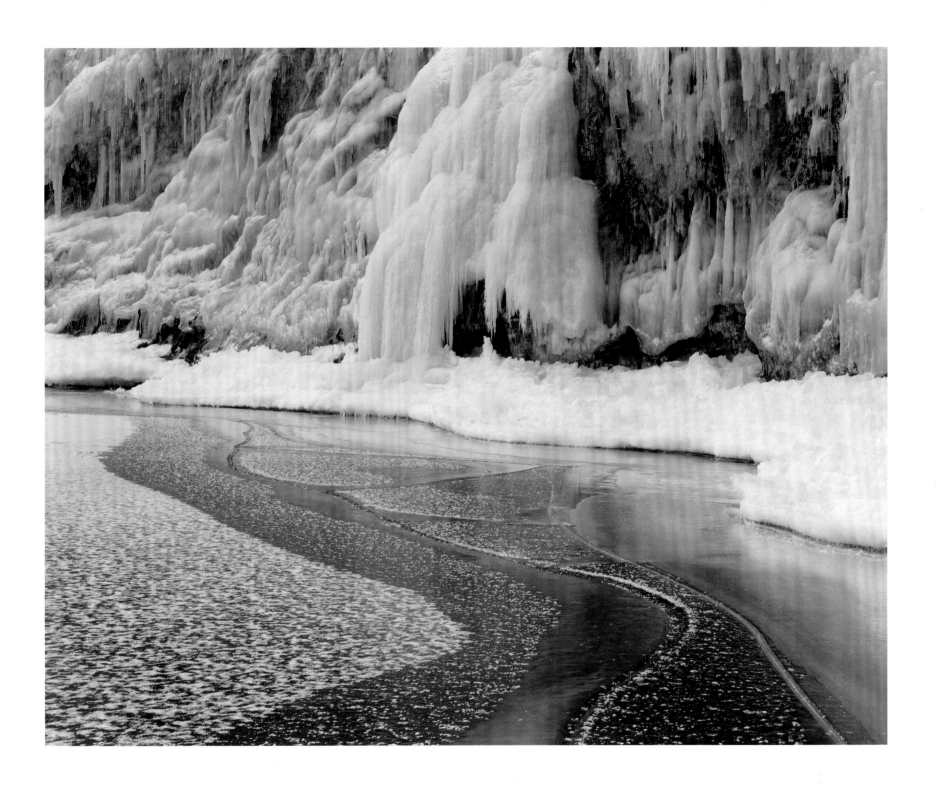

Plate 12

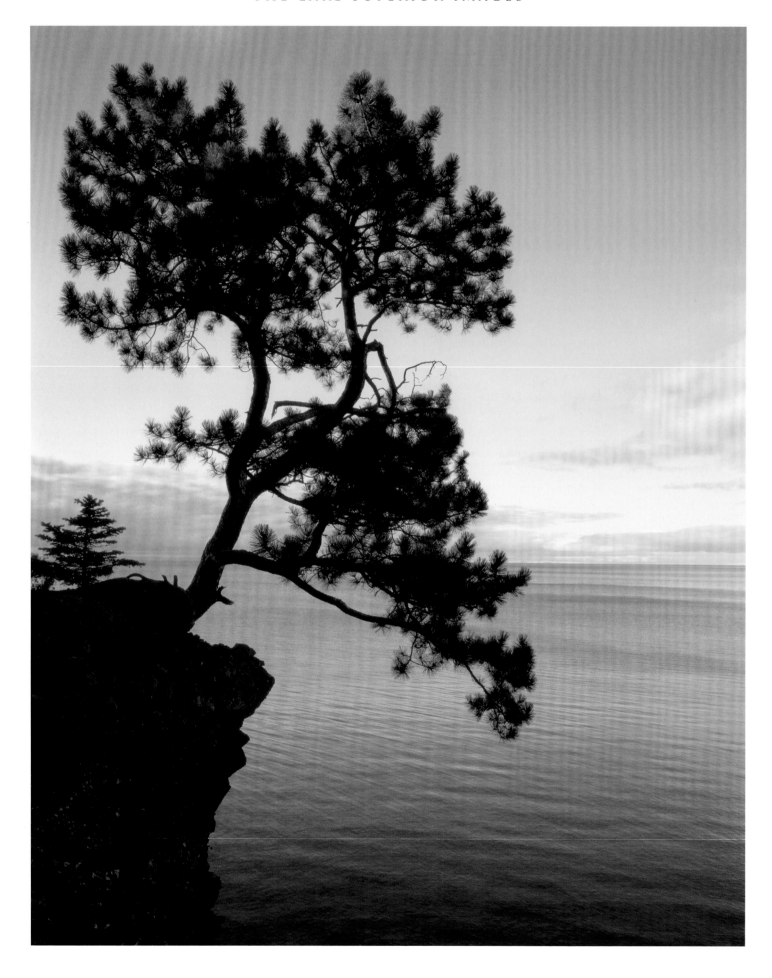

Plate 13

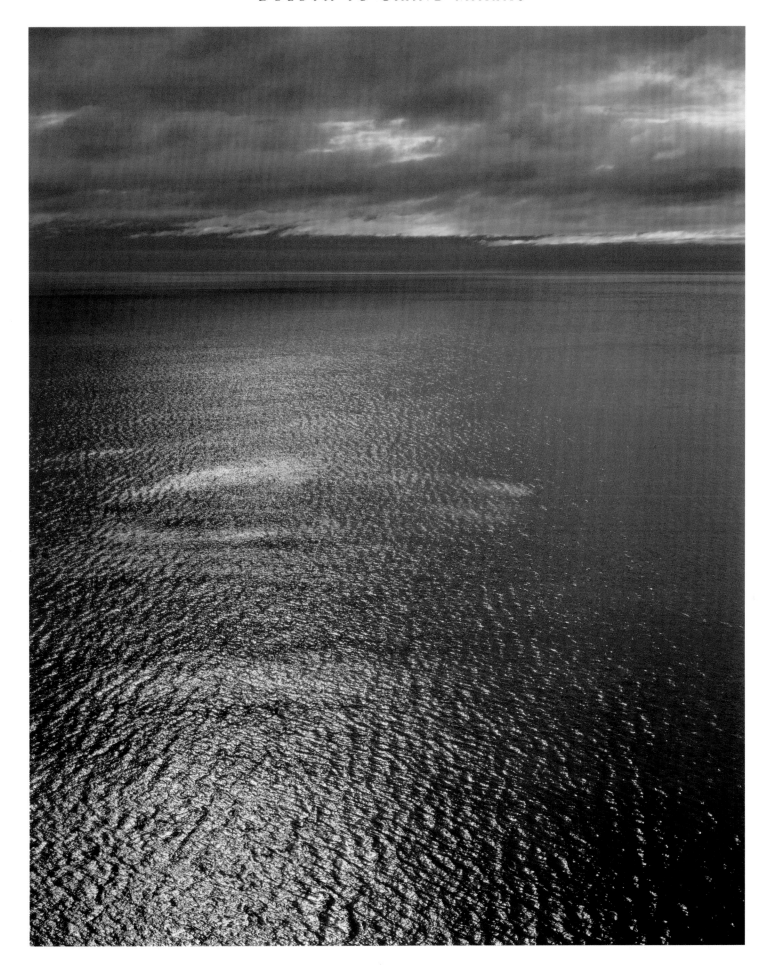

Plate 14

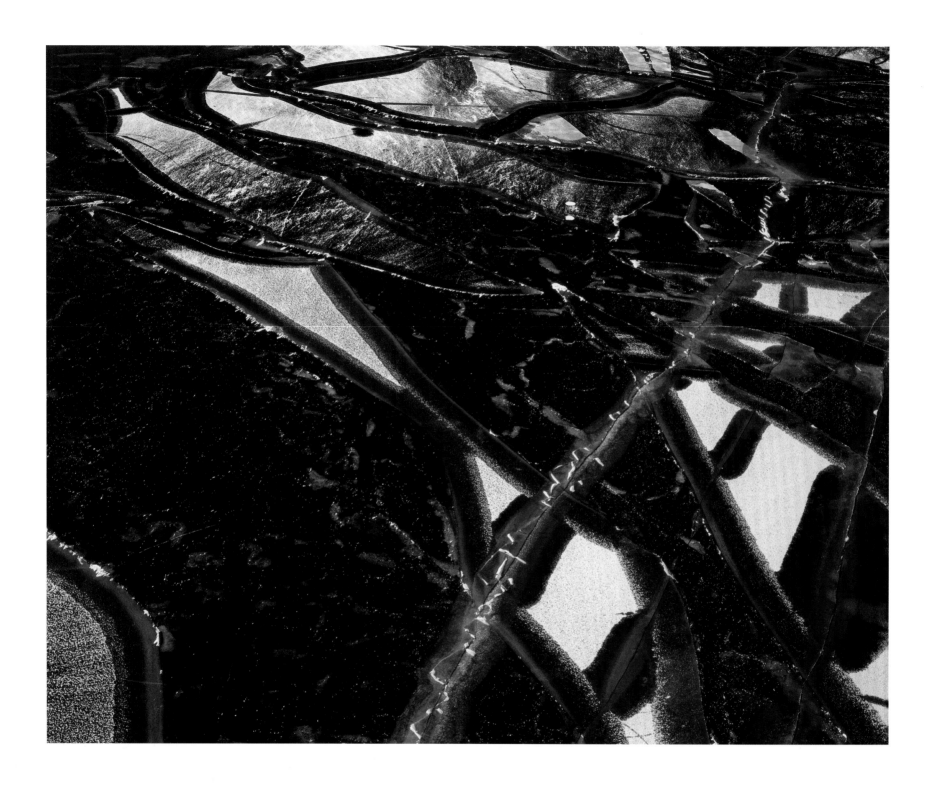

Plate 15

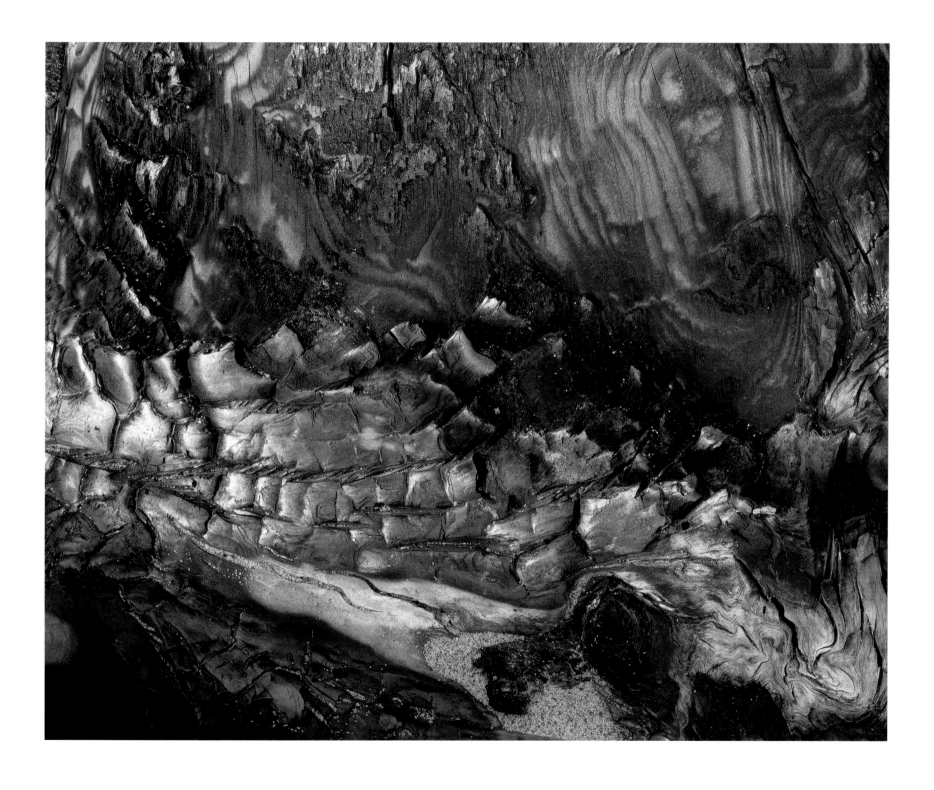

Plate 16

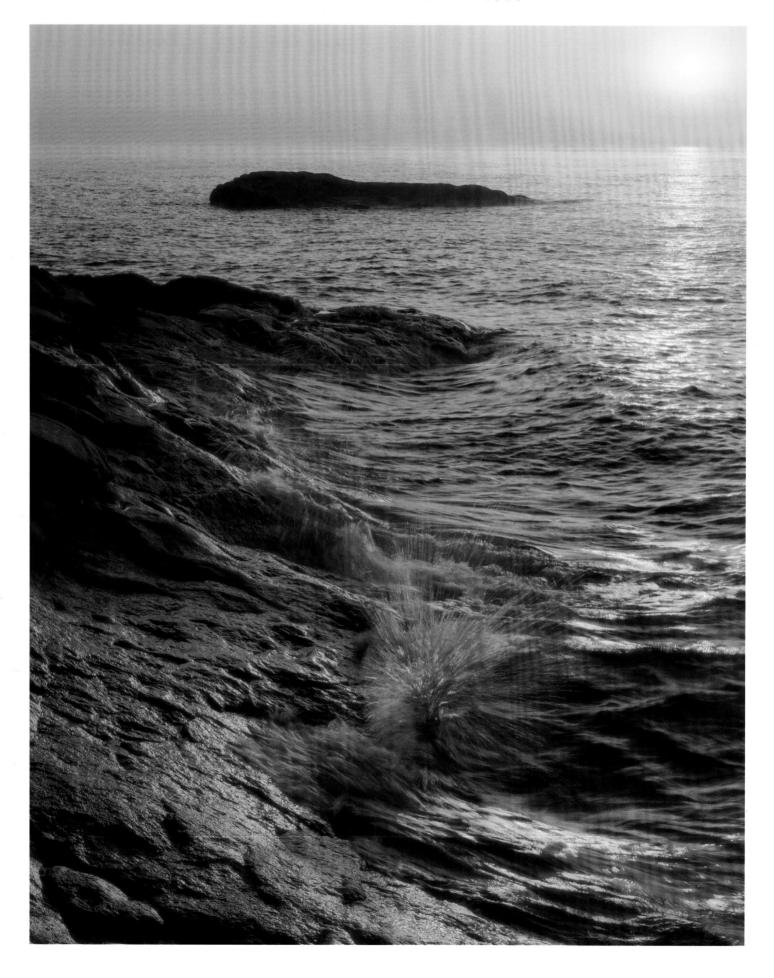

Plate 17

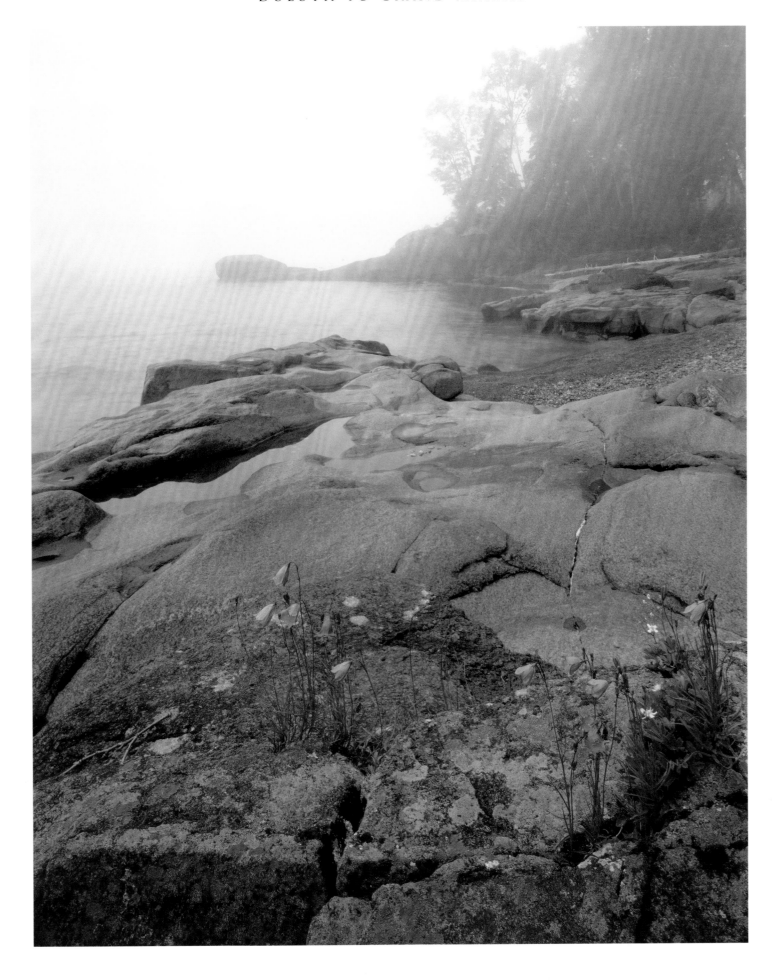

Plate 18

20, 24, 26, 27, 32

25

21, 22, 23, 28, 30

31

19

29, 33

GRAND MARAIS TO PIGEON POINT

Plate 19 Grand Portage State Forest. June, 1992
Plate 20 Rain squalls, Magnet Island, Grand Portage Indian Reservation. July, 1985
Plate 21 Blowing snow, Grand Portage Indian Reservation. February, 1985
Plate 22 Witch Tree, Grand Portage Indian Reservation. July, 1985
Plate 23 Witch Tree, Grand Portage Indian Reservation. July, 1985
Plate 24 Clearing Storm, Magnet Island, Grand Portage Indian Reservation. July, 1985
Plate 25 Stones and bedrock, Wauswaugoning Bay, Grand Portage Indian Reservation. July, 1985
Plate 26 Susie Island and Mount Josephine from Magnet Island, Grand Portage Indian Reservation. July, 1985
Plate 27 Susie Islands, Grand Portage Indian Reservation. July, 1985
Plate 28 Ice-covered rock, Grand Portage Indian Reservation. February, 1985
Plate 29 Frozen pools, Artist's Point, Grand Marais. February, 1985
Plate 30 Mountain ash berries, Mount Josephine, Grand Portage Indian Reservation. September, 1984
Plate 31 Wood lilies and shrubby cinquefoil, Grand Portage Indian Reservation. July, 1984
Plate 32 Susie Island. July, 1985
Plate 33 Ice, Artist's Point, Grand Marais. March, 1986

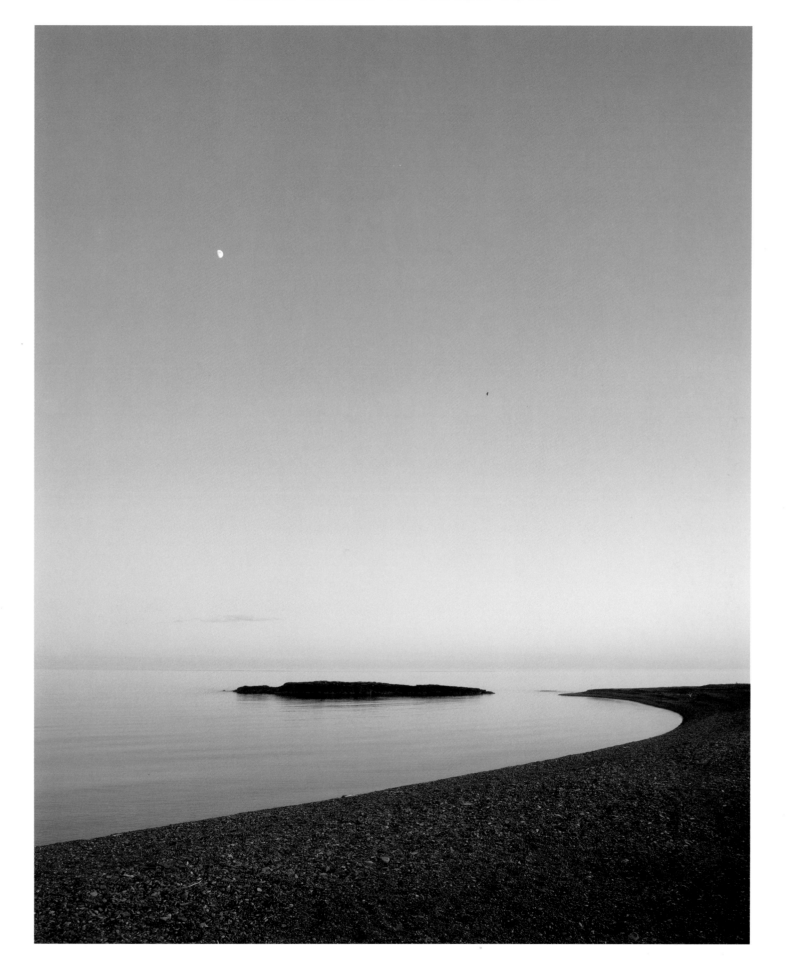

Plate 19

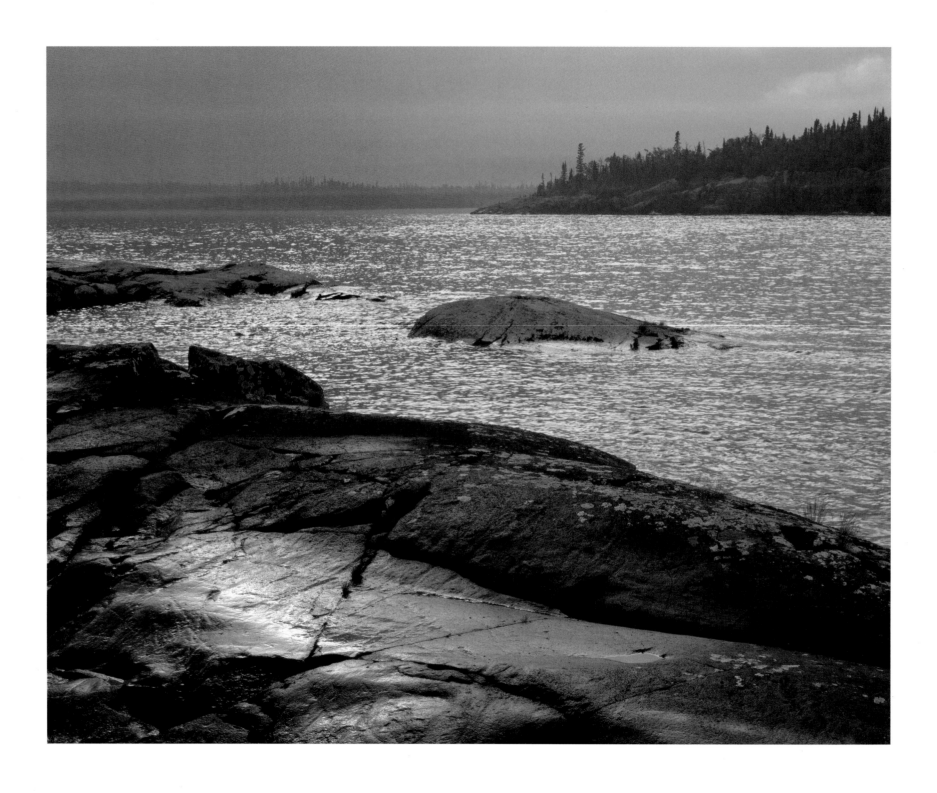

Plate 20

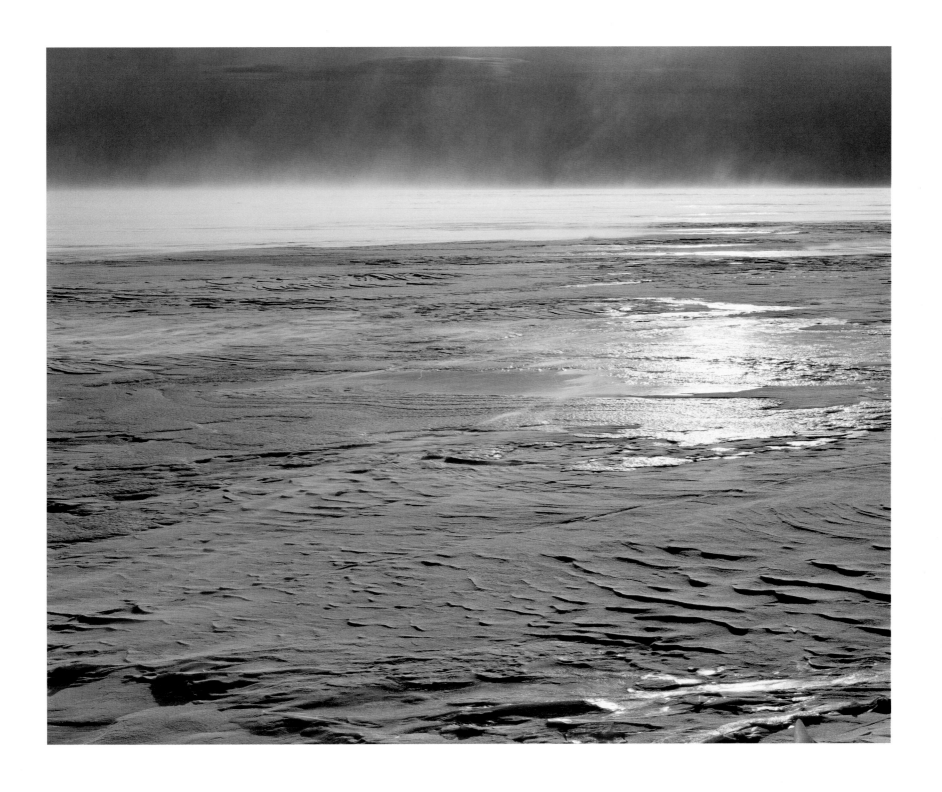

Plate 21

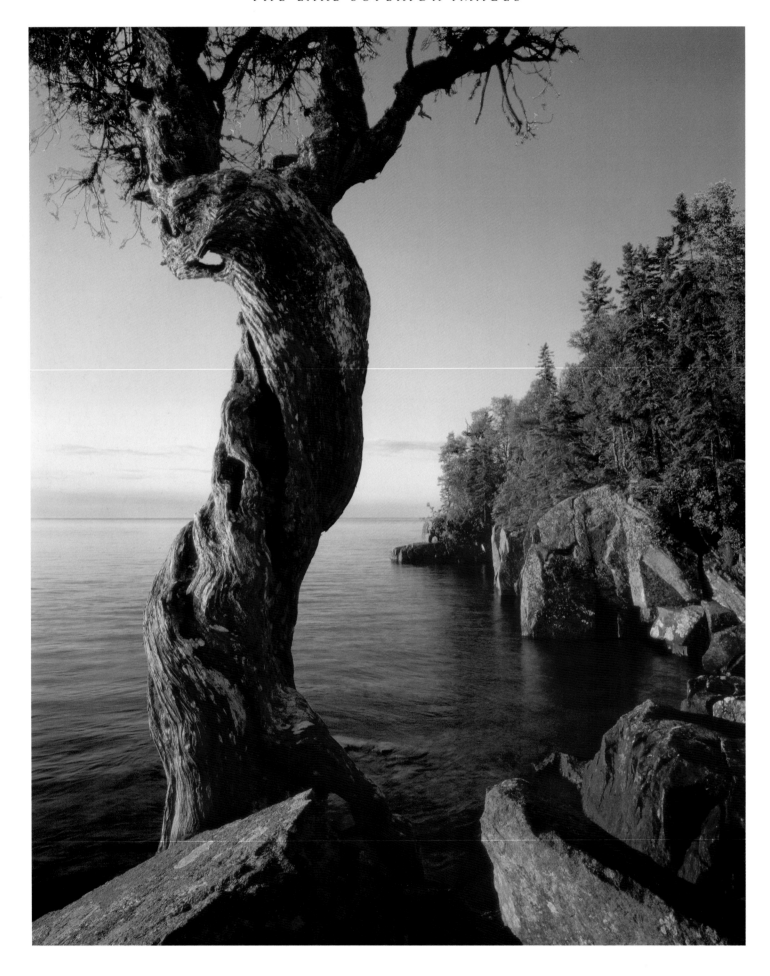

Plate 22

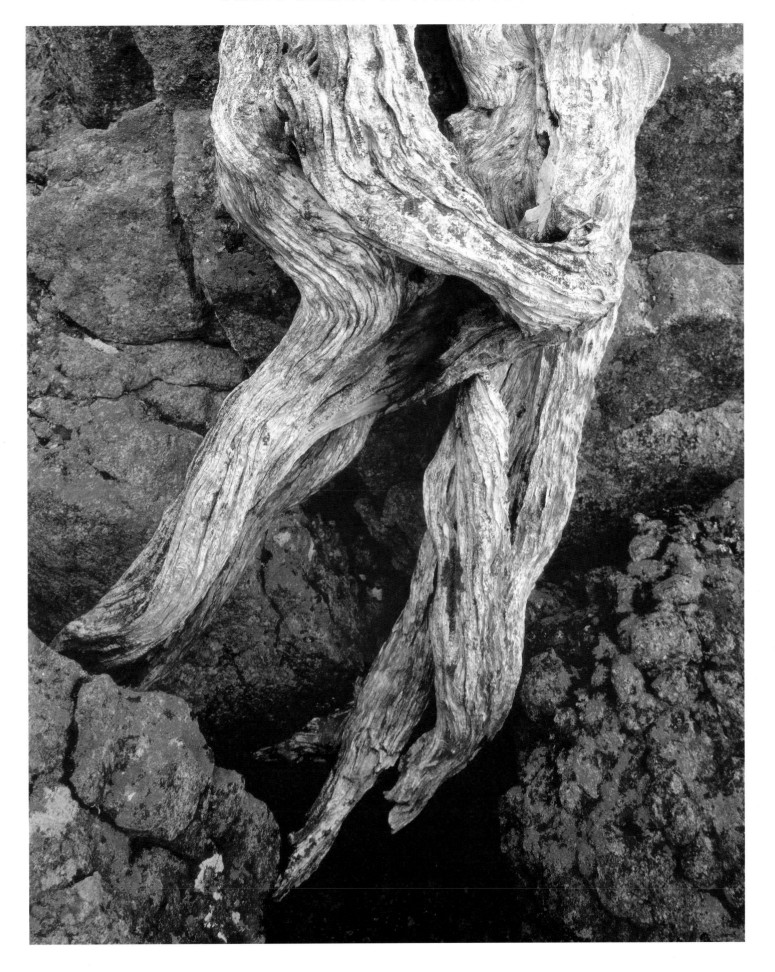

Plate 23

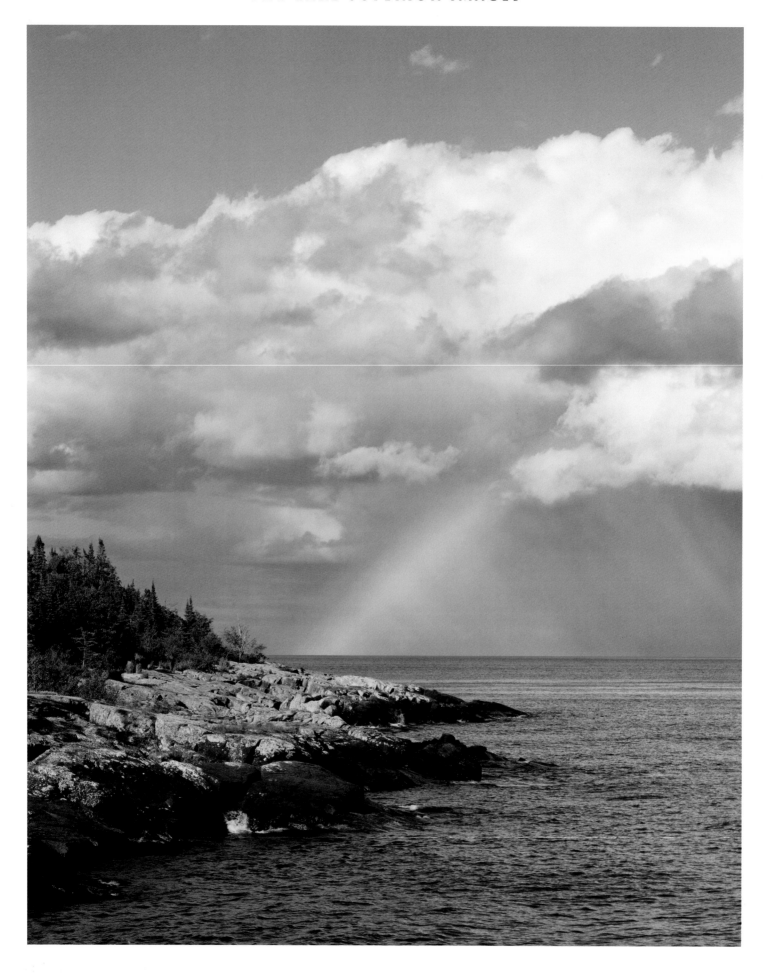

Plate 24

Plate 25

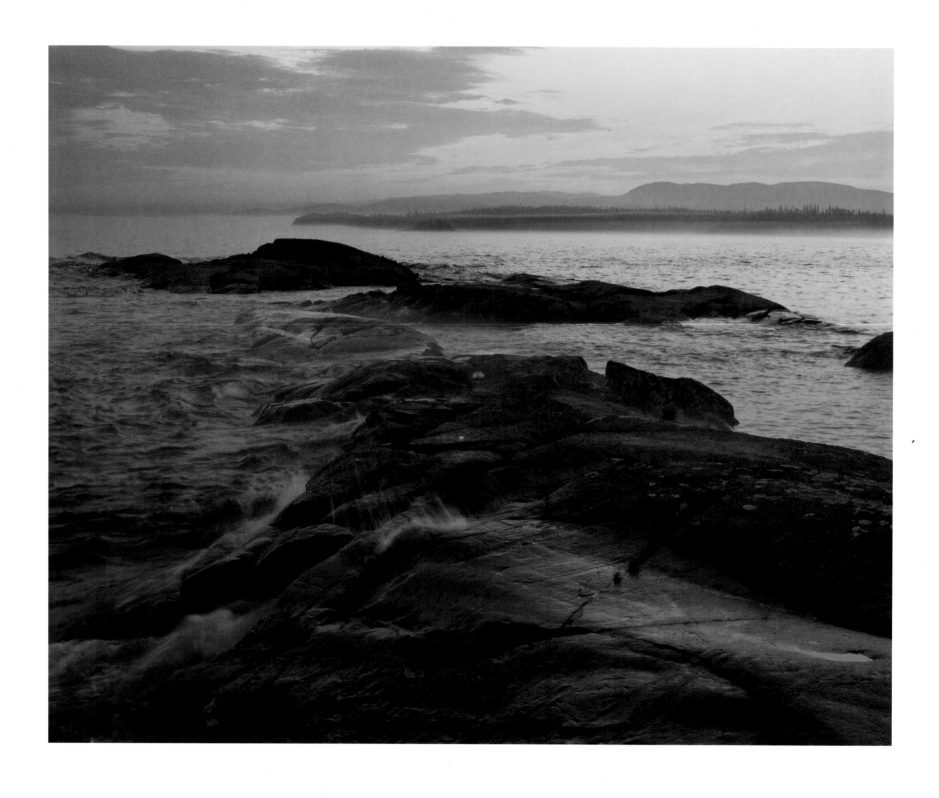

Plate 26

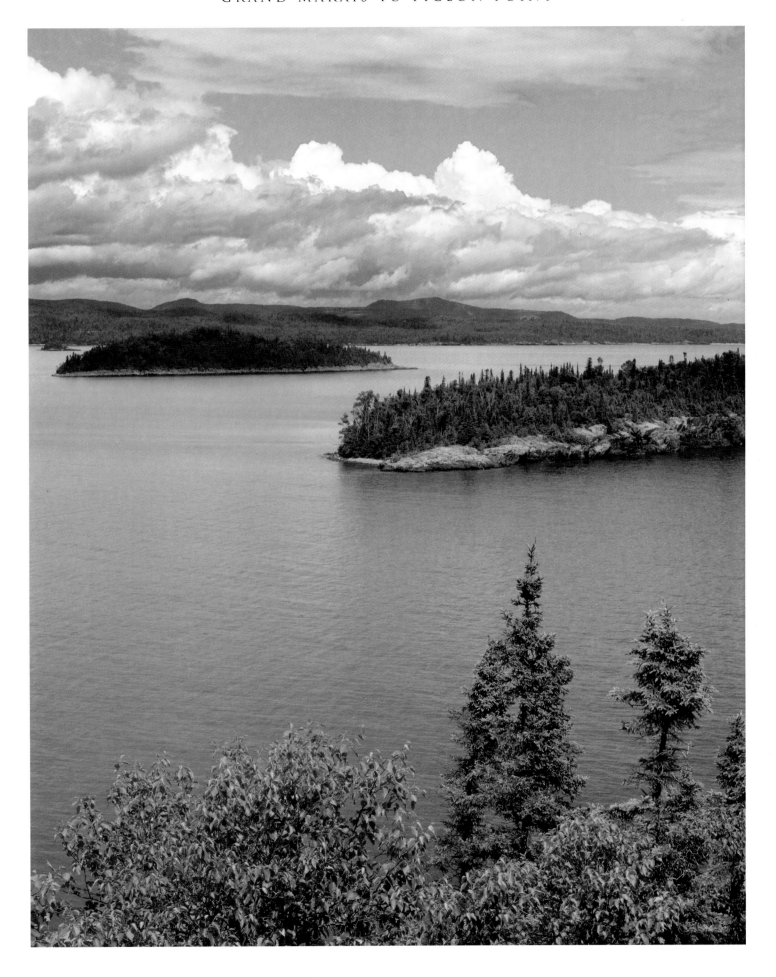

Plate 27

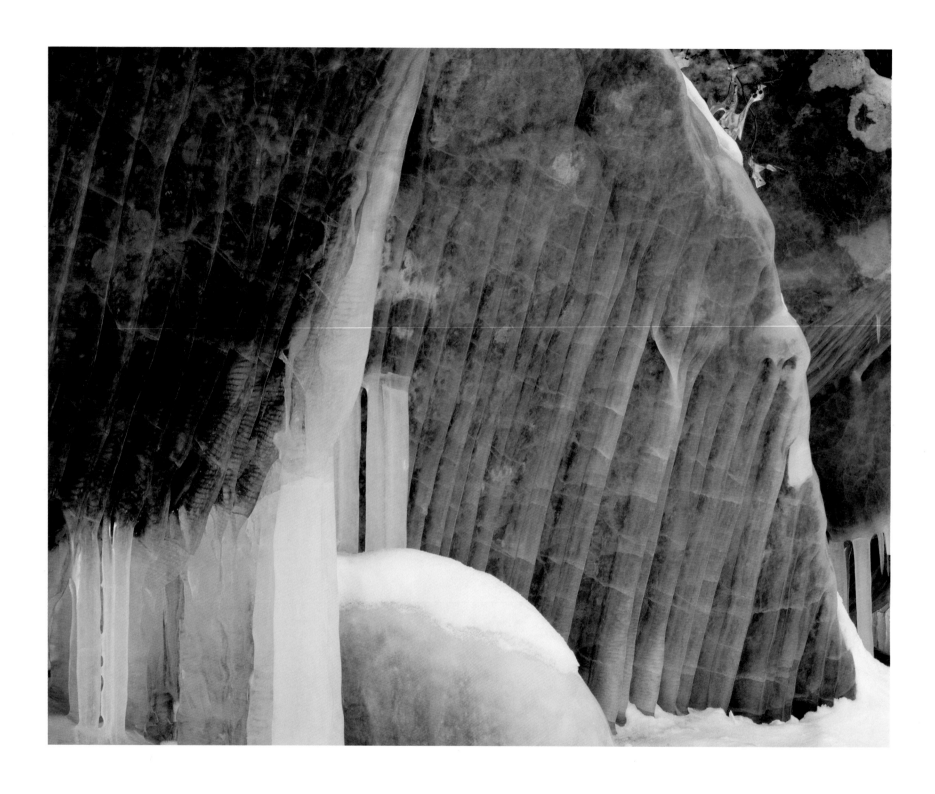

Plate 28

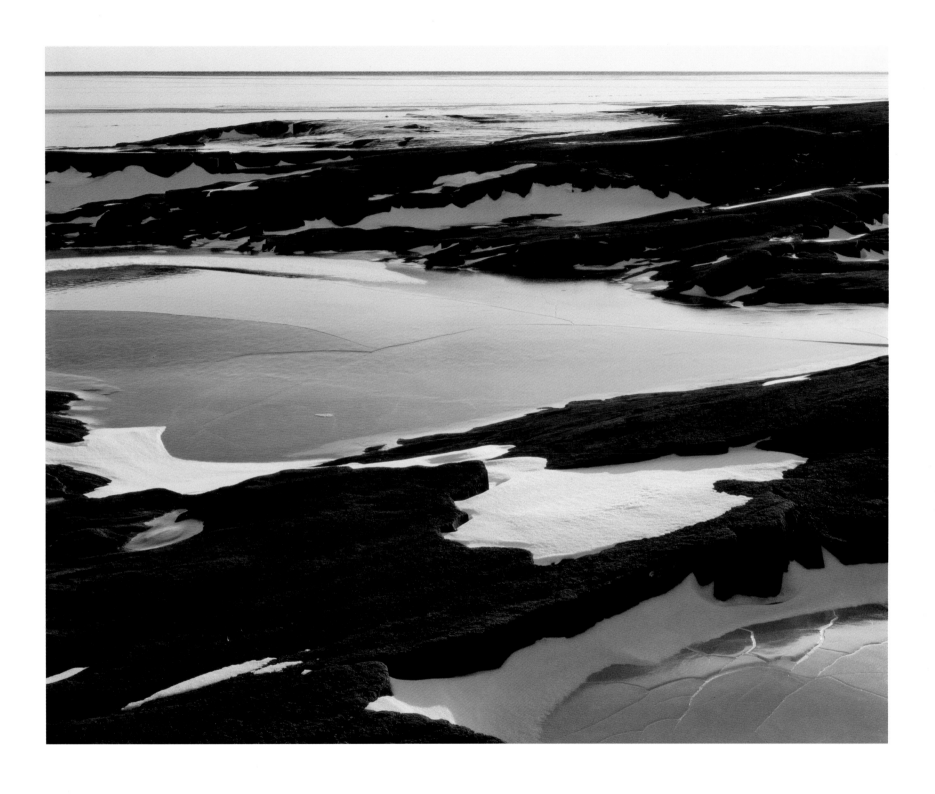

Plate 29

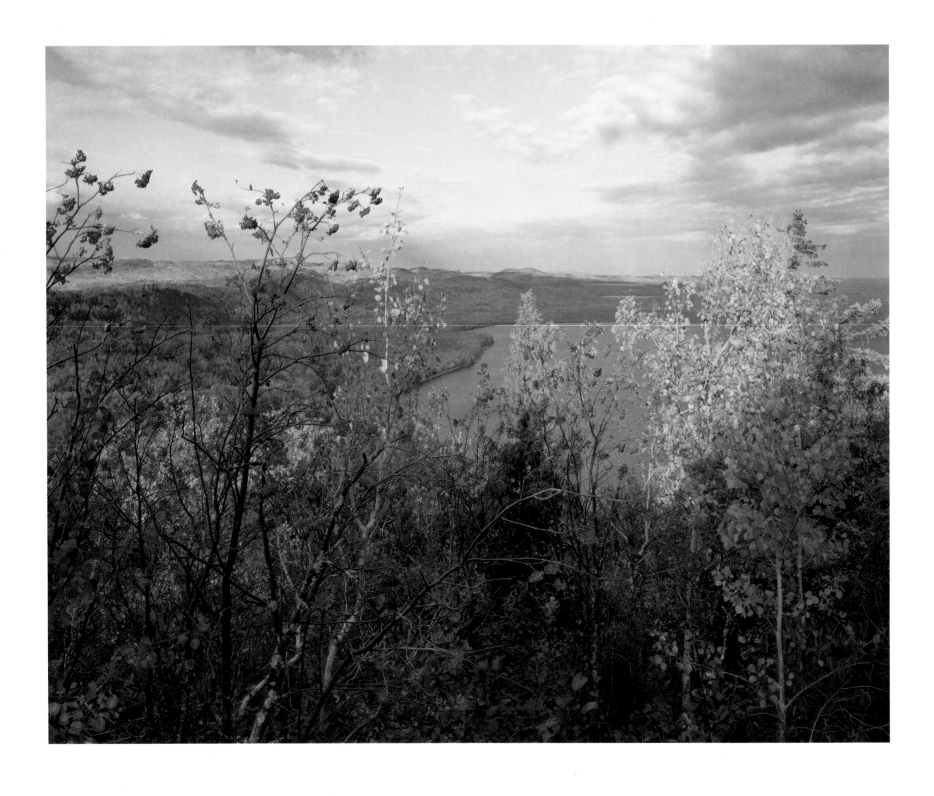

Plate 30

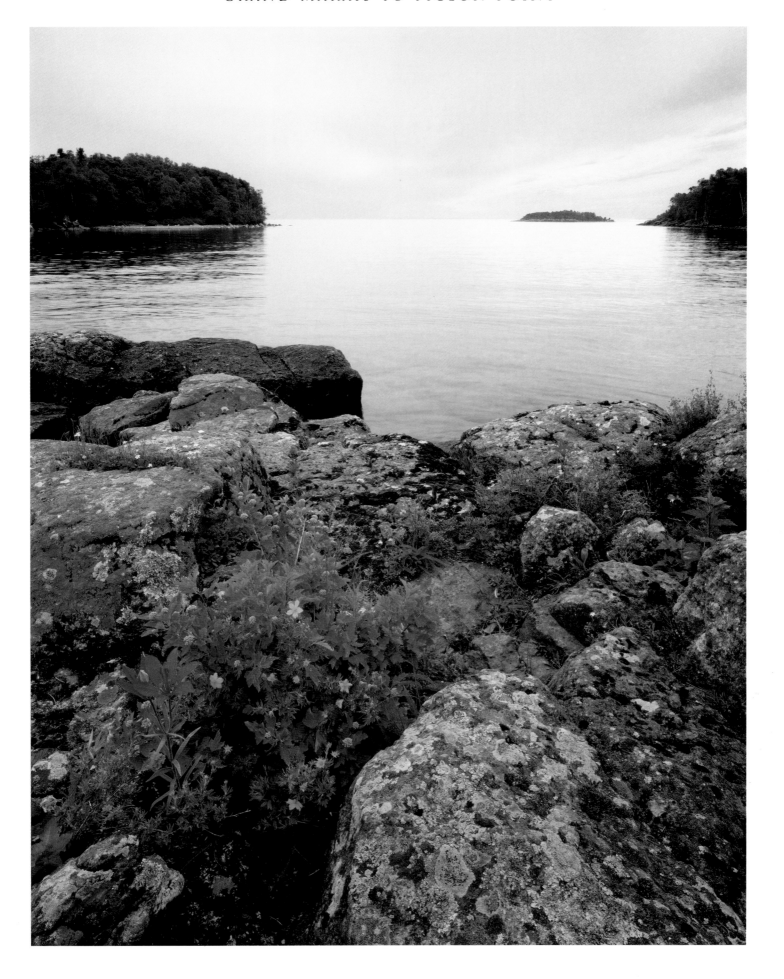

Plate 31

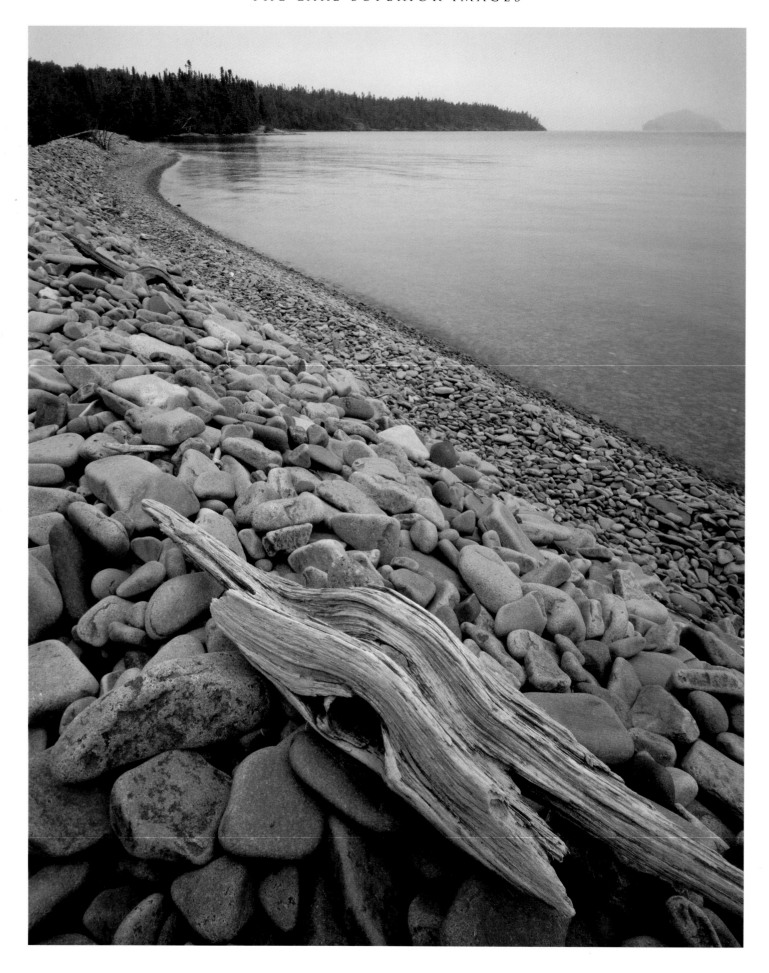

Plate 32

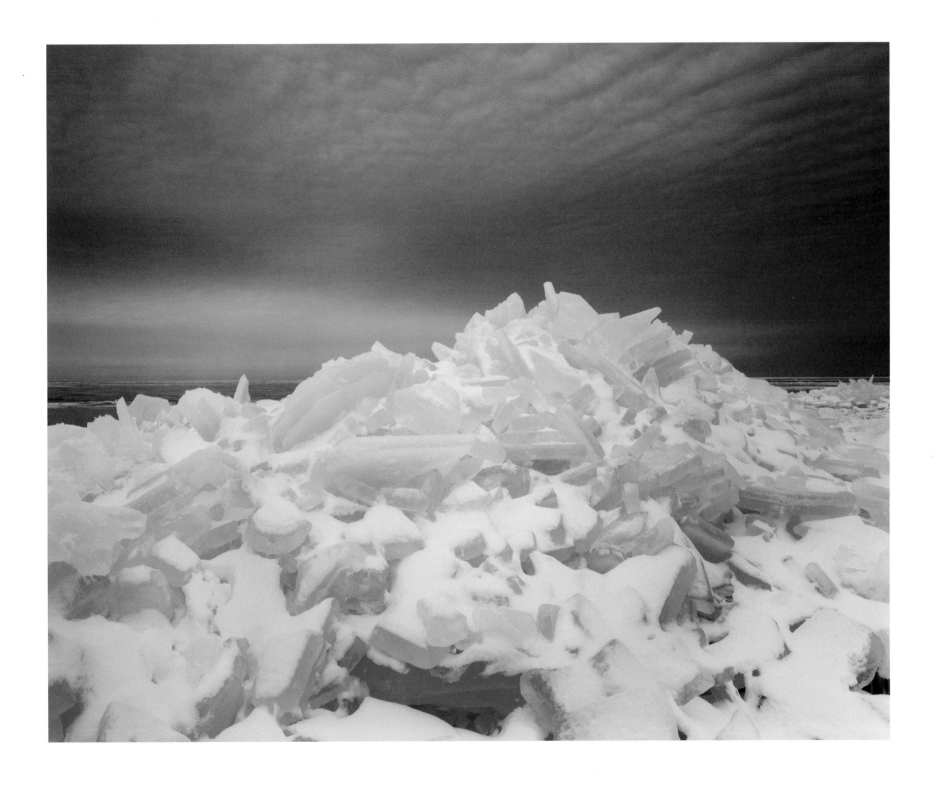

Plate 33

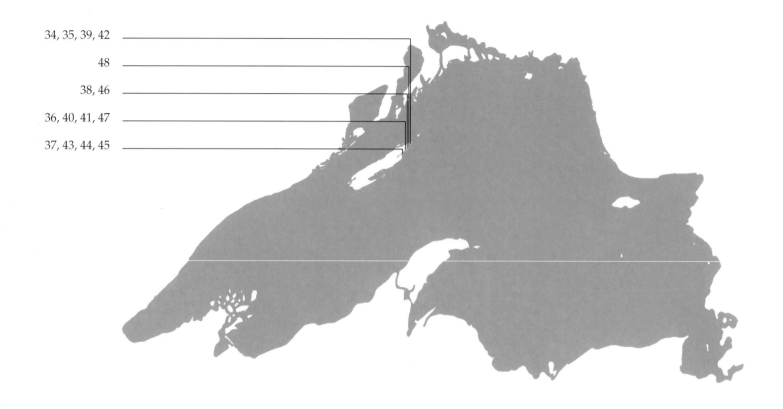

34, 35, 39, 42 ——————

48 ——————

38, 46 ——————

36, 40, 41, 47 ——————

37, 43, 44, 45 ——————

ISLE ROYALE

Plate 34	Moonrise from Merritts Lane, June, 1992
Plate 35	Looking southeast from near Blake Point. June, 1992
Plate 36	Basalt outcrops south of Tookers Island. June, 1992
Plate 37	Fringed Polygala. June, 1992
Plate 38	Fireweed and driftwood, Raspberry Island. September, 1989
Plate 39	Small island southeast of Blake Point. June, 1992
Plate 40	Small islands east of Davidson Island. June, 1992
Plate 41	Bird's-eye primrose. June, 1992
Plate 42	Columnar jointed basalt. June, 1992
Plate 43	West Caribou Island. June, 1992
Plate 44	Small islands east of Middle Islands Passage. June, 1992
Plate 45	West Caribou Island. September, 1989
Plate 46	Raspberry Island. September, 1989
Plate 47	Basalt islands southeast of Tookers Island. June, 1992
Plate 48	Moonrise northeast of Scoville Point. June, 1992

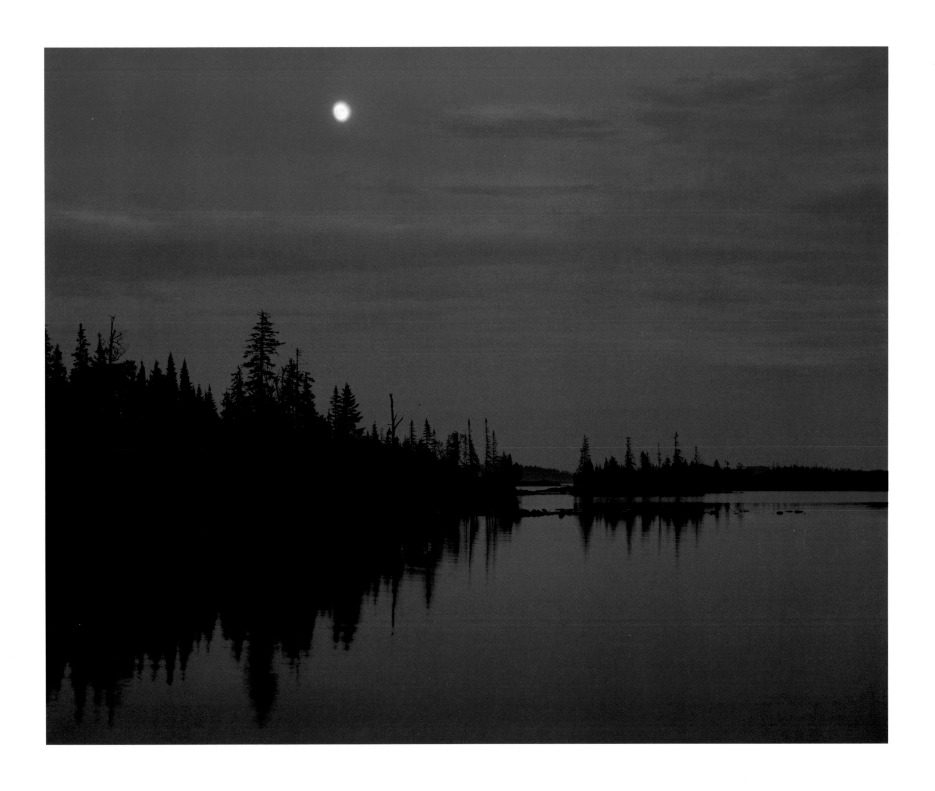

Plate 34

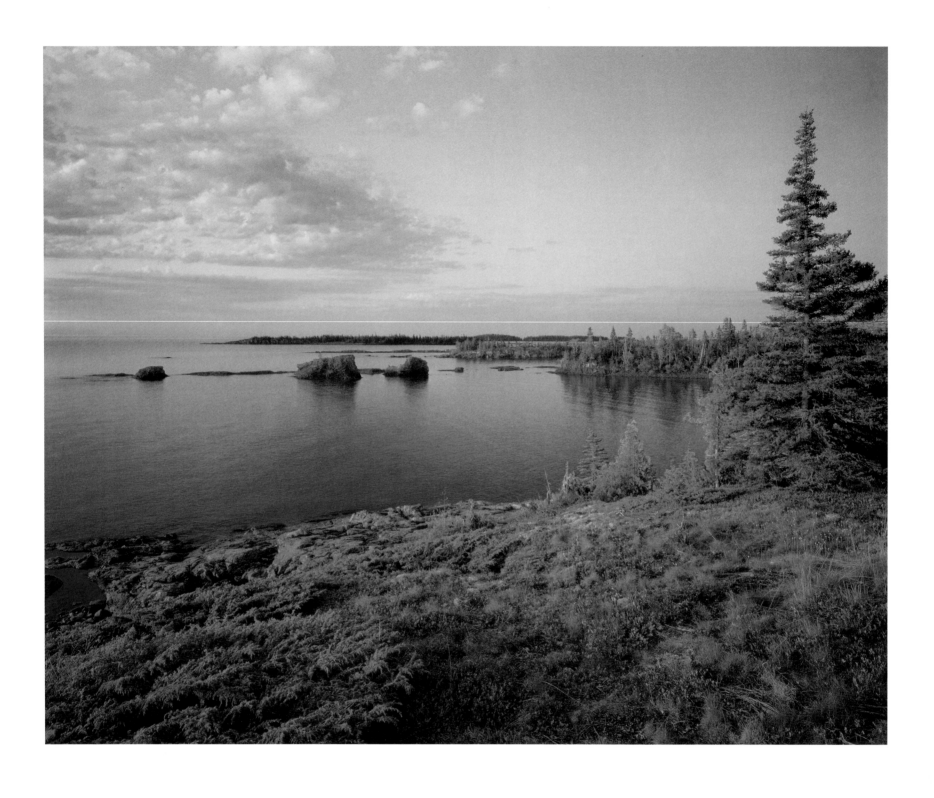

Plate 35

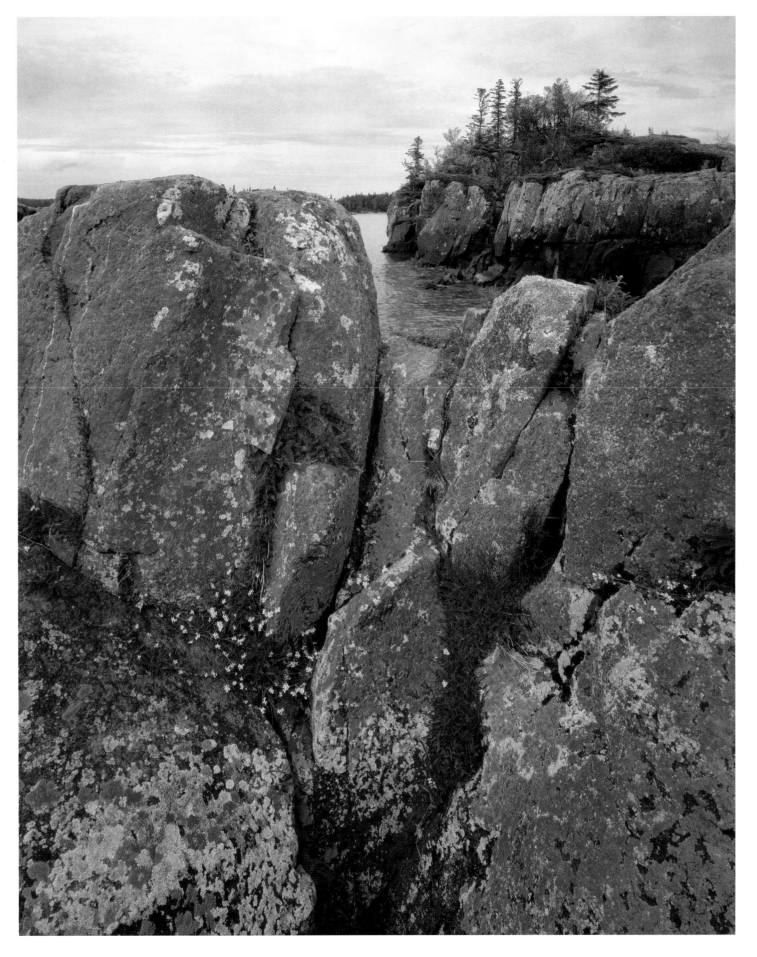

Plate 36

Plate 37

Plate 38

Plate 39

Plate 40

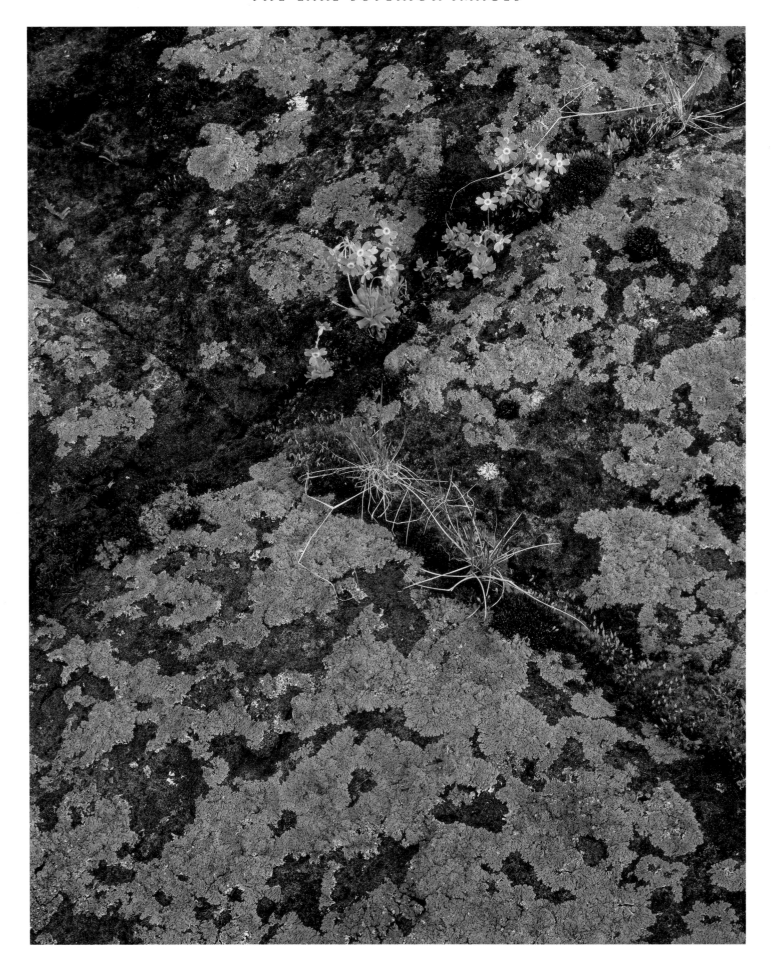

Plate 41

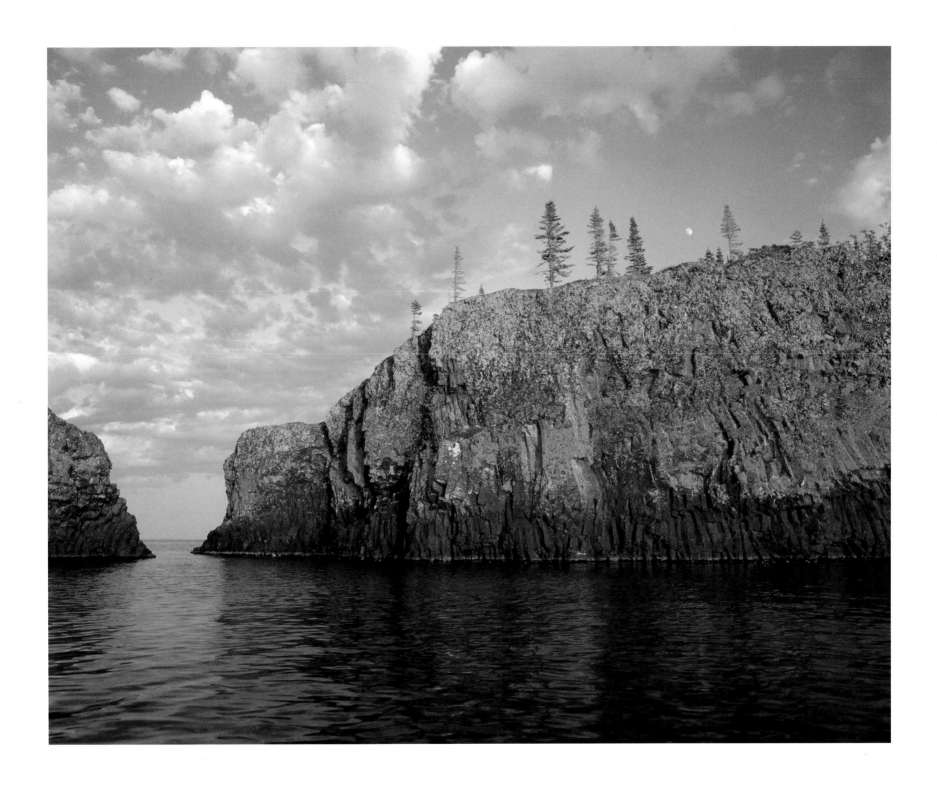

Plate 42

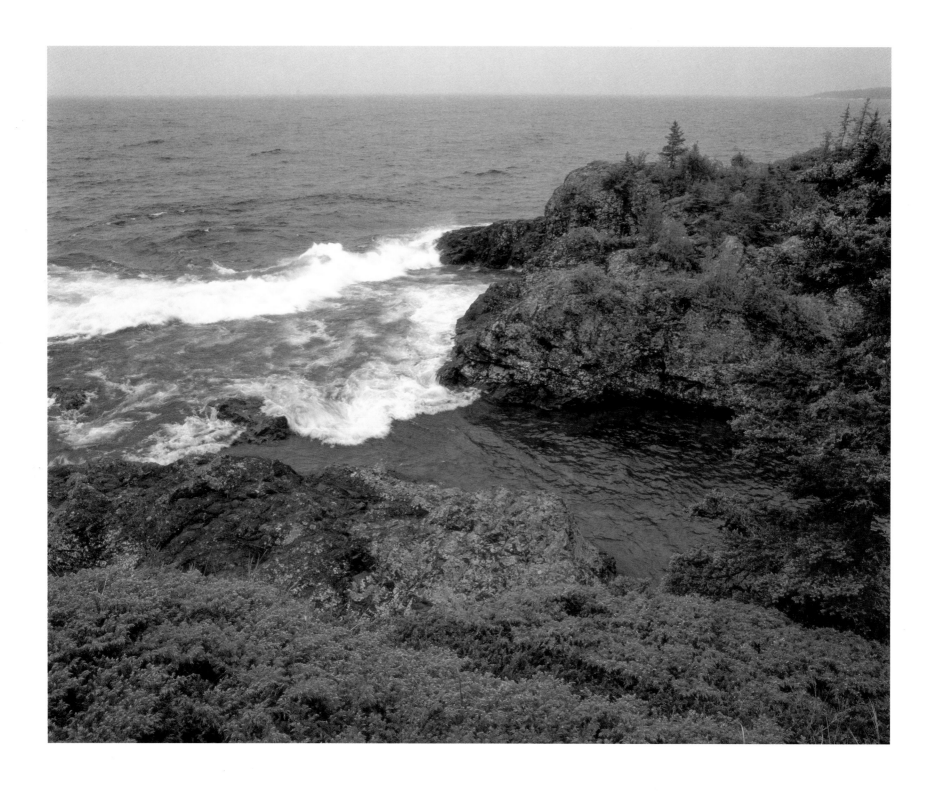

Plate 43

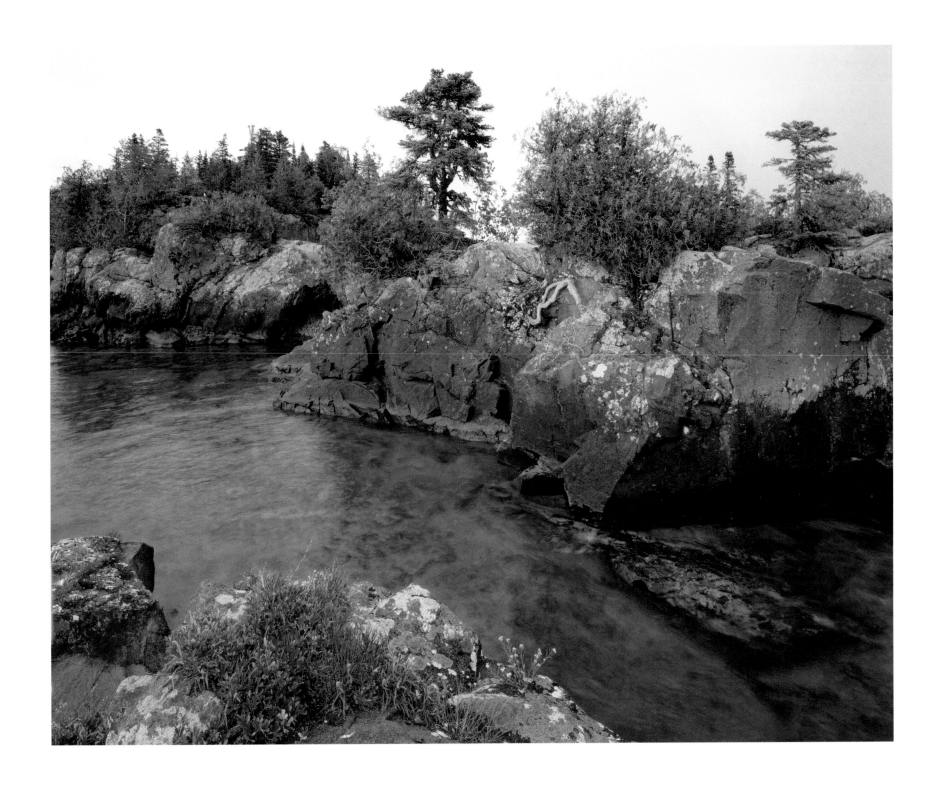

Plate 44

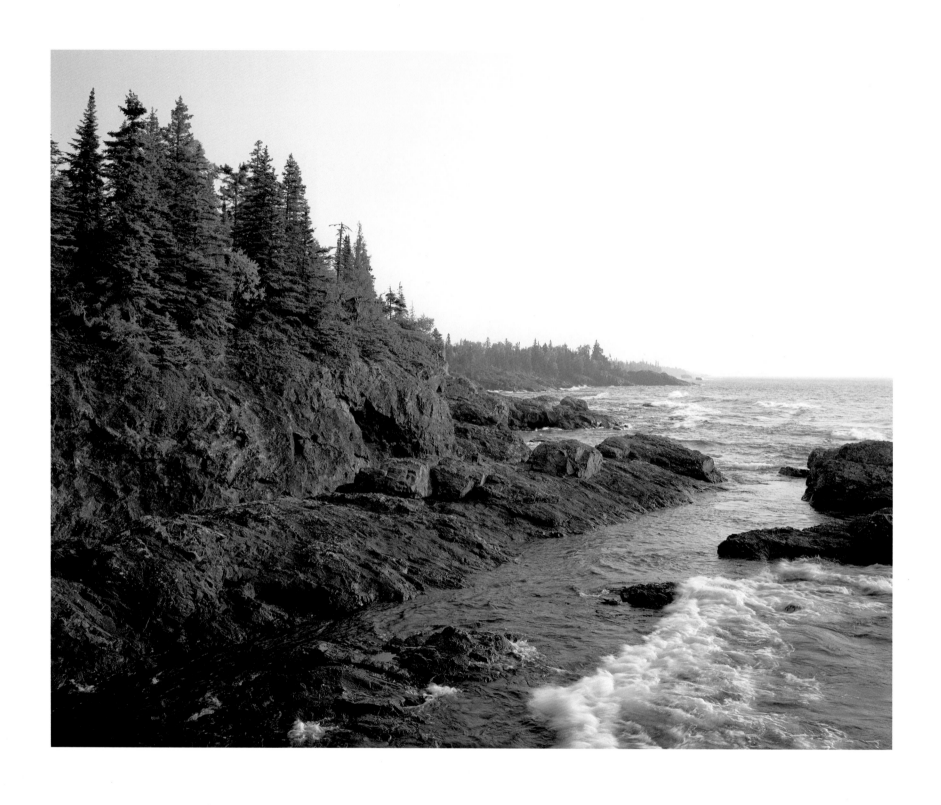

Plate 45

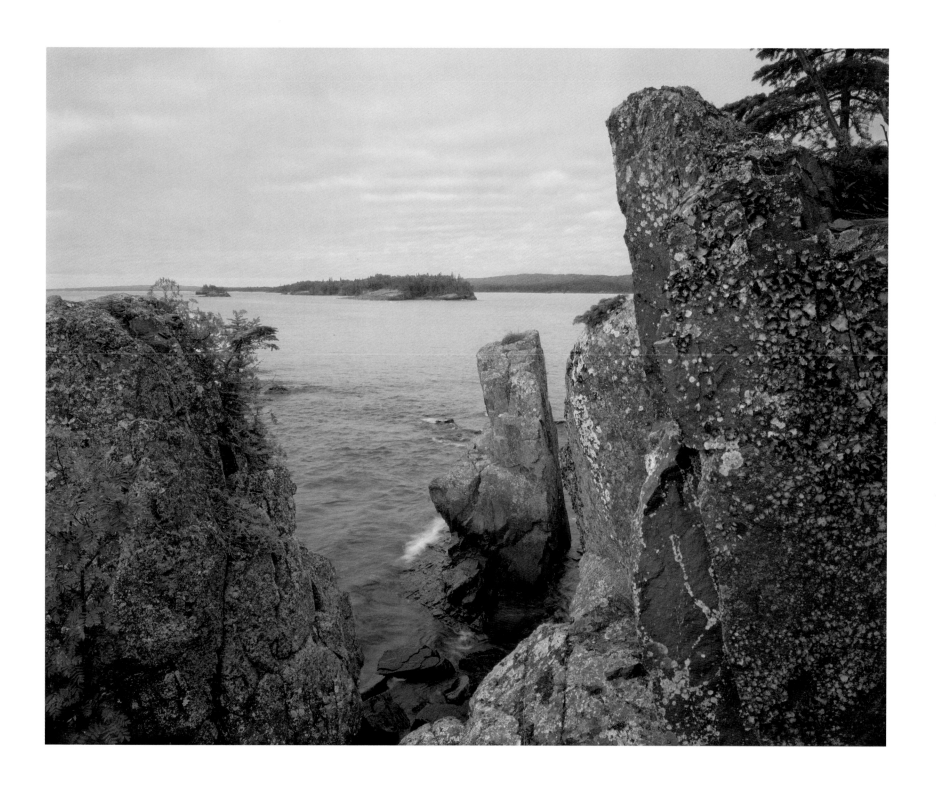

Plate 46

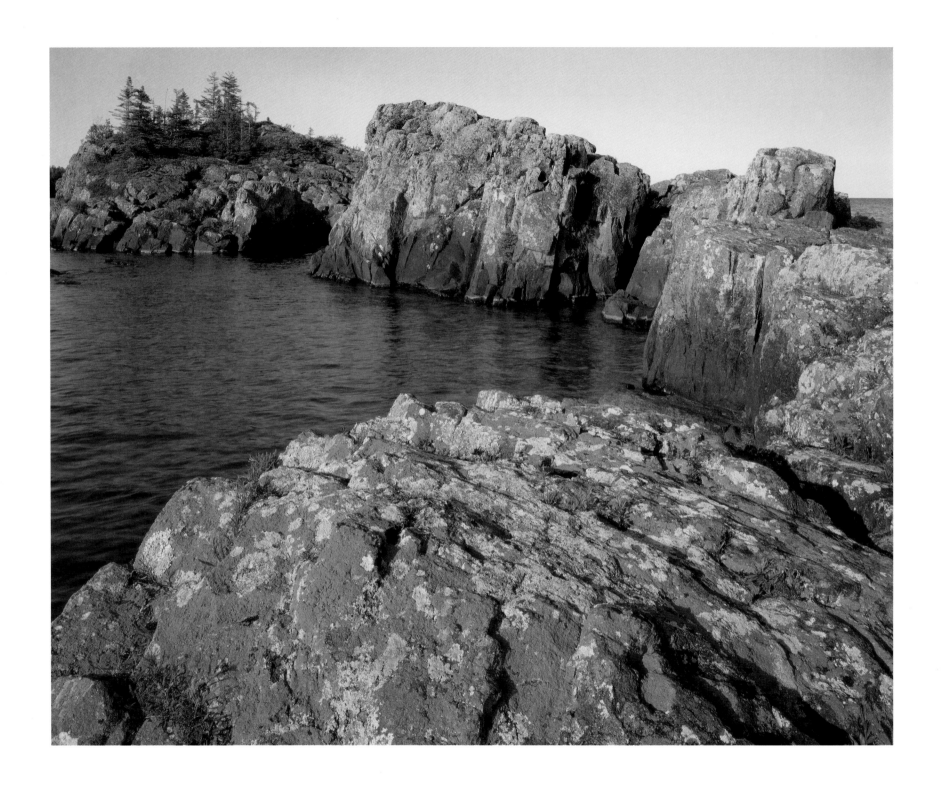

Plate 47

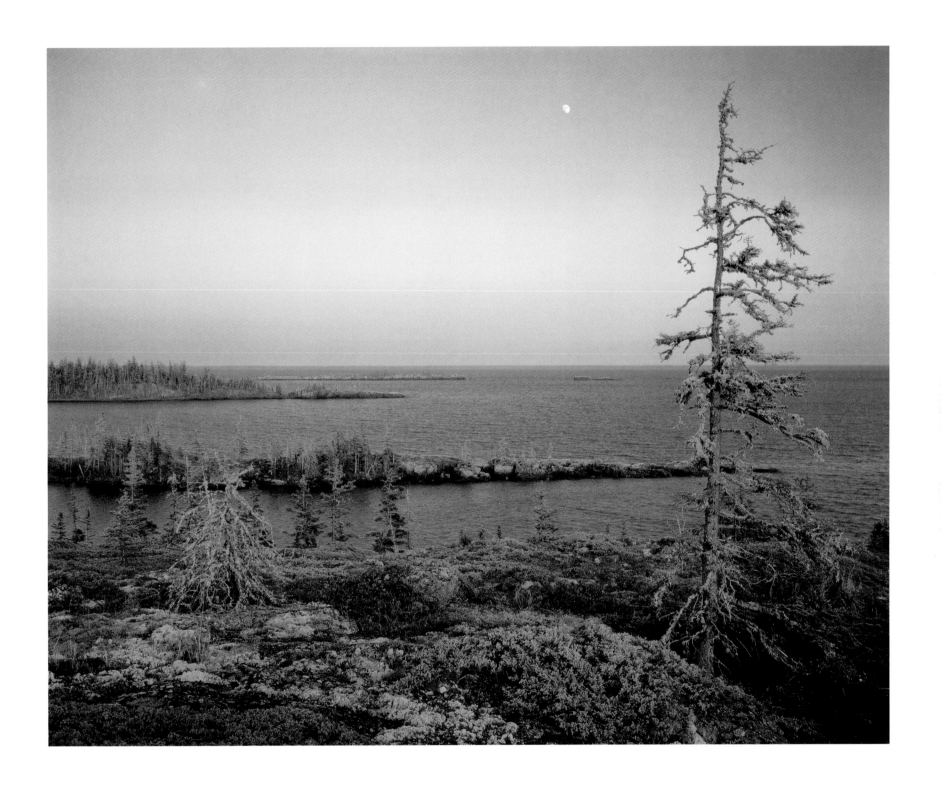

Plate 48

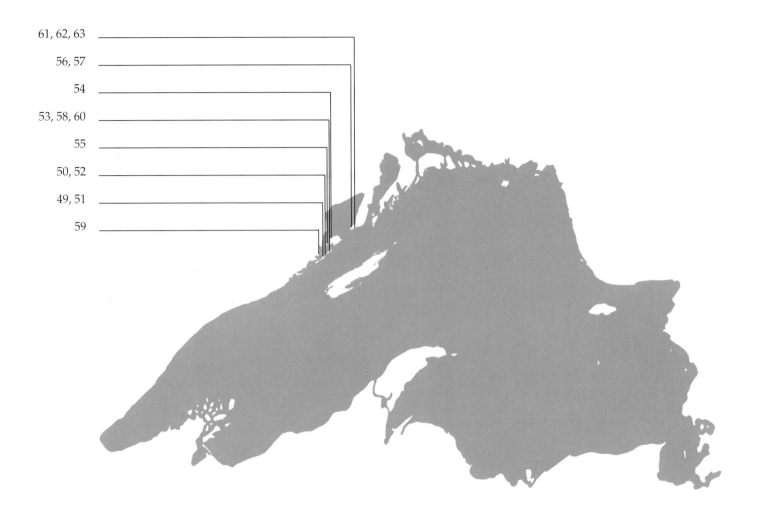

PIGEON POINT TO BLACK BAY

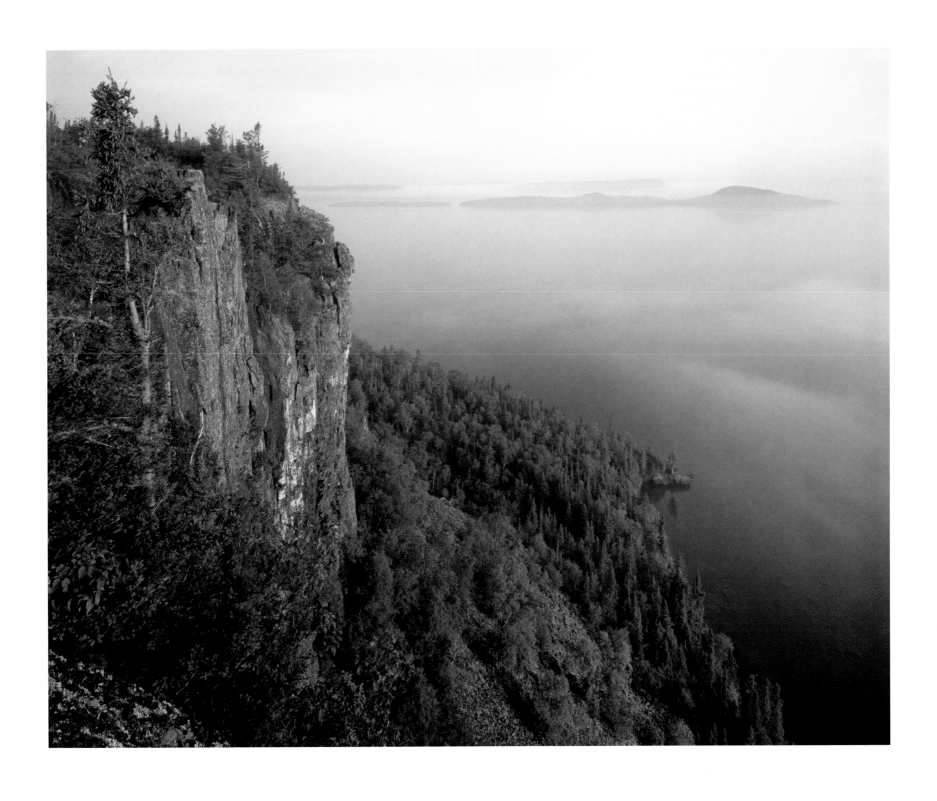

Plate 49

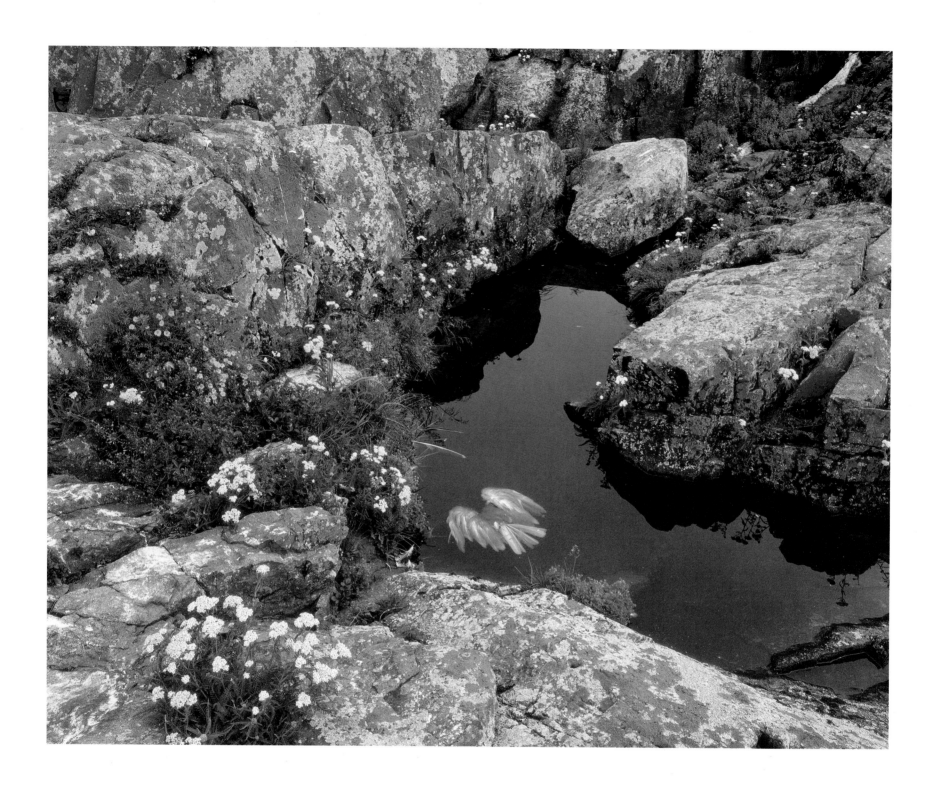

Plate 50

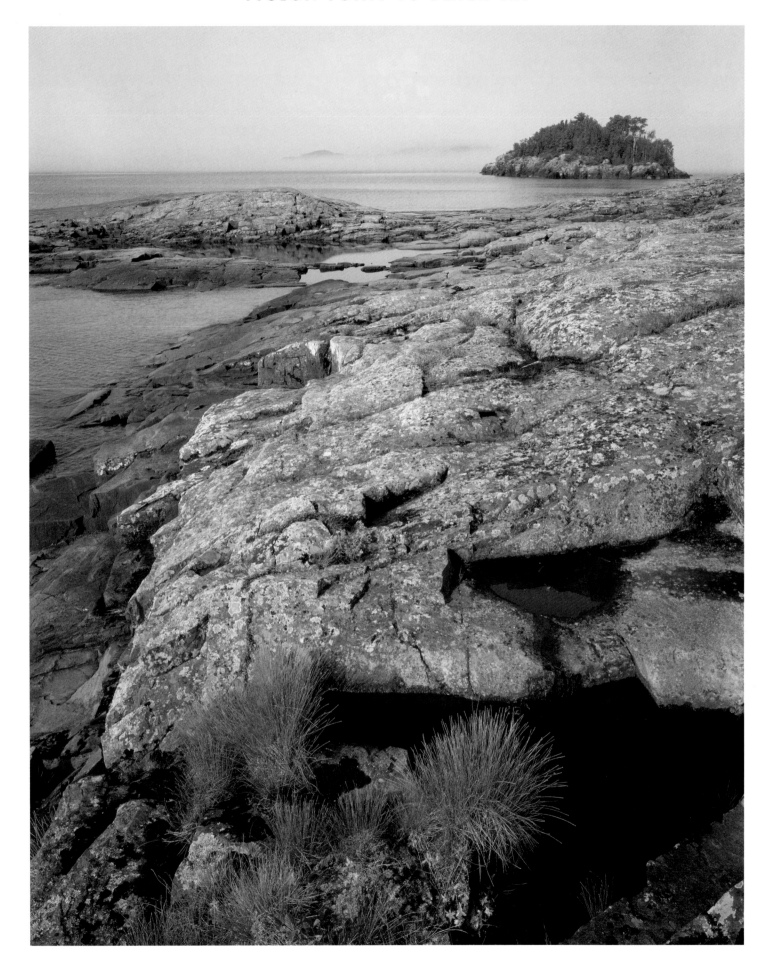

Plate 51

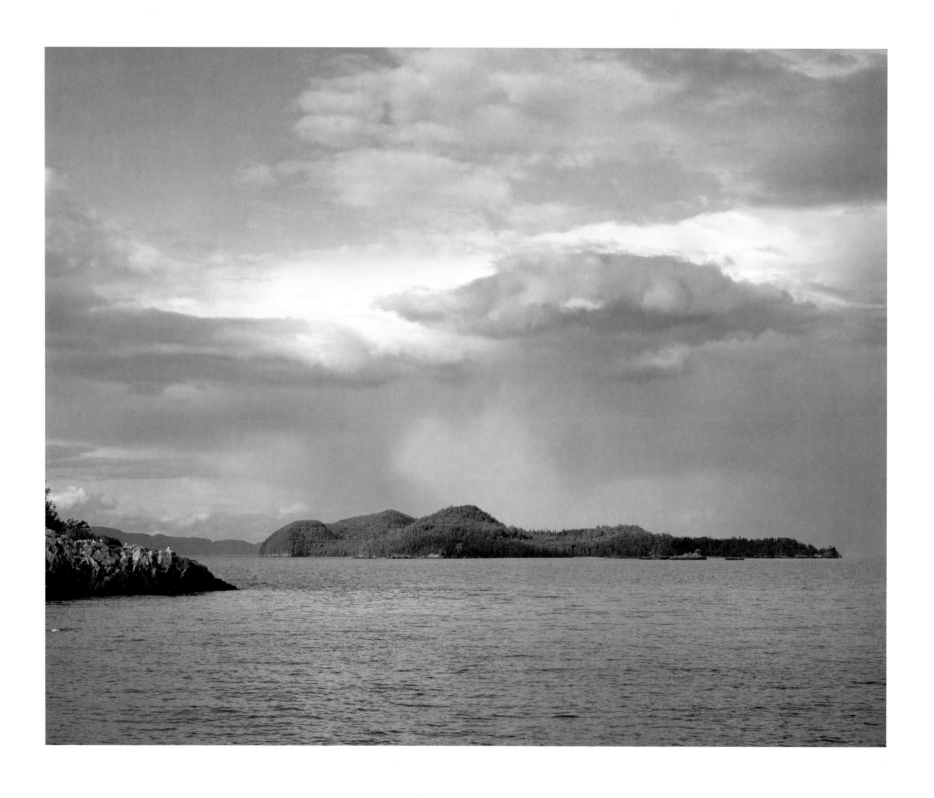

Plate 52

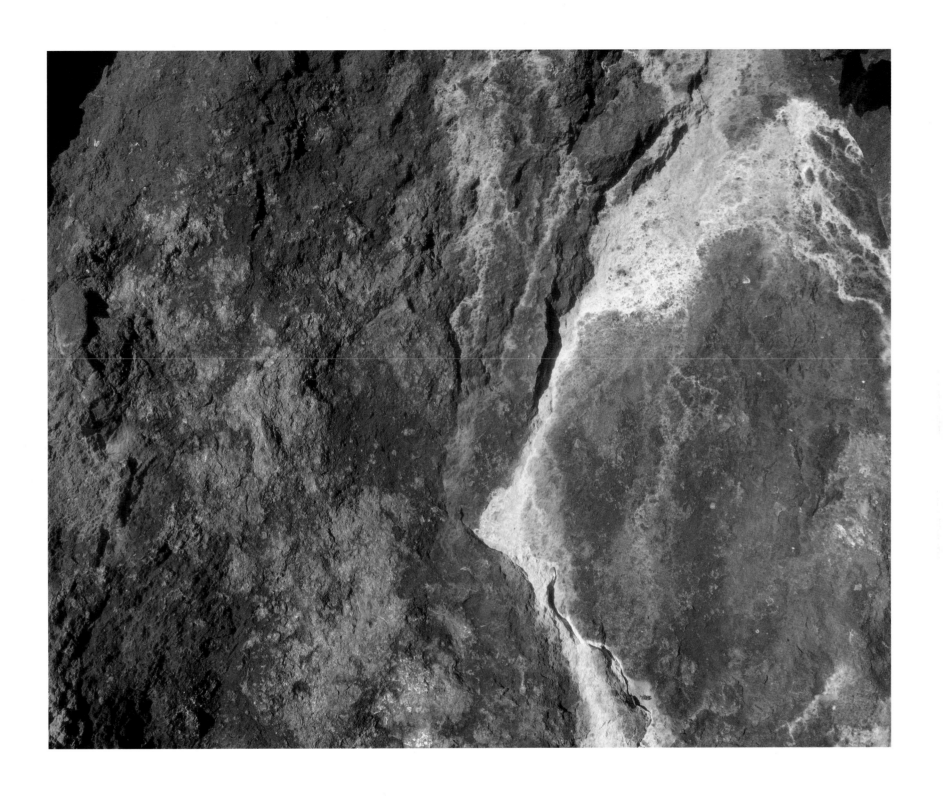

Plate 5 3

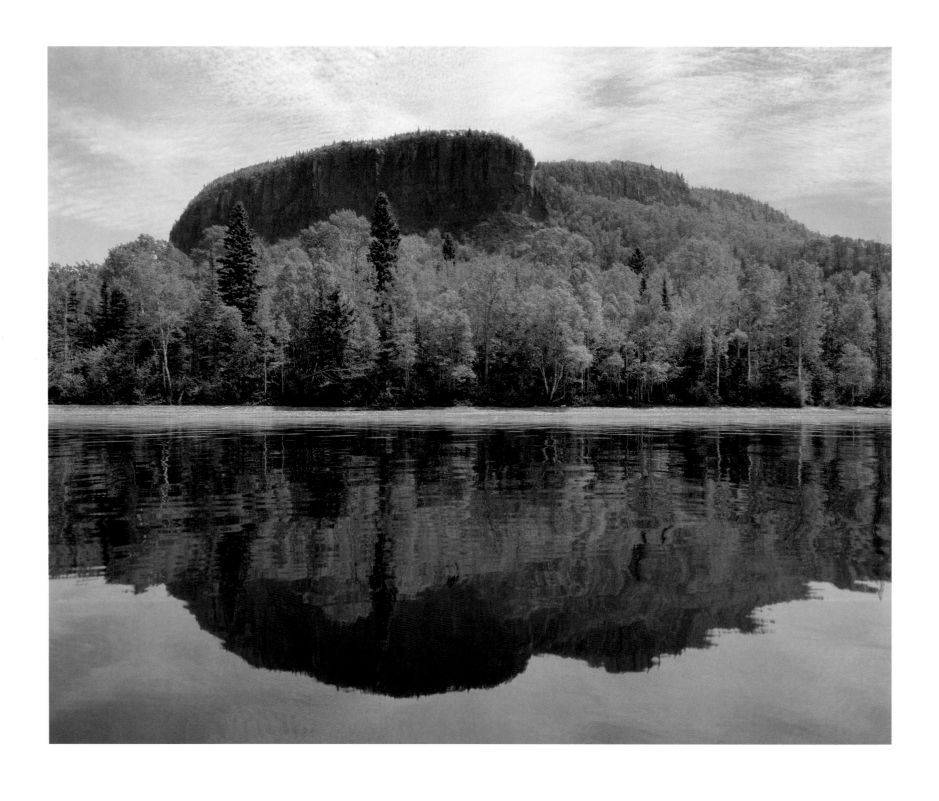

Plate 54

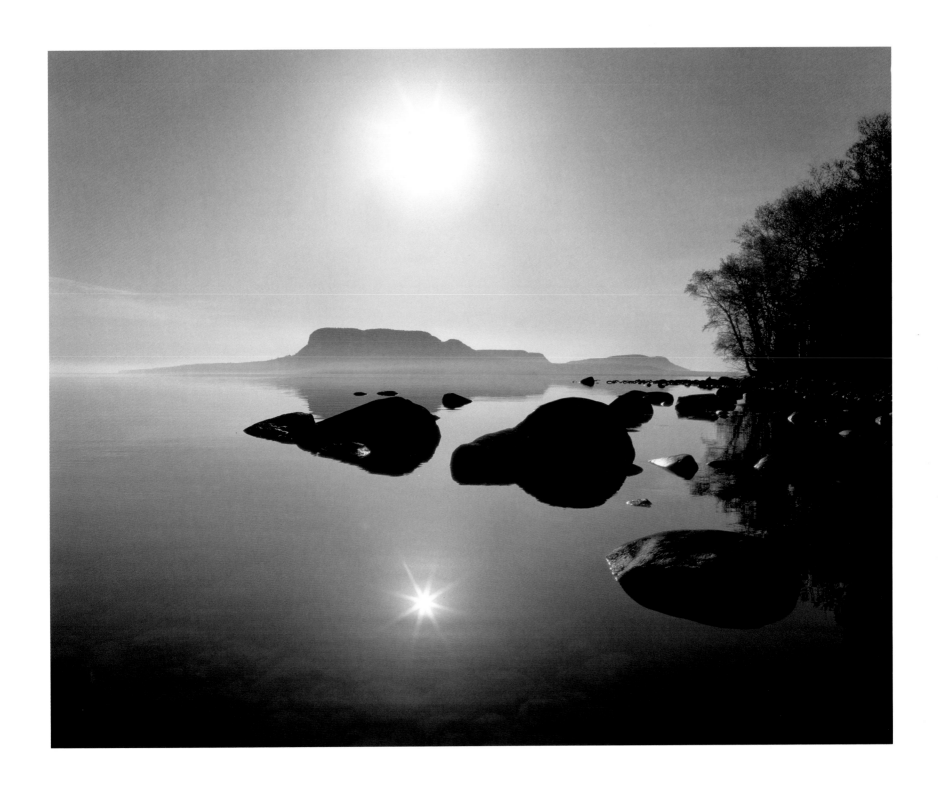

Plate 55

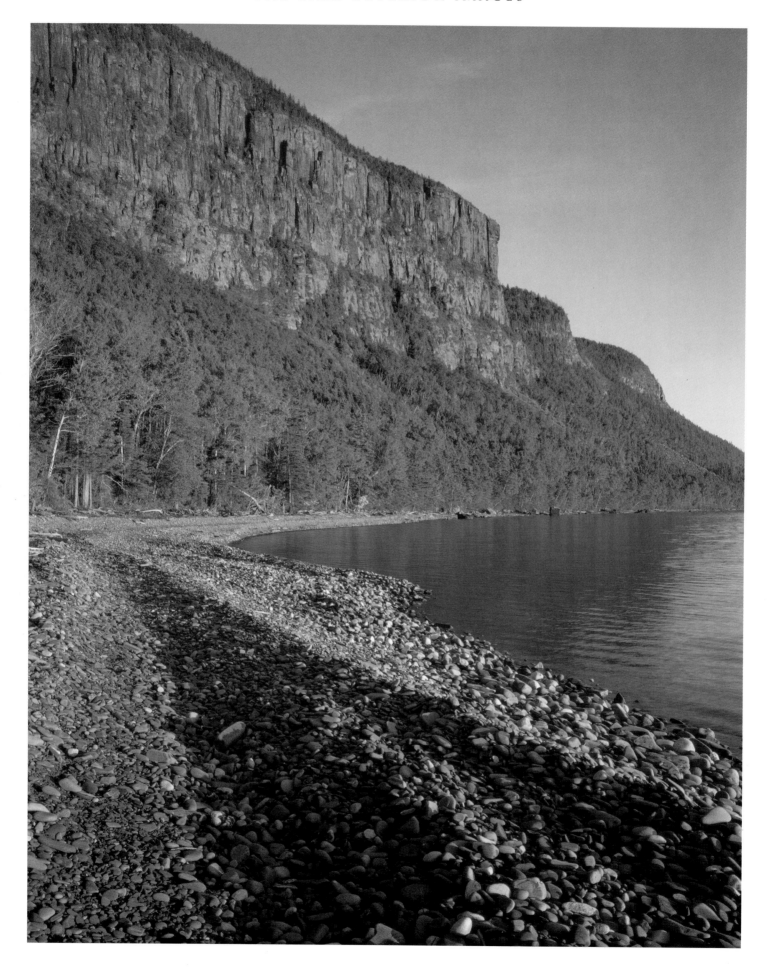

Plate 56

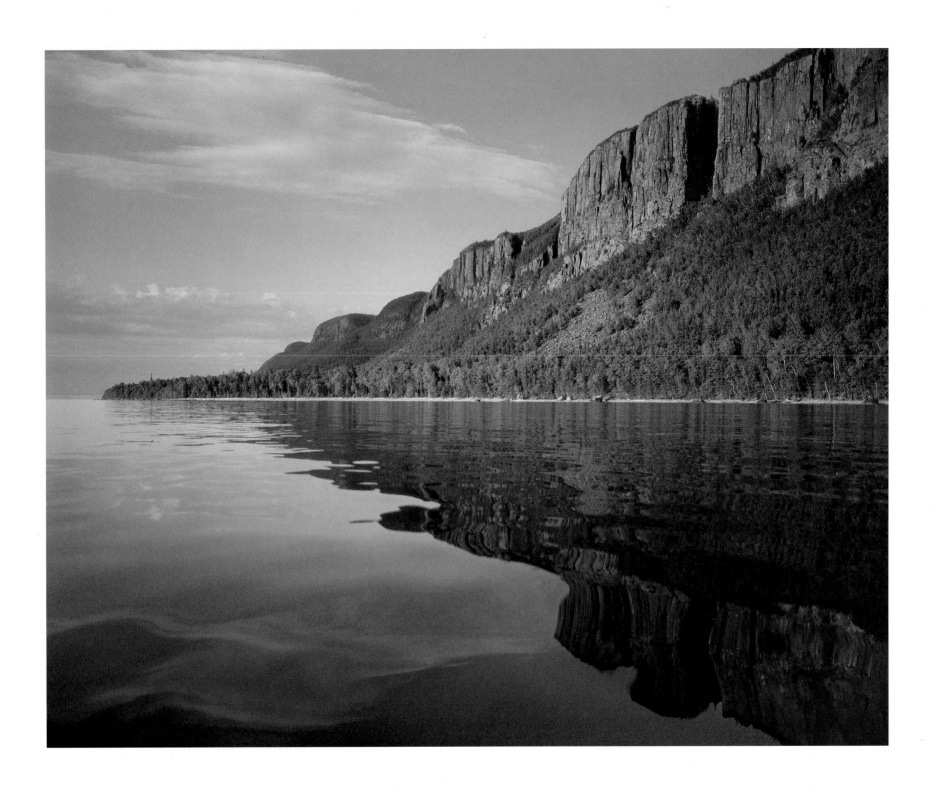

Plate 57

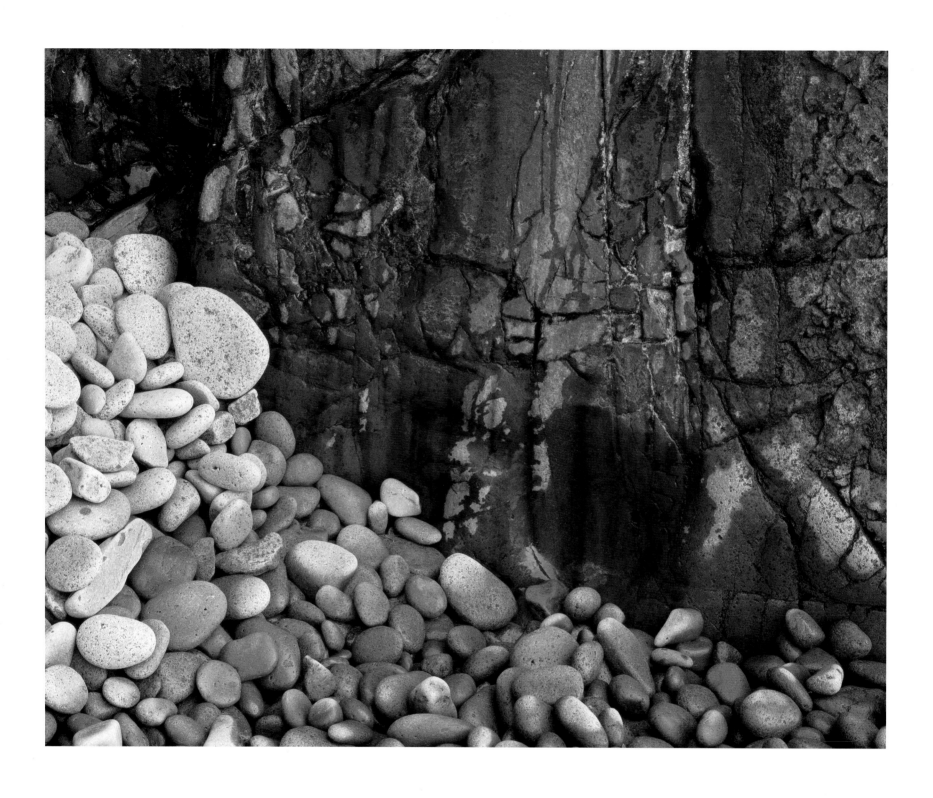

Plate 58

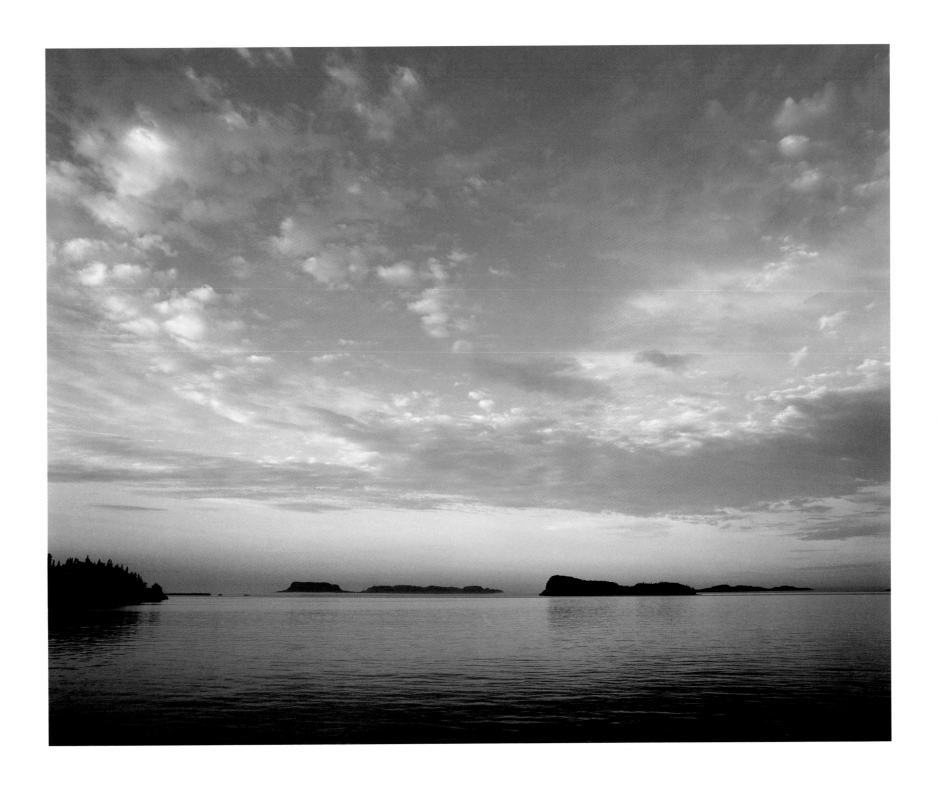

Plate 59

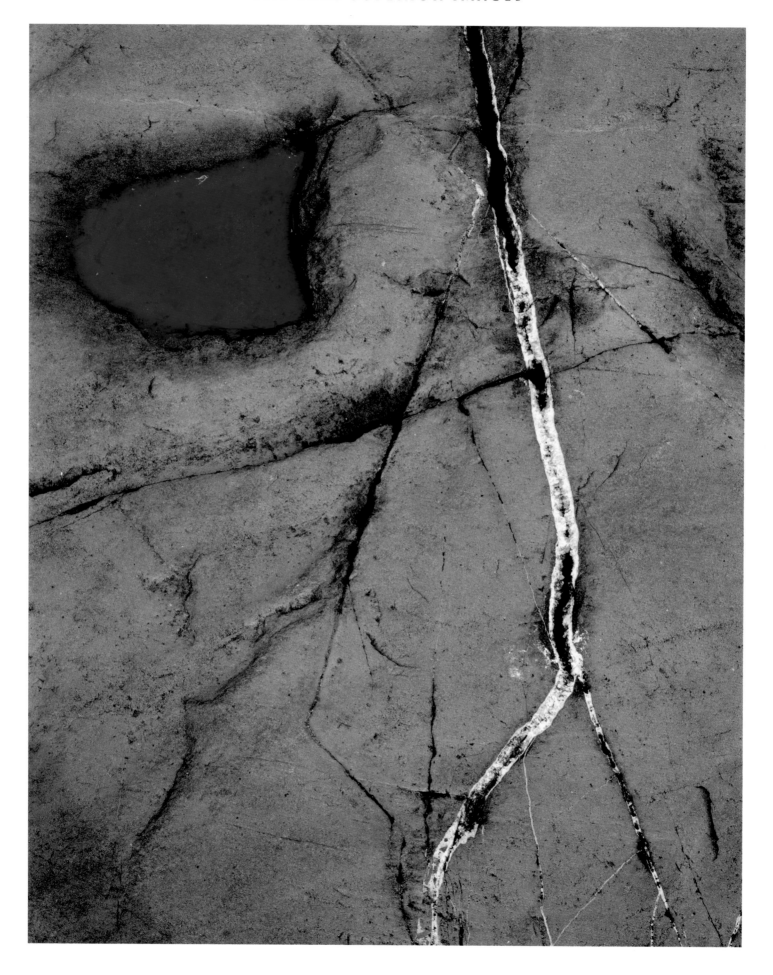

Plate 60

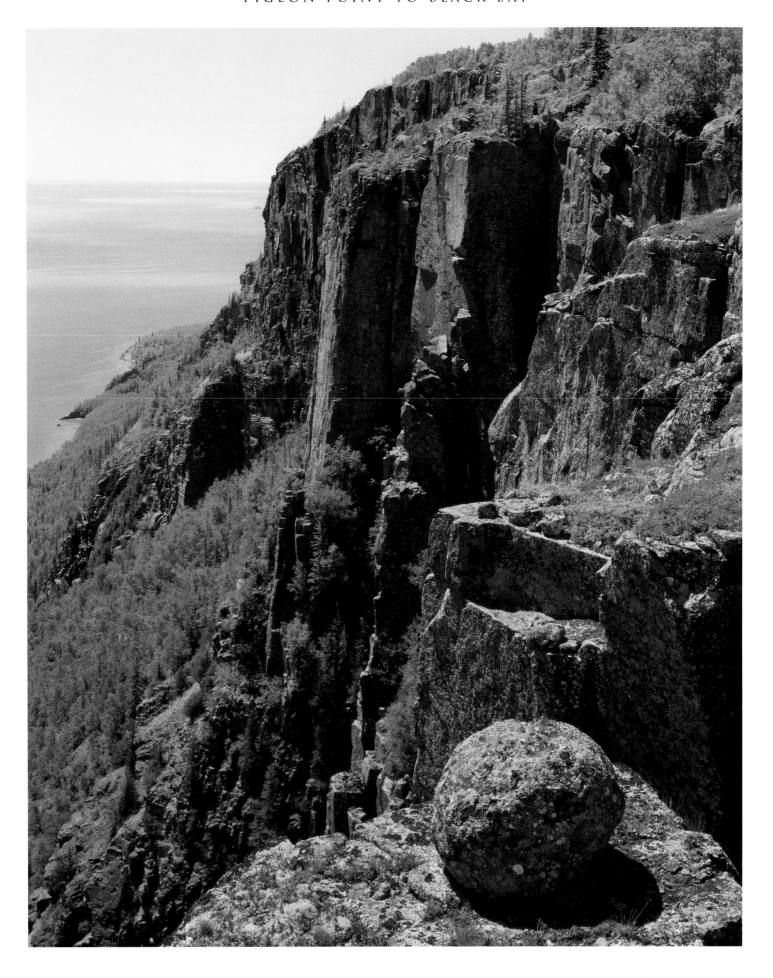

Plate 61

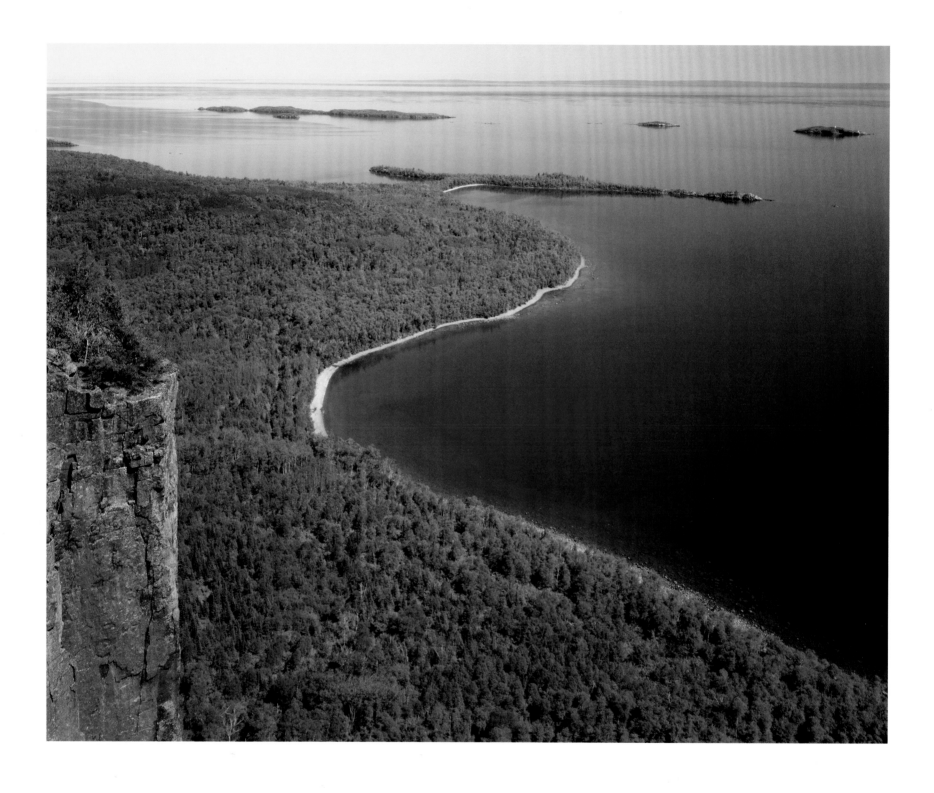

Plate 62

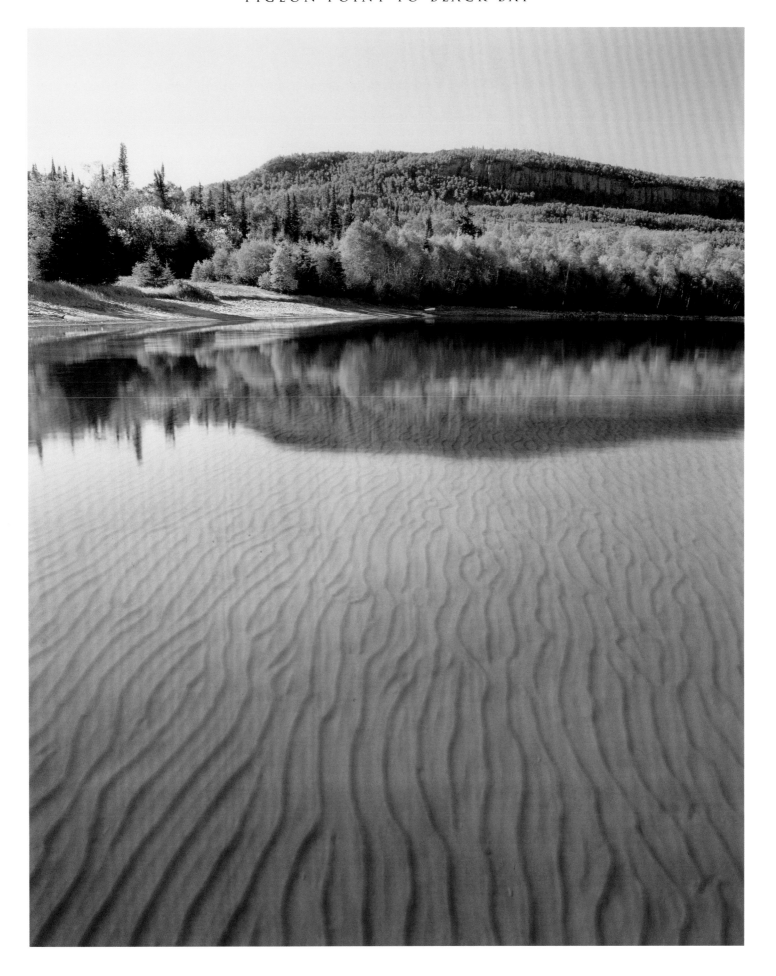

Plate 63

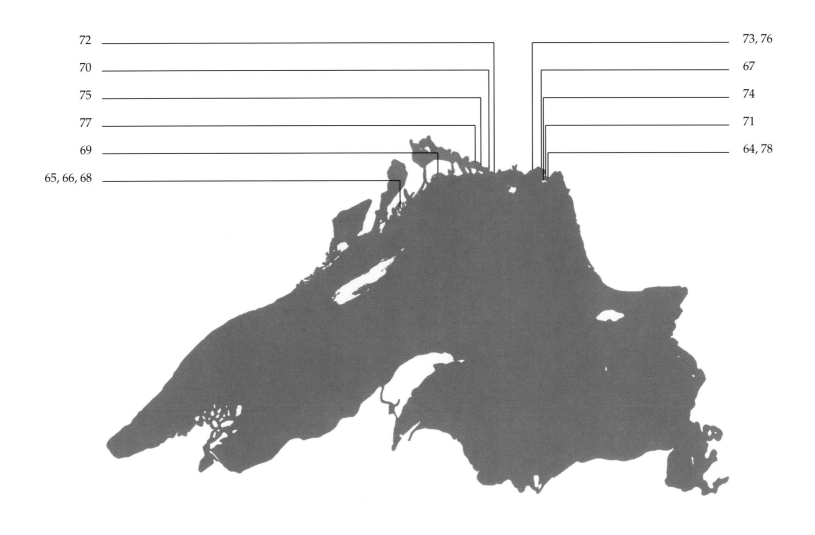

BLACK BAY TO PIC RIVER

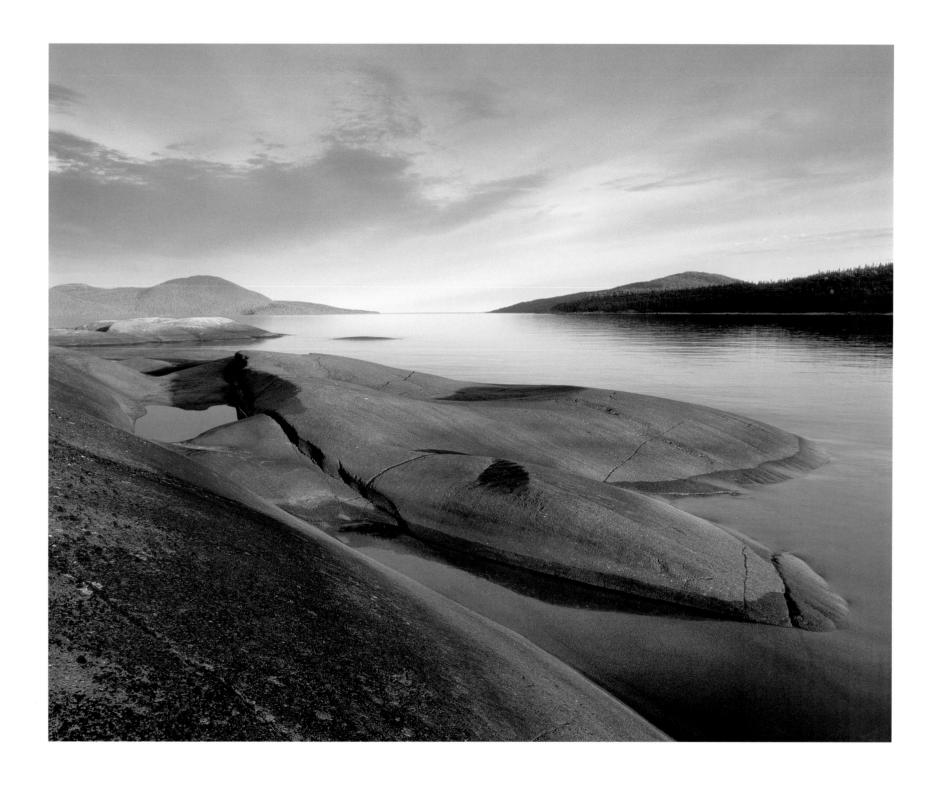

Plate 64

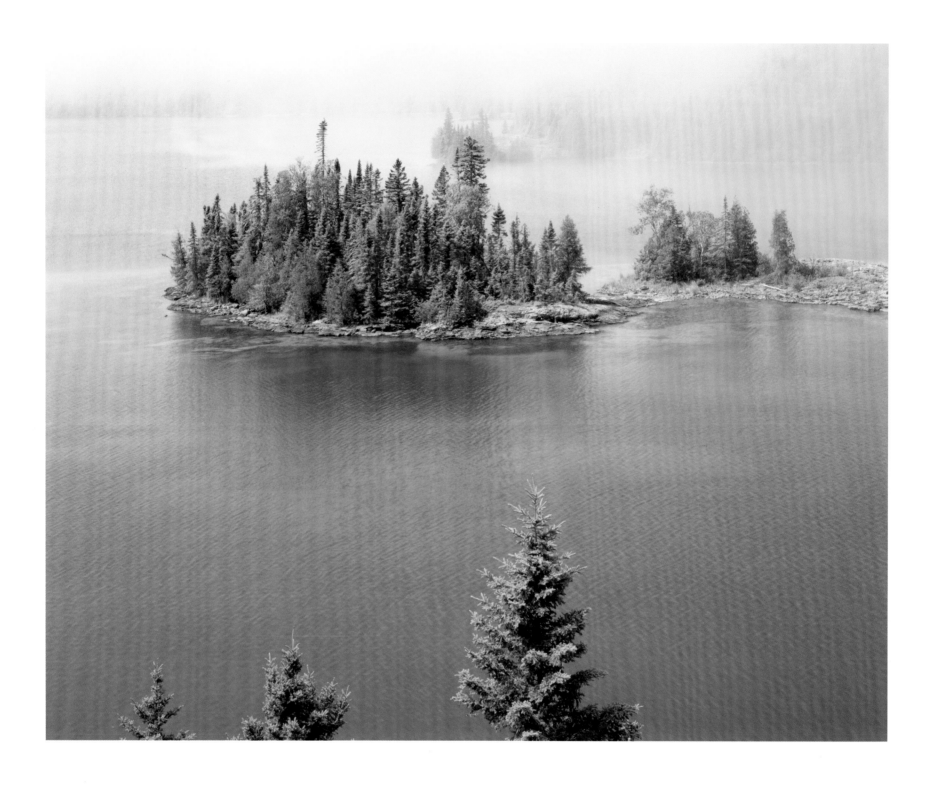

Plate 65

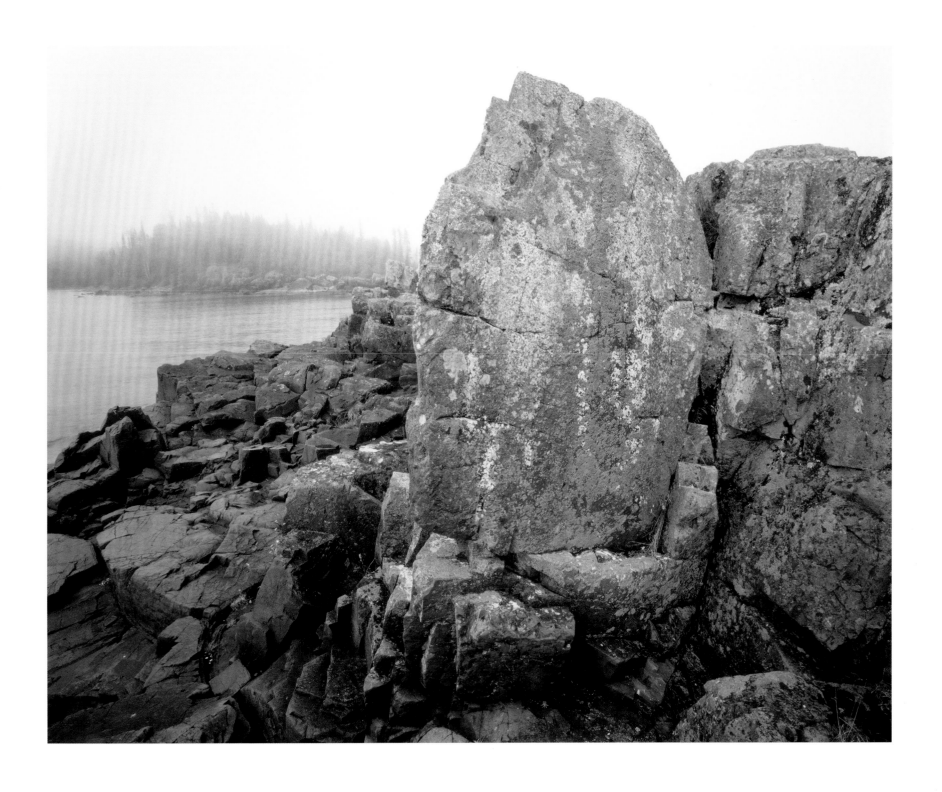

Plate 66

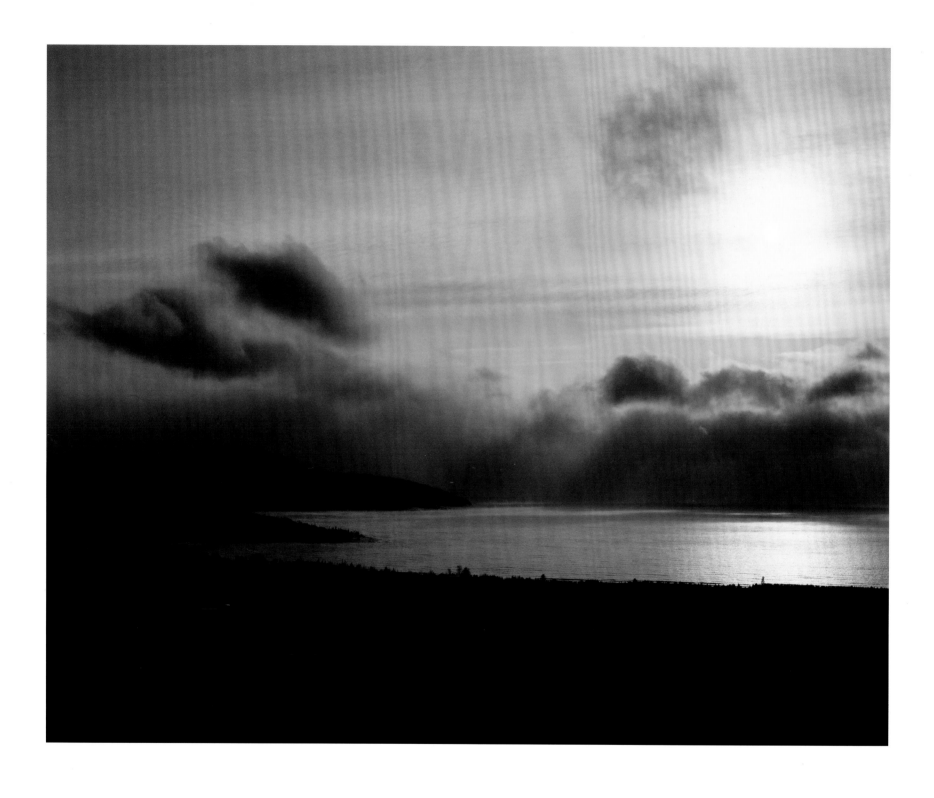

Plate 67

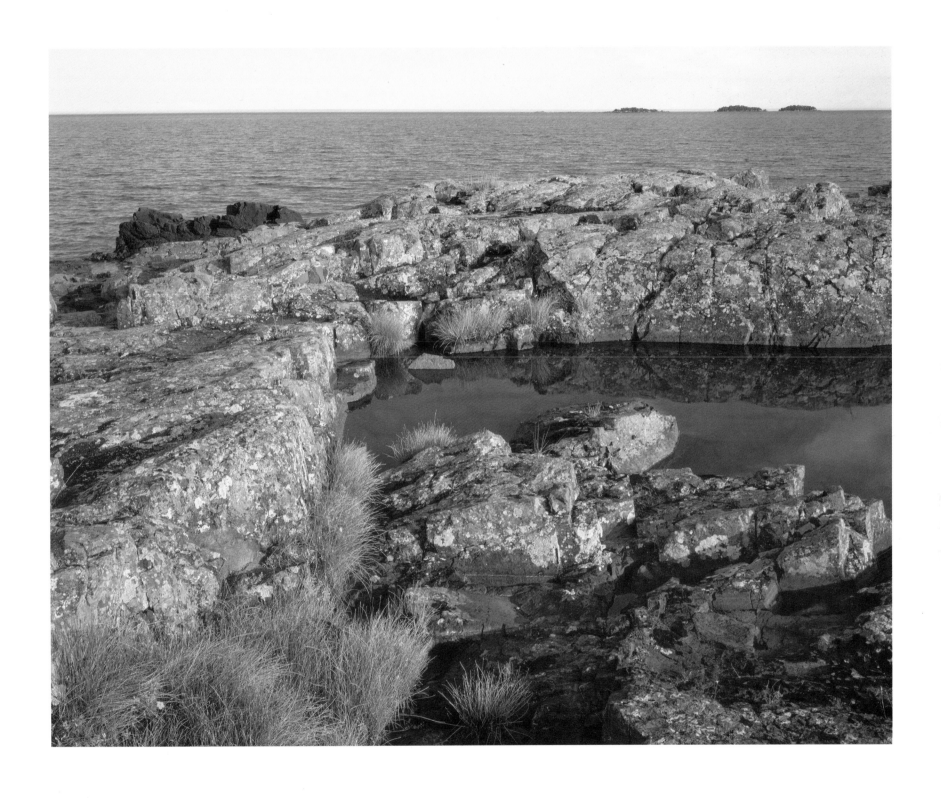

Plate 68

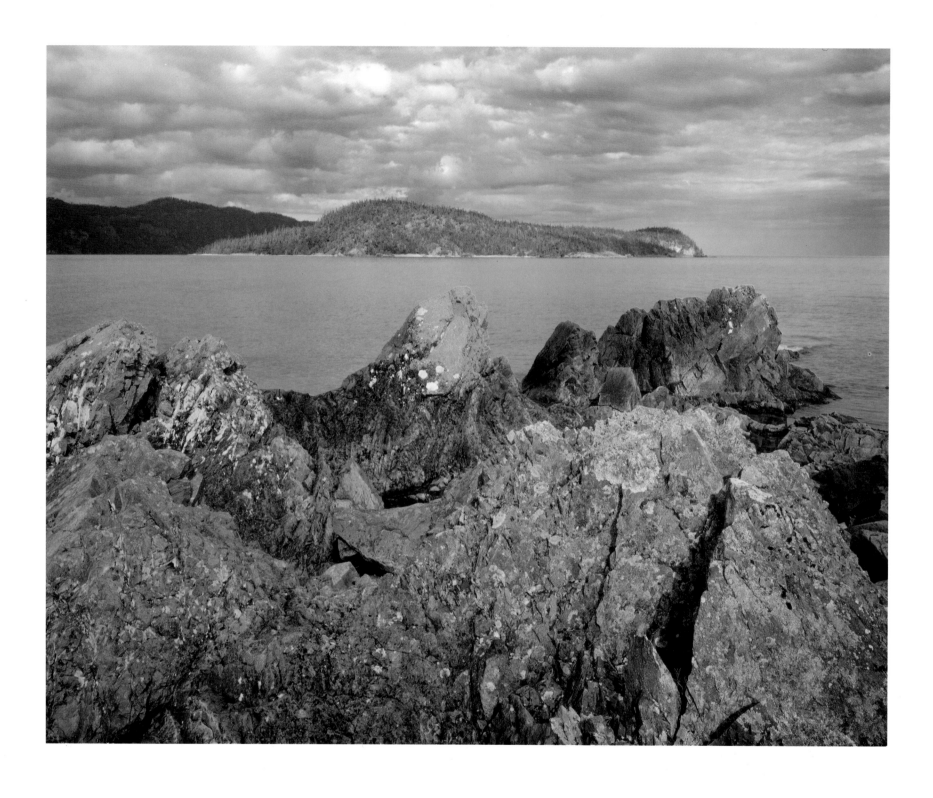

Plate 69

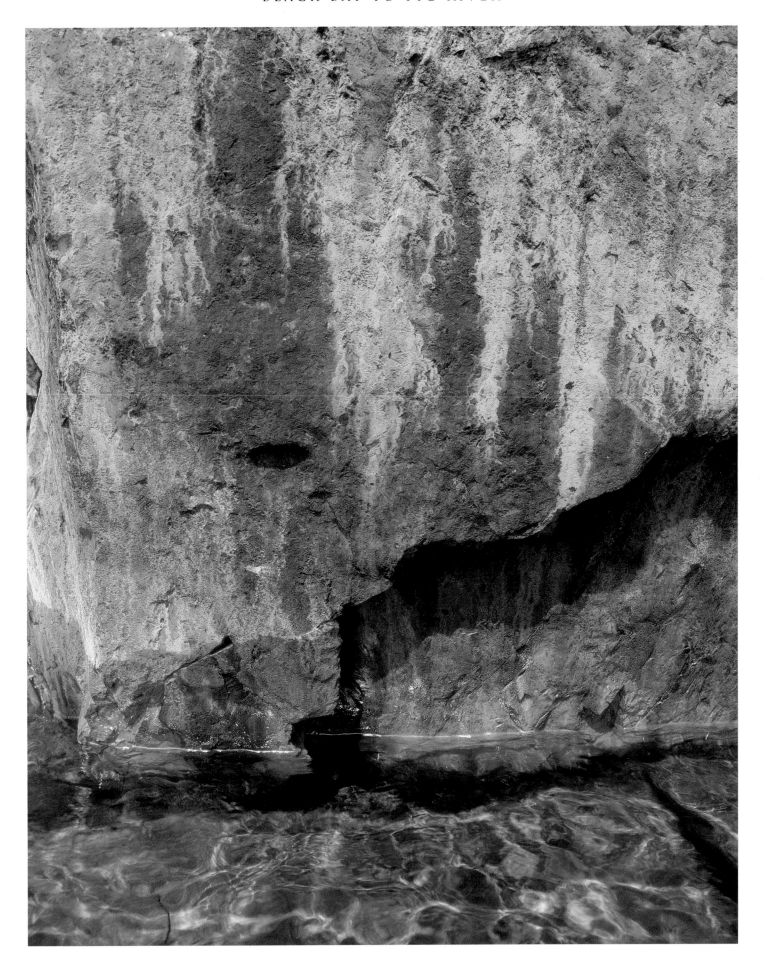

Plate 70

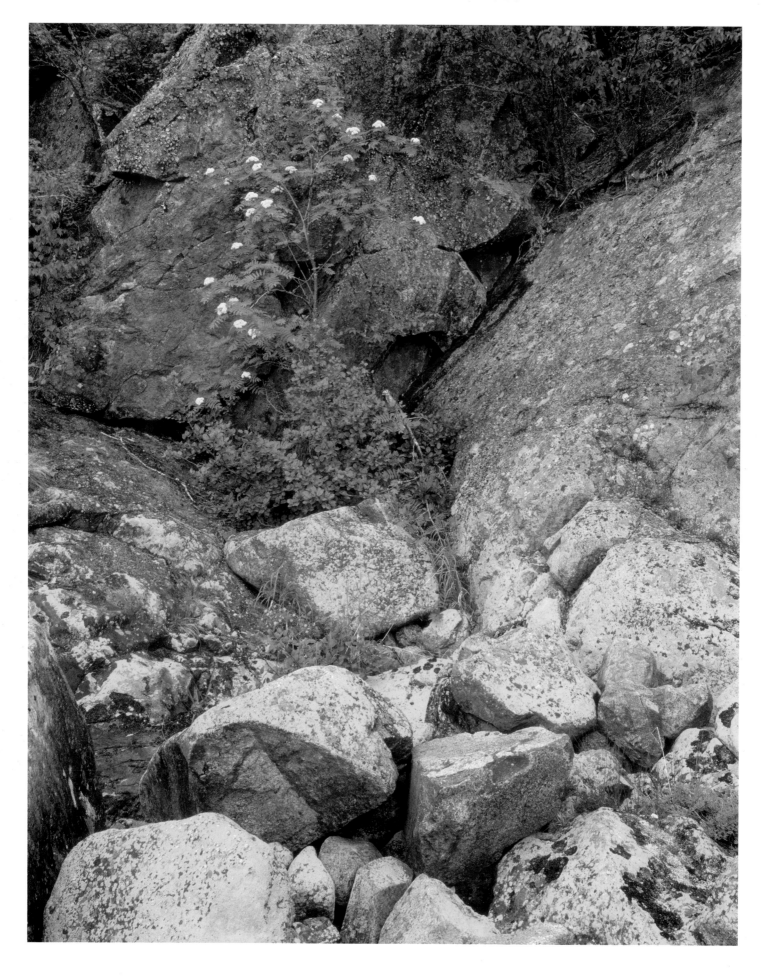

Plate 71

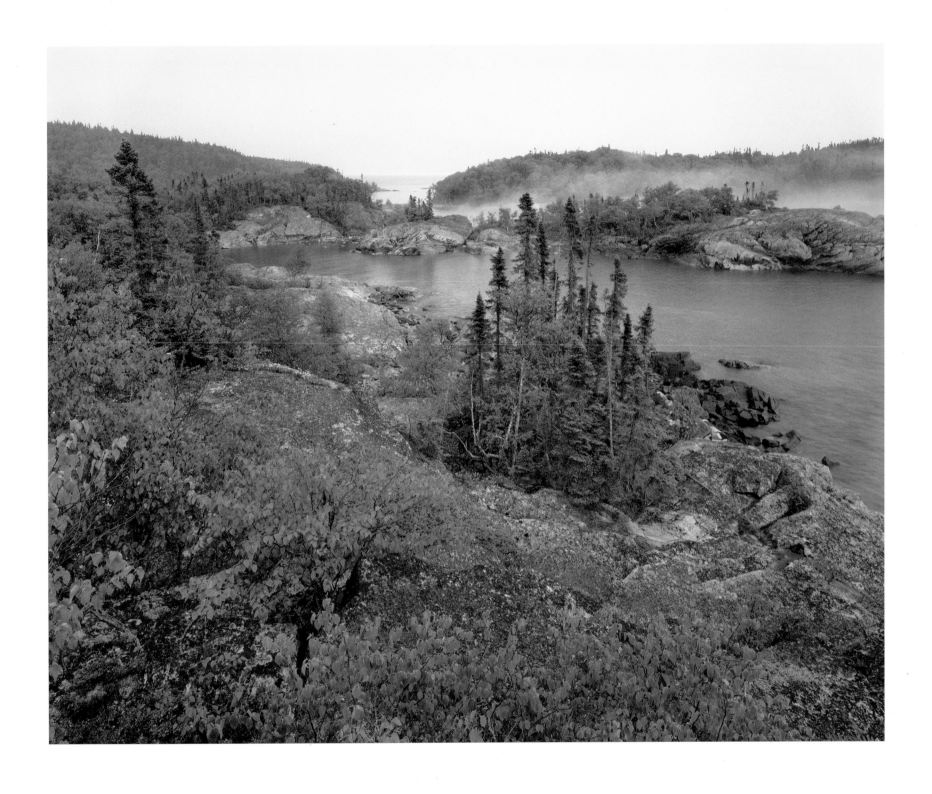

Plate 72

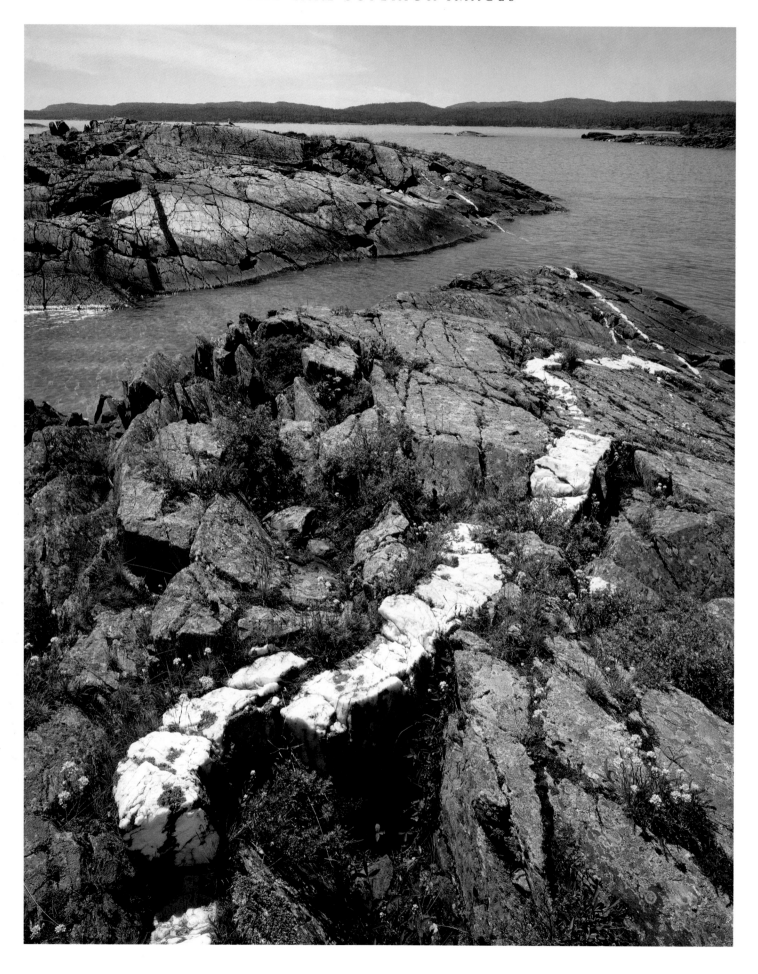

Plate 73

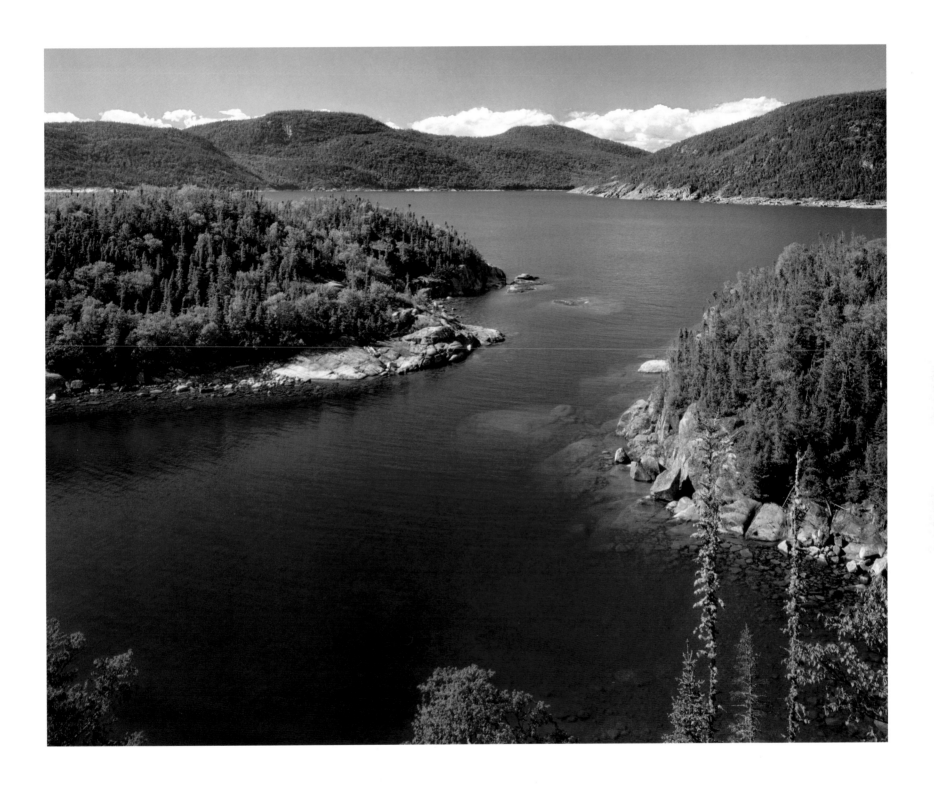

BLACK BAY TO PIC RIVER

Plate 74

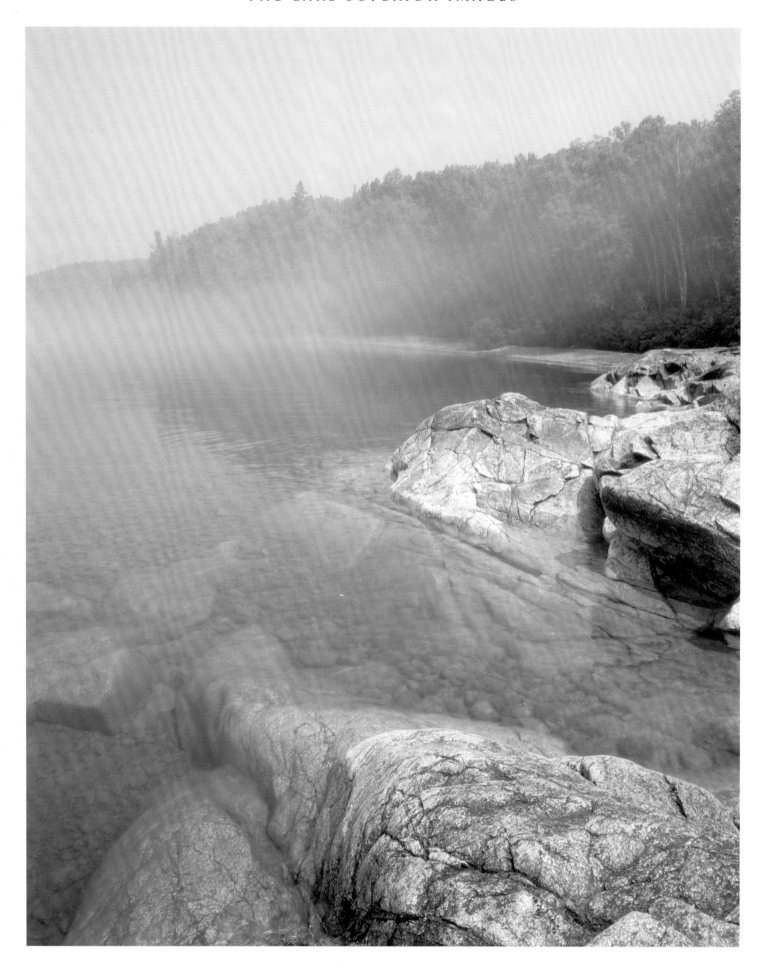

Plate 75

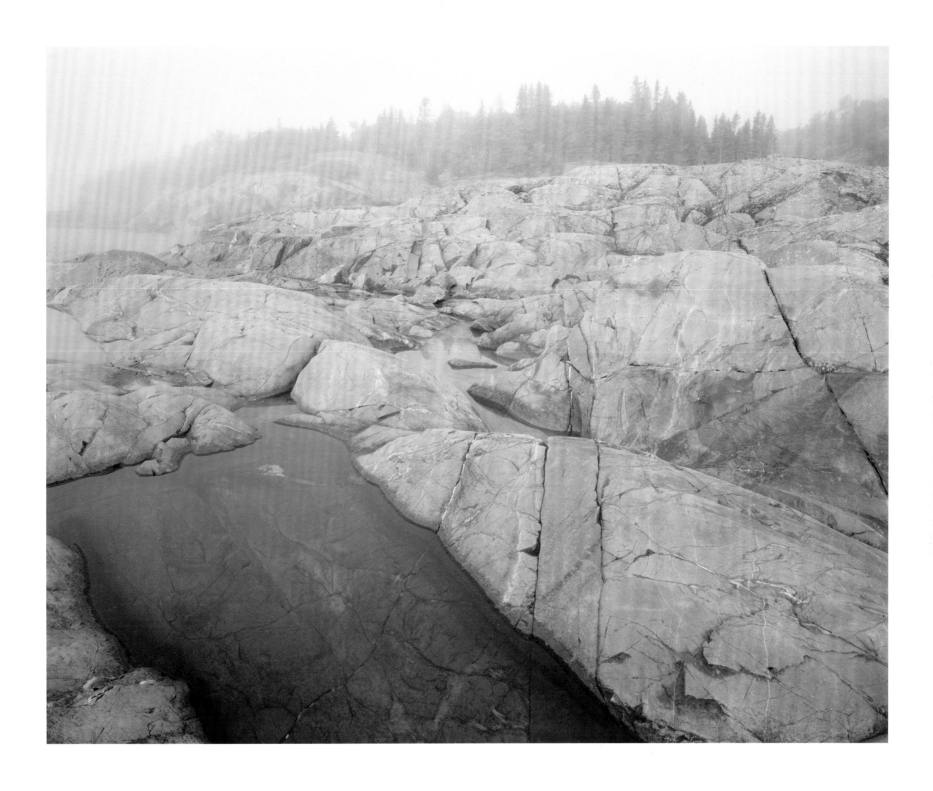

Plate 76

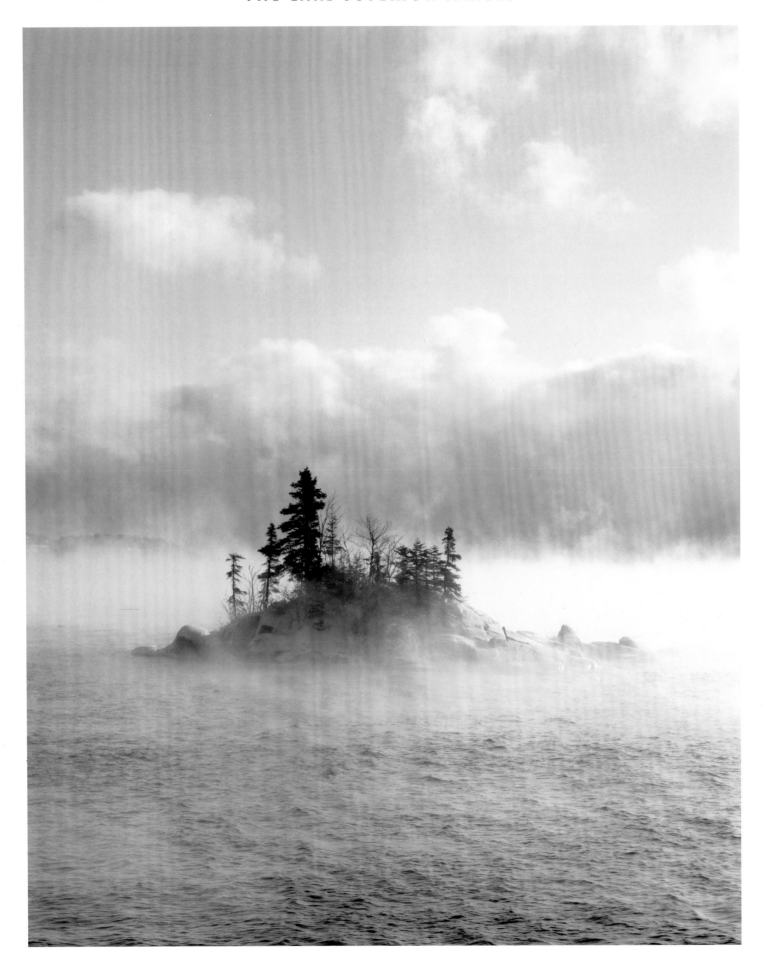

Plate 77

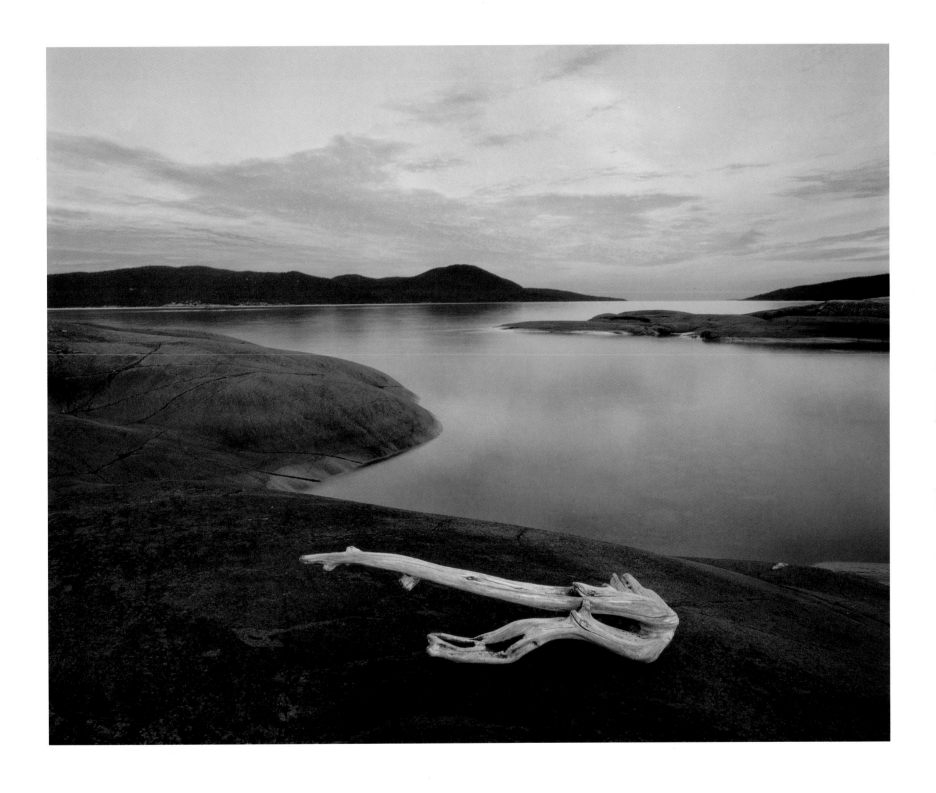

Plate 78

80, 88, 89, 93
79, 84, 86, 91
82
90, 92
83
85
81
87

PIC RIVER TO MICHIPICOTEN HARBOUR

Plate 79 Oiseau Bay, Pukaskwa National Park. August, 1990
Plate 80 Basaltic dike and granitic veins, south of White River, Pukaskwa National Park. July, 1991
Plate 81 Wood lilies and shrubby cinquefoil, near False Ganley Harbour. July, 1991
Plate 82 North of One Lake Island, Pukaskwa National Park. July, 1991
Plate 83 Cascade Falls, Pukaskwa National Park. July, 1991
Plate 84 Migmatite, Oiseau Bay, Pukaskwa National Park. July, 1991
Plate 85 Richardson Harbour, Pukaskwa National Park. July, 1991
Plate 86 Migmatite, Oiseau Bay, Pukaskwa National Park. July, 1991
Plate 87 Lichens, west of False Dog Harbour. July, 1991
Plate 88 Small island at mouth of Pulpwood Harbour, Pukaskwa National Park. June, 1991
Plate 89 Islands in Pulpwood Harbour, Pukaskwa National Park. June, 1991
Plate 90 Simons Harbour, Pukaskwa National Park. July, 1991
Plate 91 Migmatite, south of Oiseau Bay, Pukaskwa National Park. July, 1991
Plate 92 Hideaway Lake and English Fishery Harbour, Pukaskwa National Park. July, 1991
Plate 93 Near mouth of Pic River. June, 1991

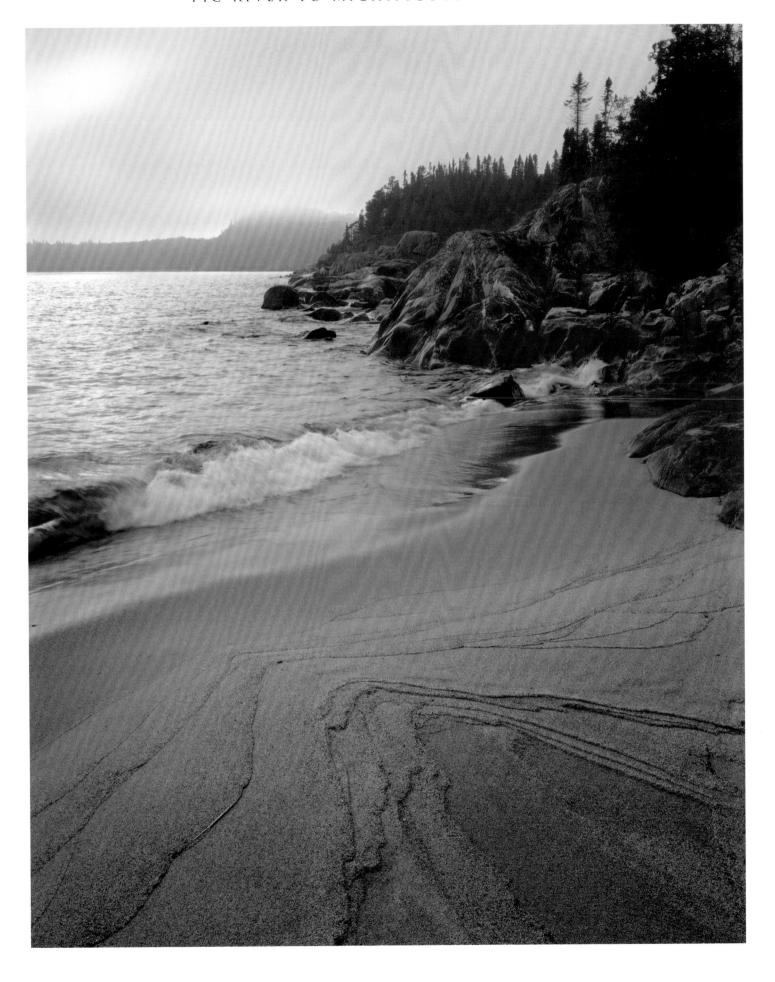

Plate 79

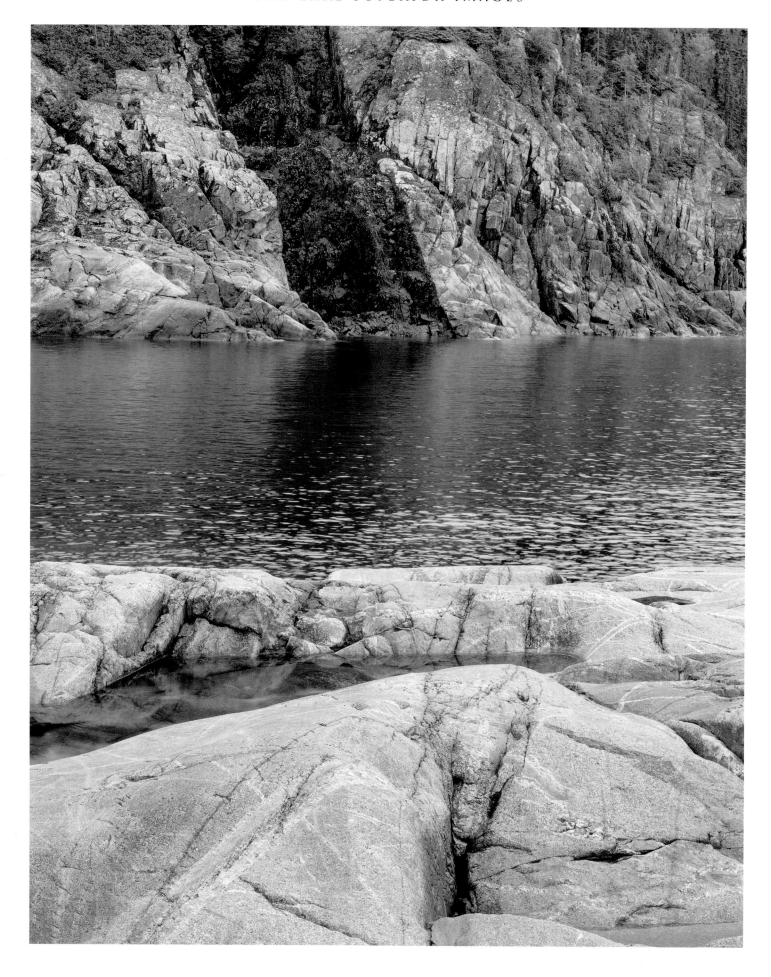

Plate 80

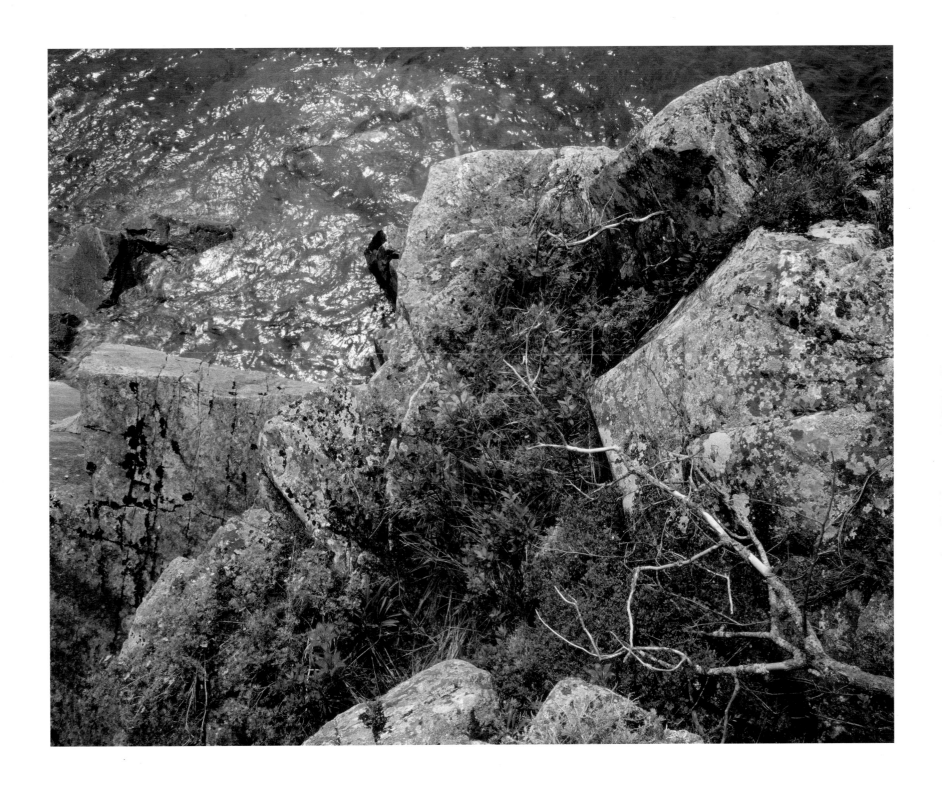

Plate 81

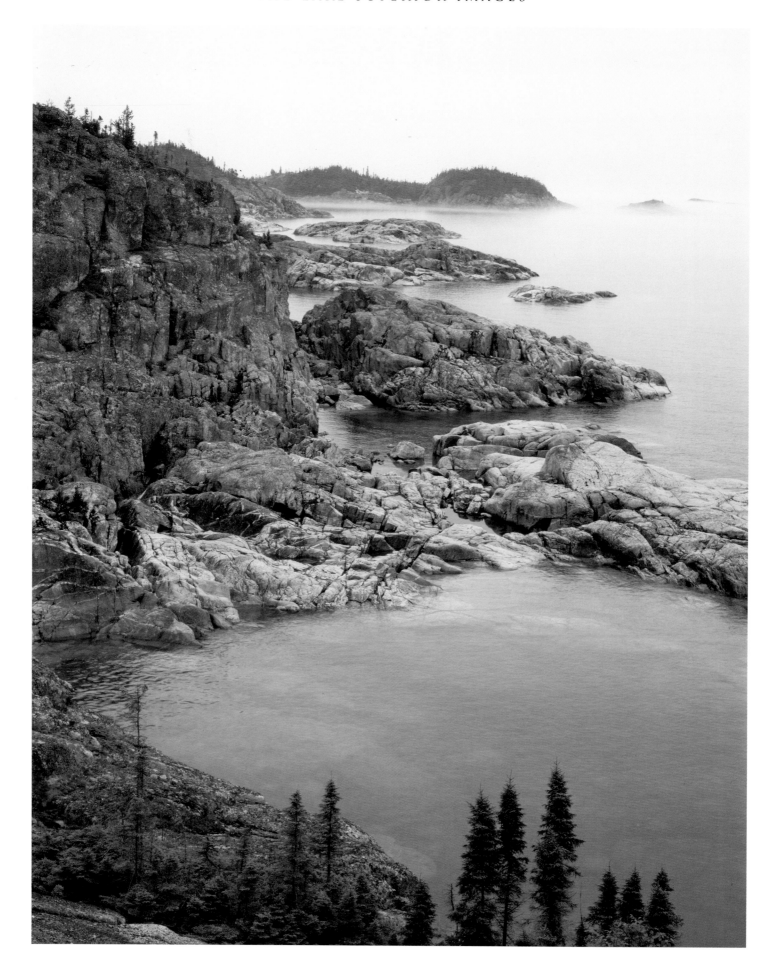

Plate 82

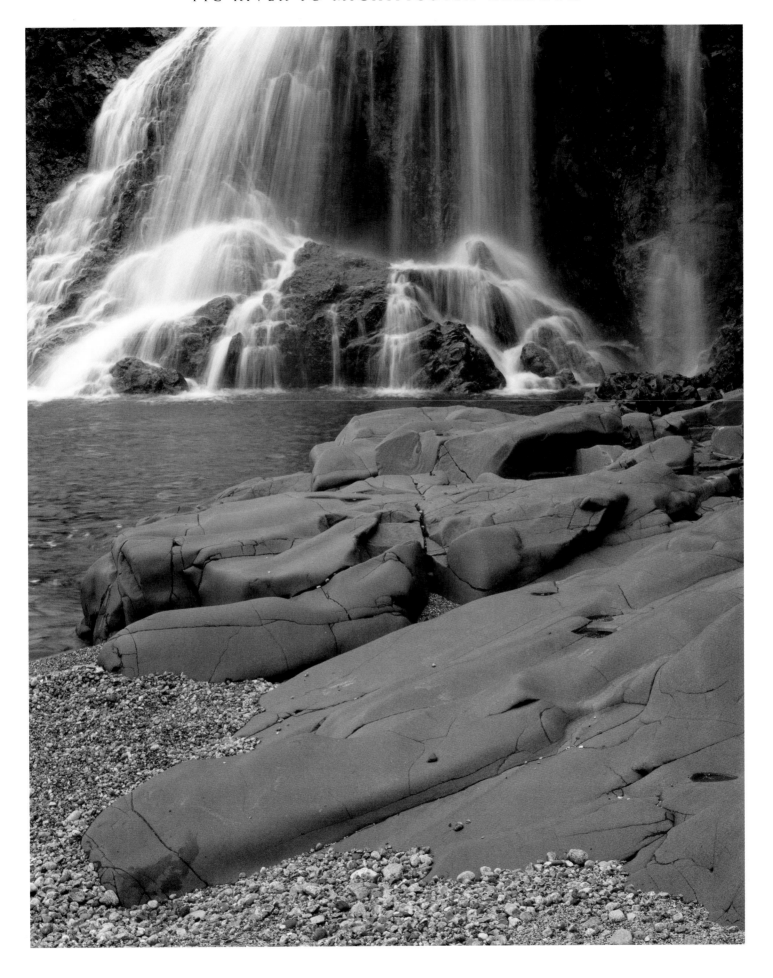

Plate 83

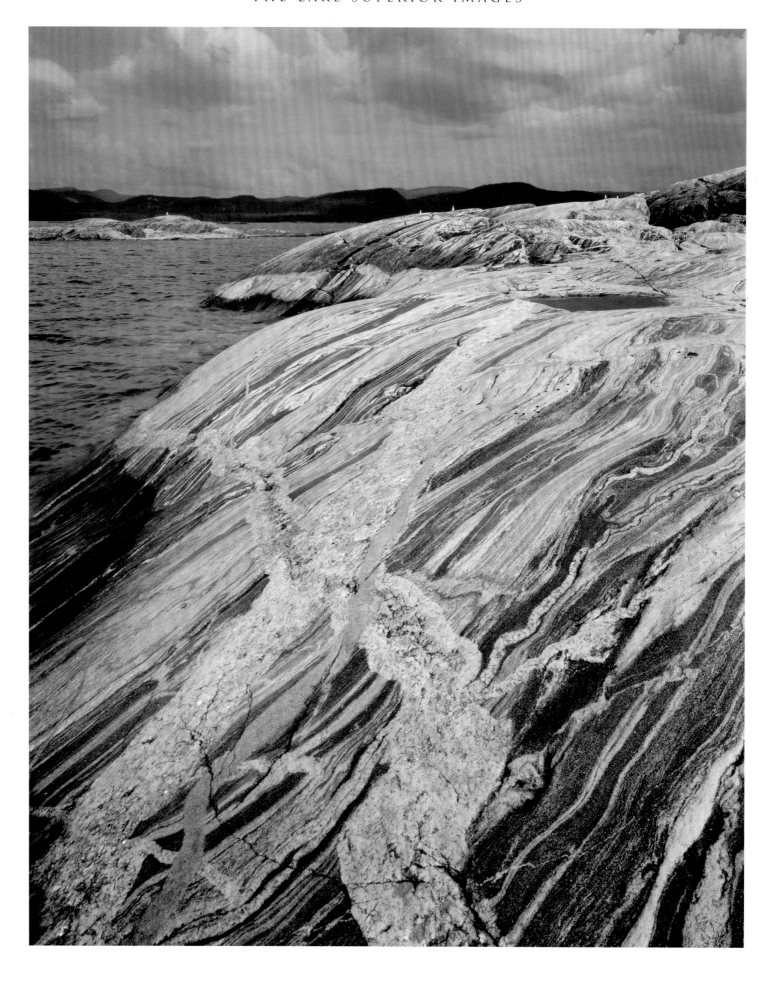

Plate 84

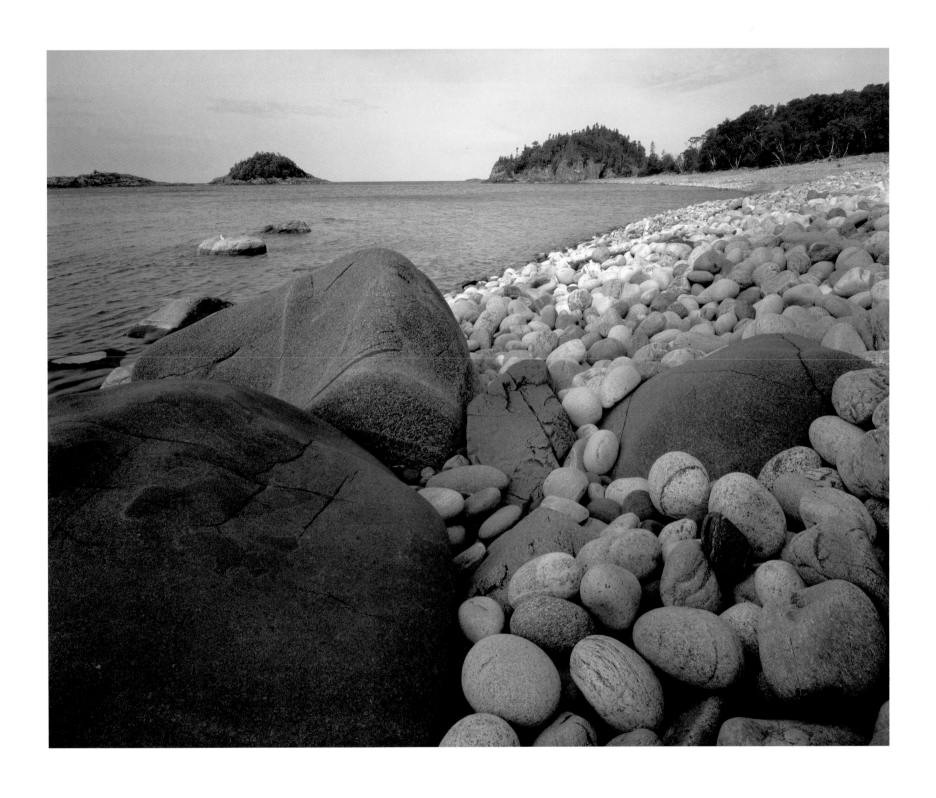

Plate 85

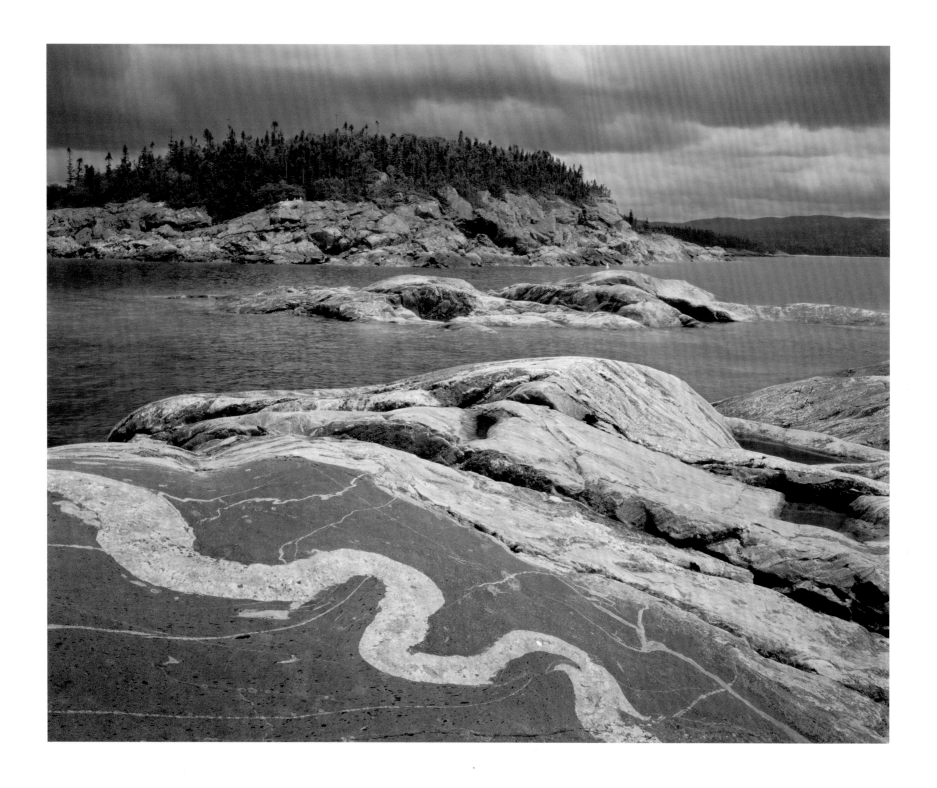

Plate 86

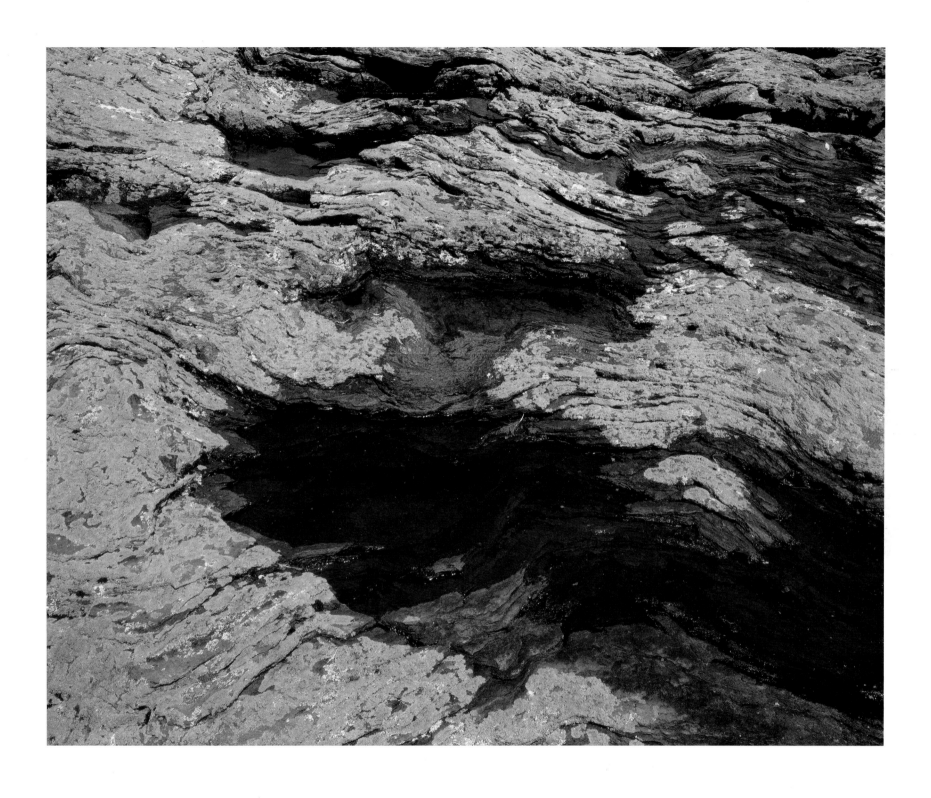

Plate 87

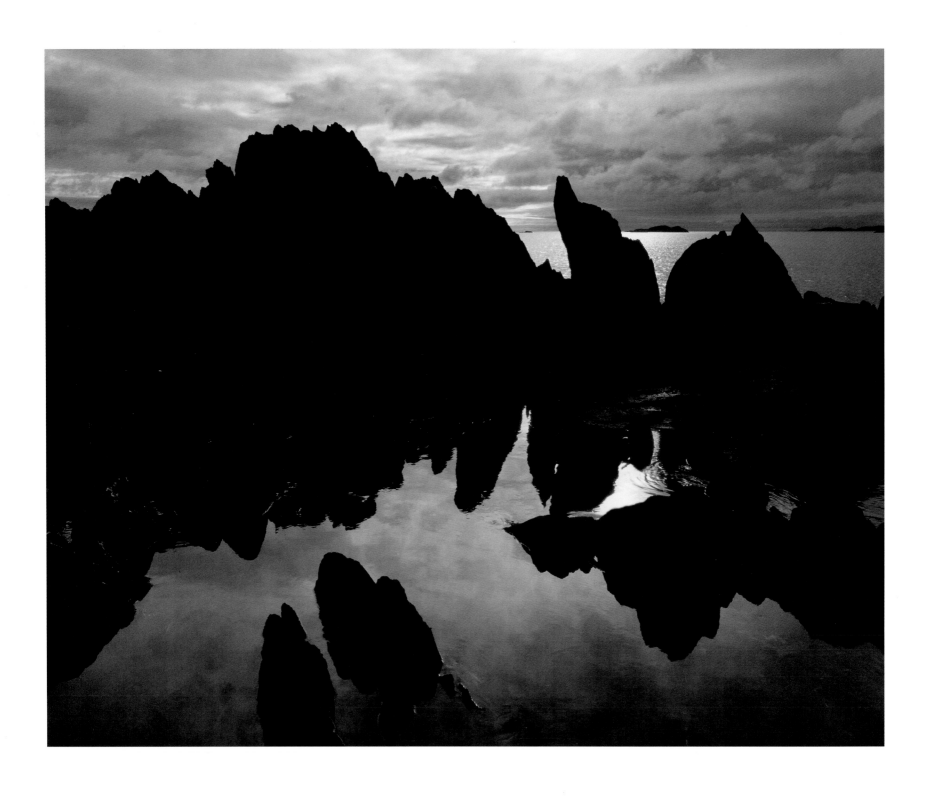

Plate 88

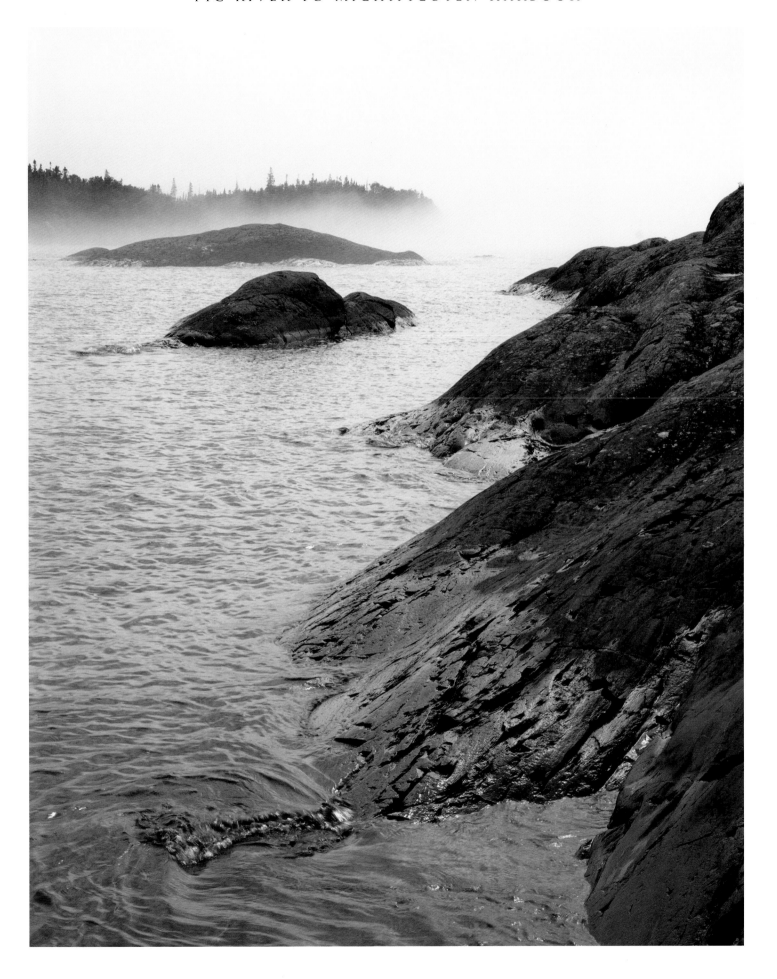

Plate 89

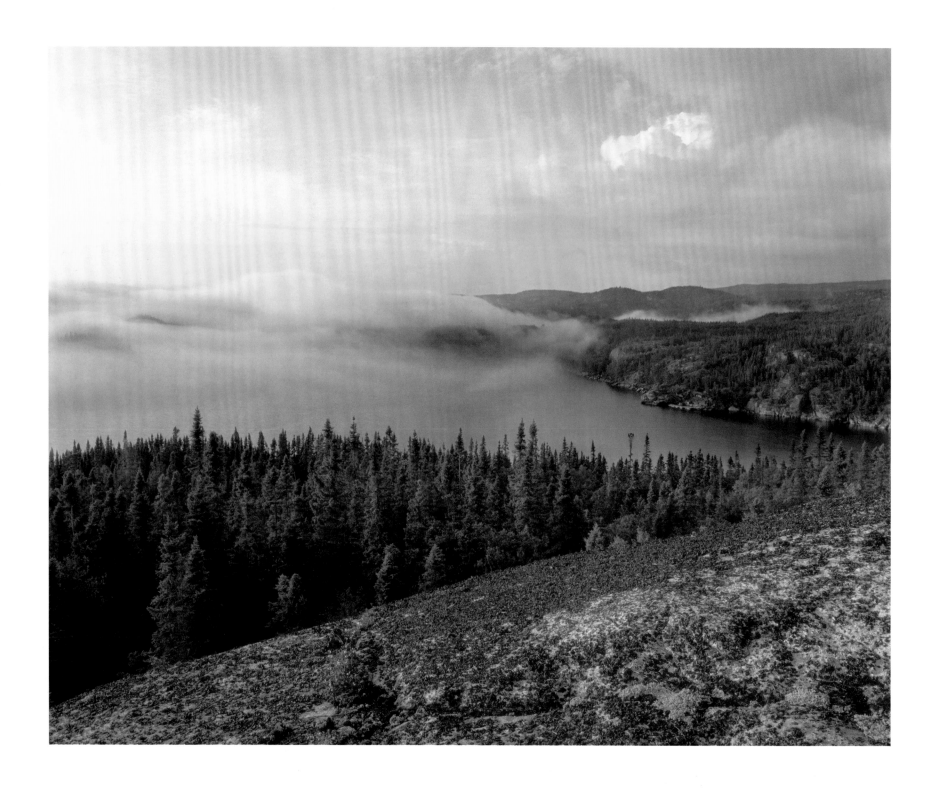

Plate 90

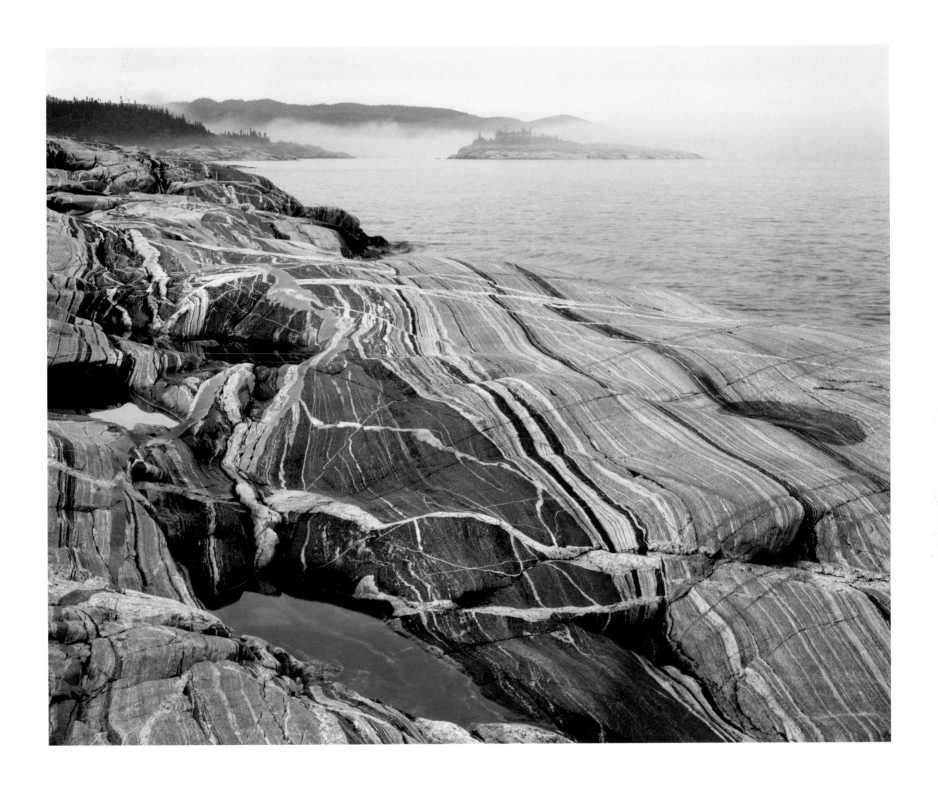

Plate 91

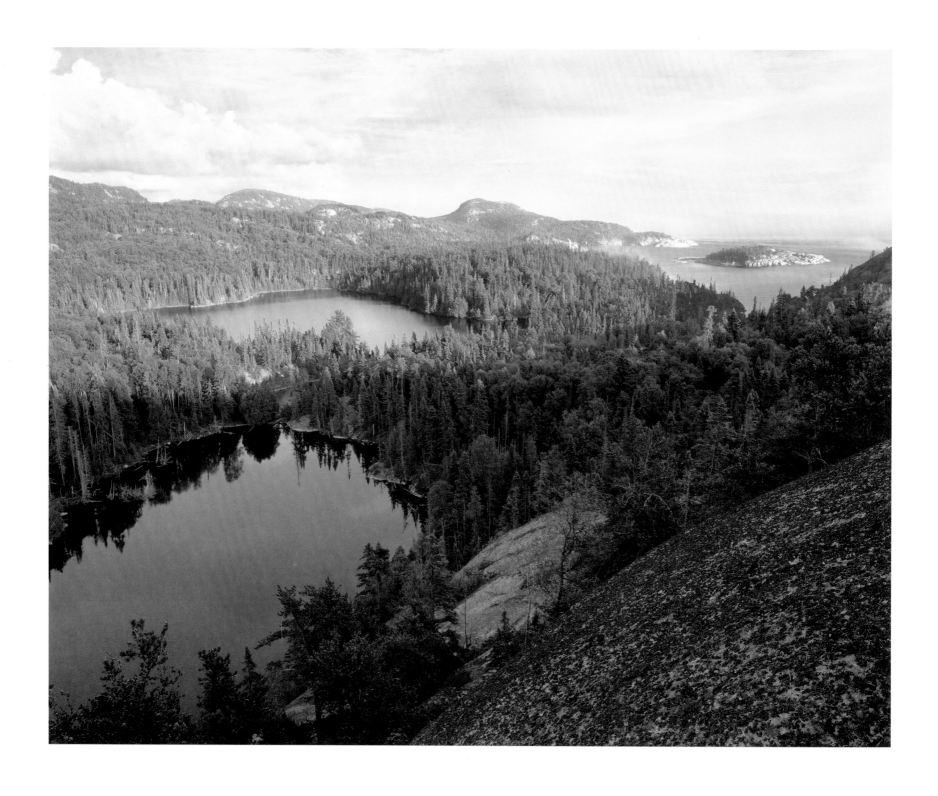

Plate 92

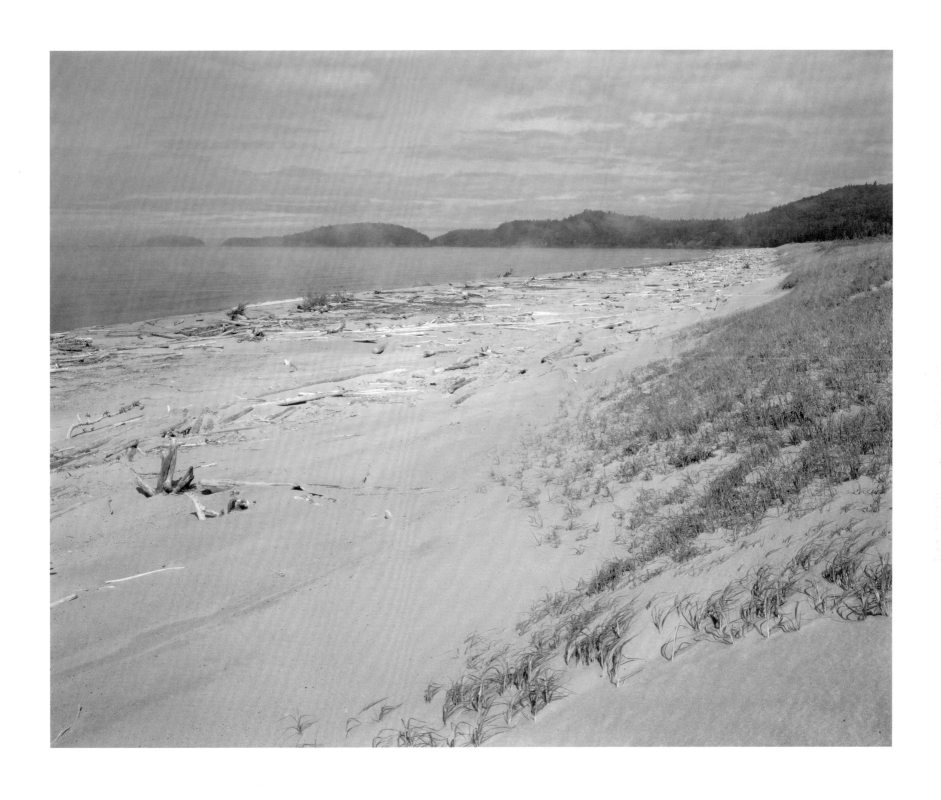

Plate 93

98, 102
94
95
99
105
100
96
108
97
103, 106
101
104
107

MICHIPICOTEN HARBOUR TO SAULT STE. MARIE

Plate 94 Devil's Chair (center island), Lake Superior Provincial Park. July, 1991
Plate 95 Devil's Warehouse Island, Lake Superior Provincial Park. July, 1991
Plate 96 Pictographs, Agawa Rock, Lake Superior Provincial Park. August, 1990
Plate 97 Granite and pegmatite veins, southeast of Speckled Trout Creek. July, 1991
Plate 98 Tugboat Channel, Lake Superior Provincial Park. August, 1990
Plate 99 Old Woman Bay, Lake Superior Provincial Park. July, 1991
Plate 100 Metamorphosed sedimentary rock, mouth of Baldhead River, Lake Superior Provincial Park. July, 1991
Plate 101 Batchawana Bay. December, 1985
Plate 102 Small, basalt islands northwest of Devil's Warehouse Island, Lake Superior Provincial Park. July, 1991
Plate 103 Alona Bay. July, 1991
Plate 104 Sandstone and boulders, northeast of North Gros Cap. July, 1991
Plate 105 Smoky Point. July, 1991
Plate 106 Theano Point (in distance). July, 1991
Plate 107 West of Pancake Point. December, 1985
Plate 108 Agawa Bay, Lake Superior Provincial Park. July, 1991

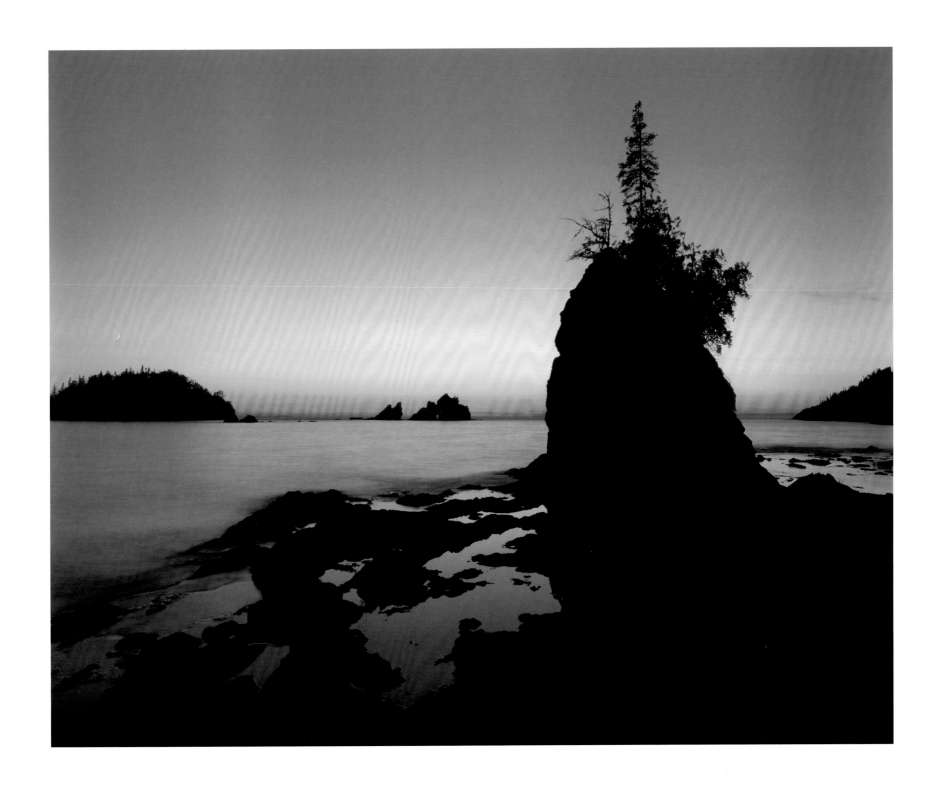

Plate 94

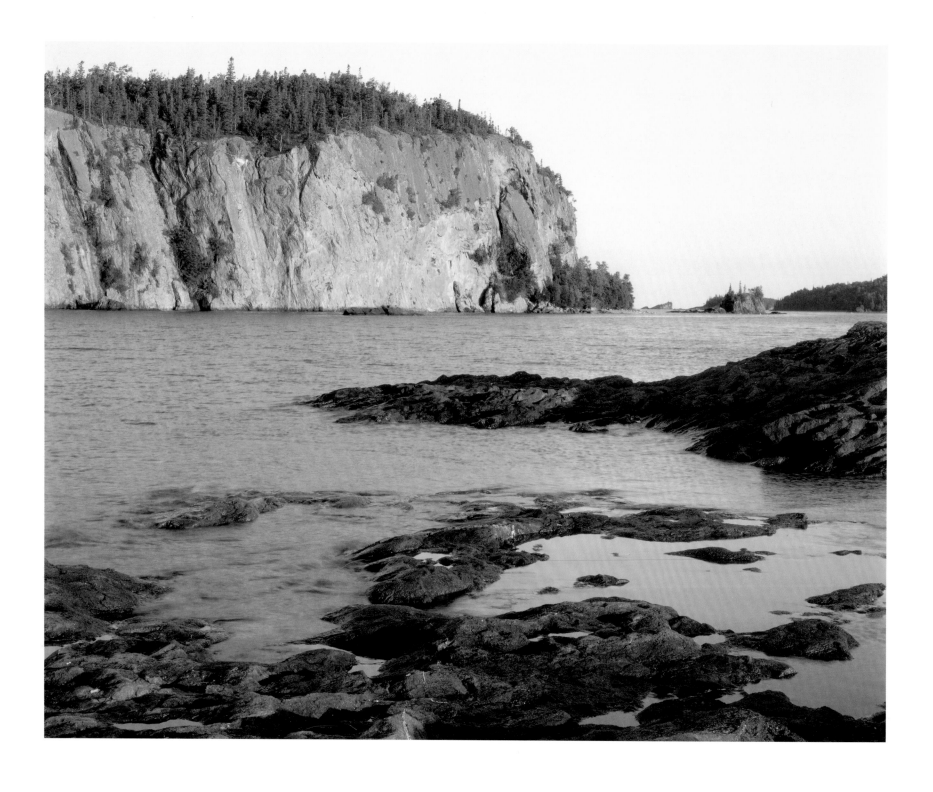

Plate 95

Plate 96

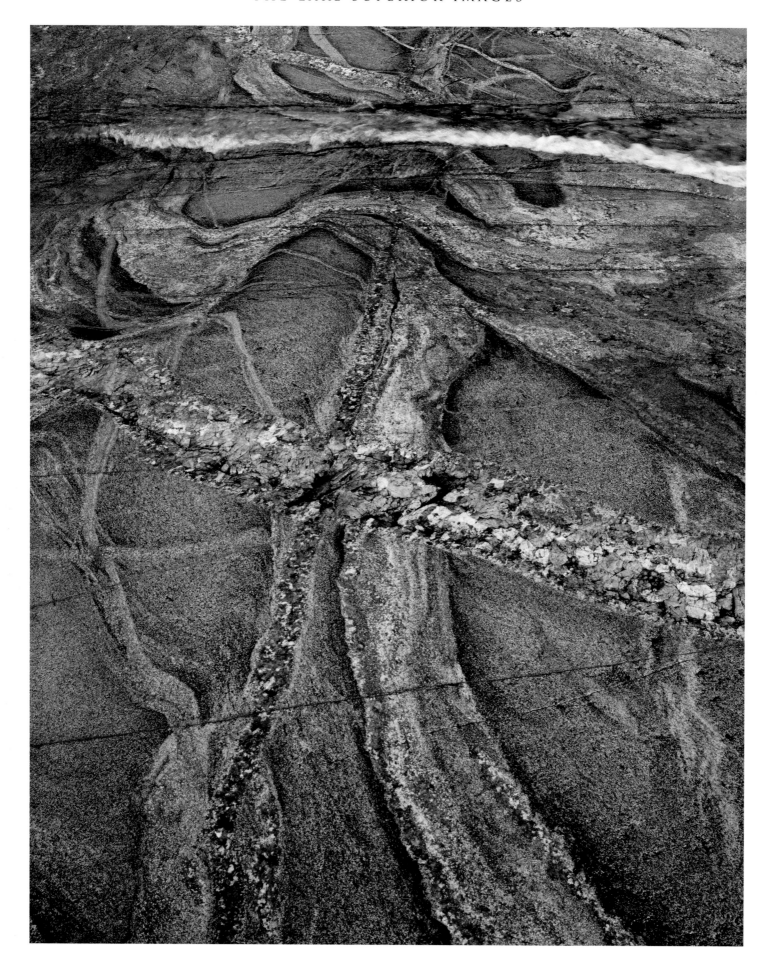

Plate 97

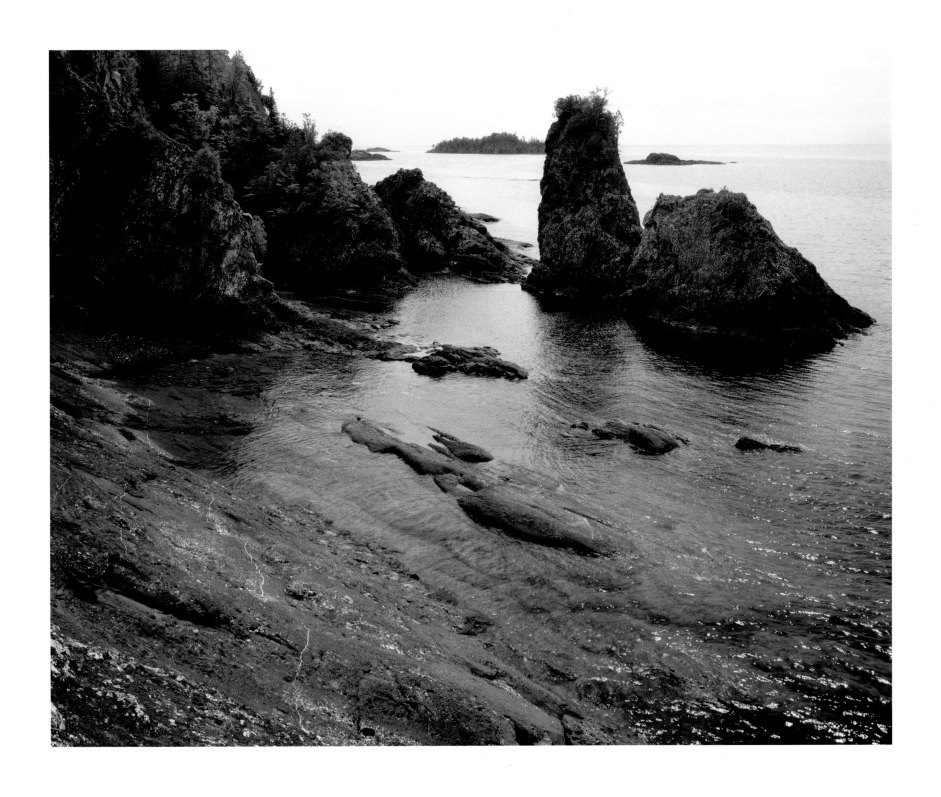

Plate 98

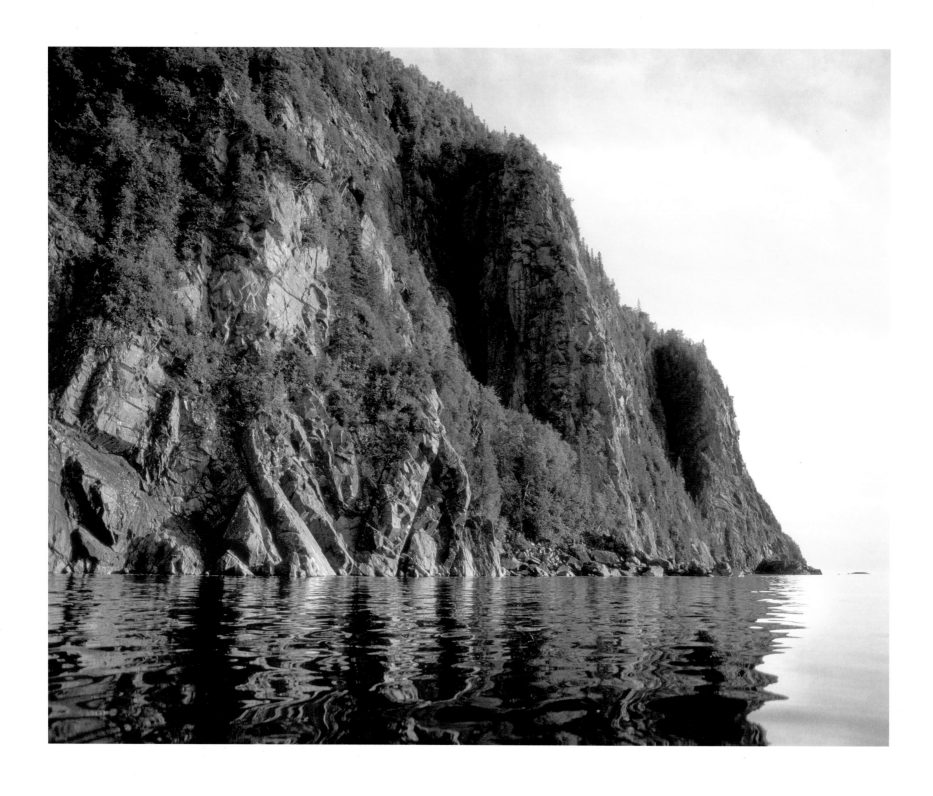

Plate 99

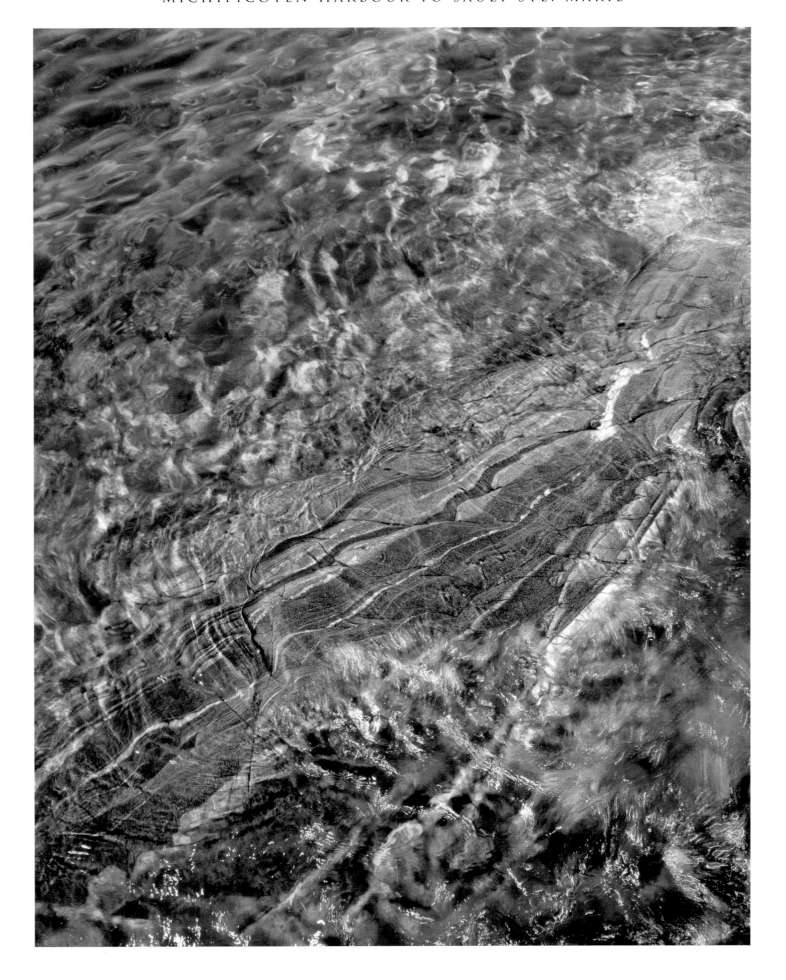

Plate 100

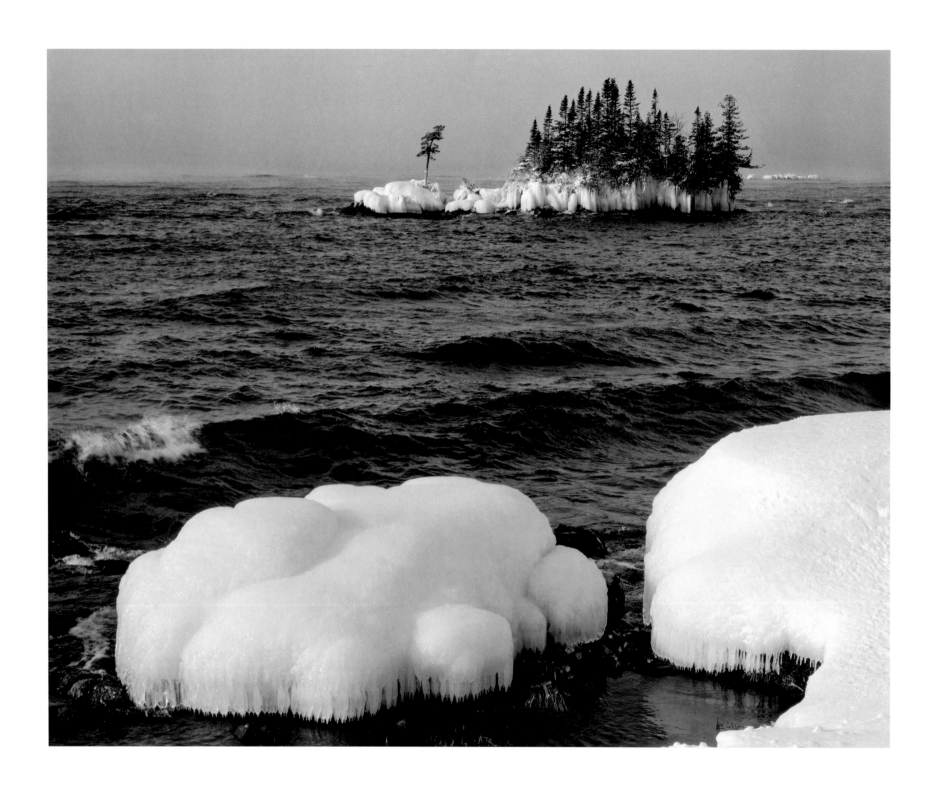

Plate 101

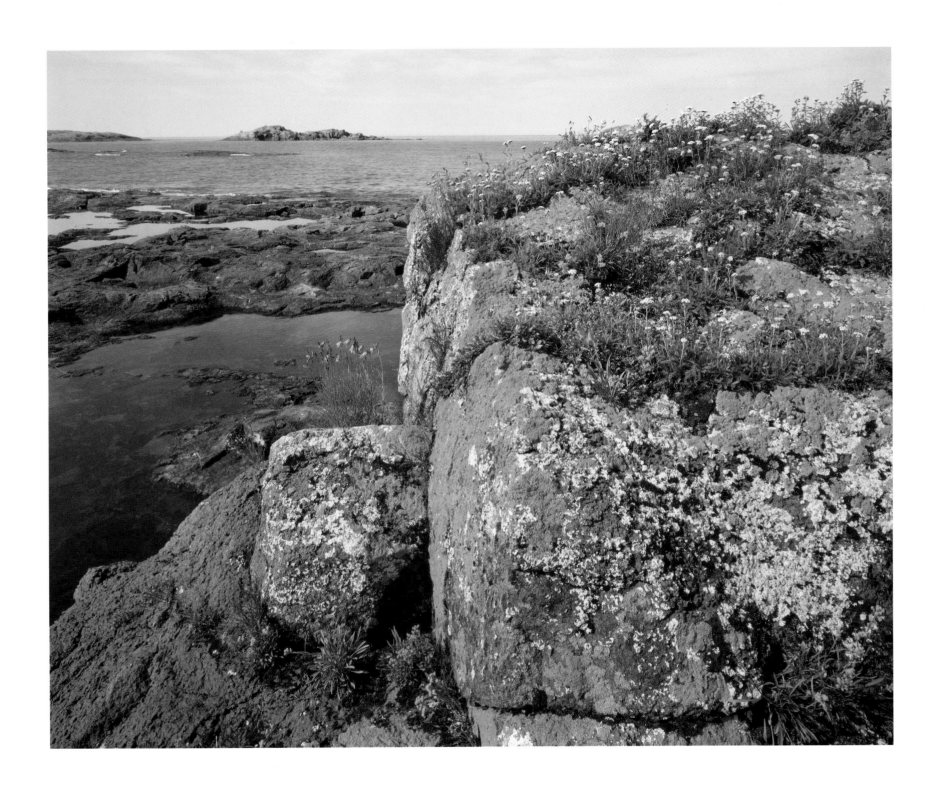

Plate 102

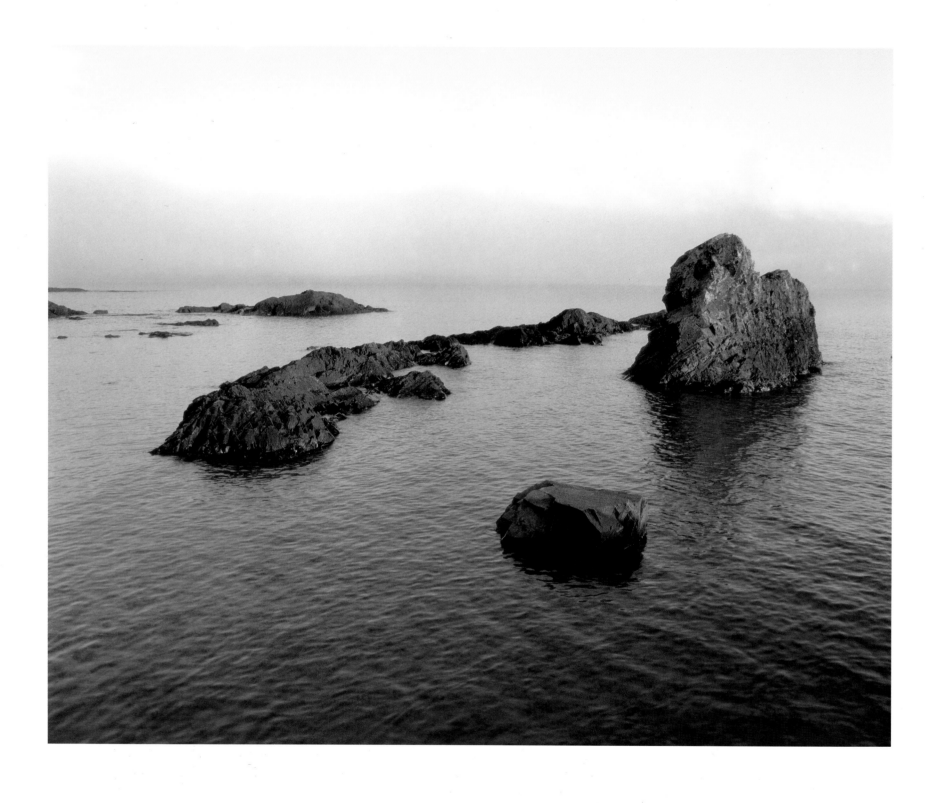

Plate 103

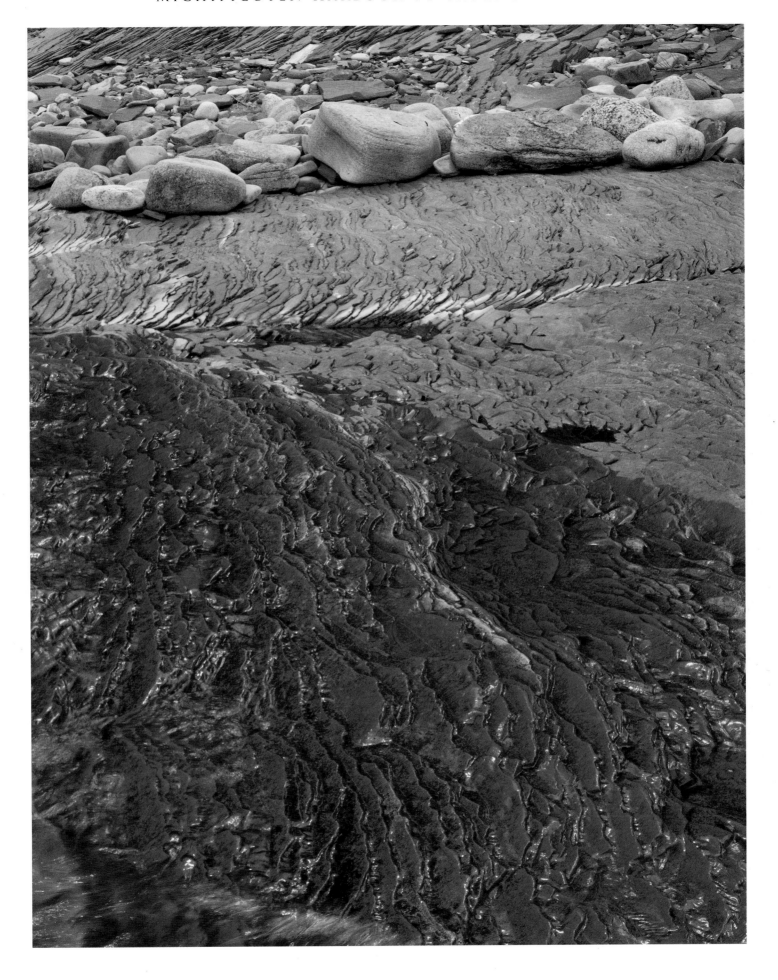

Plate 104

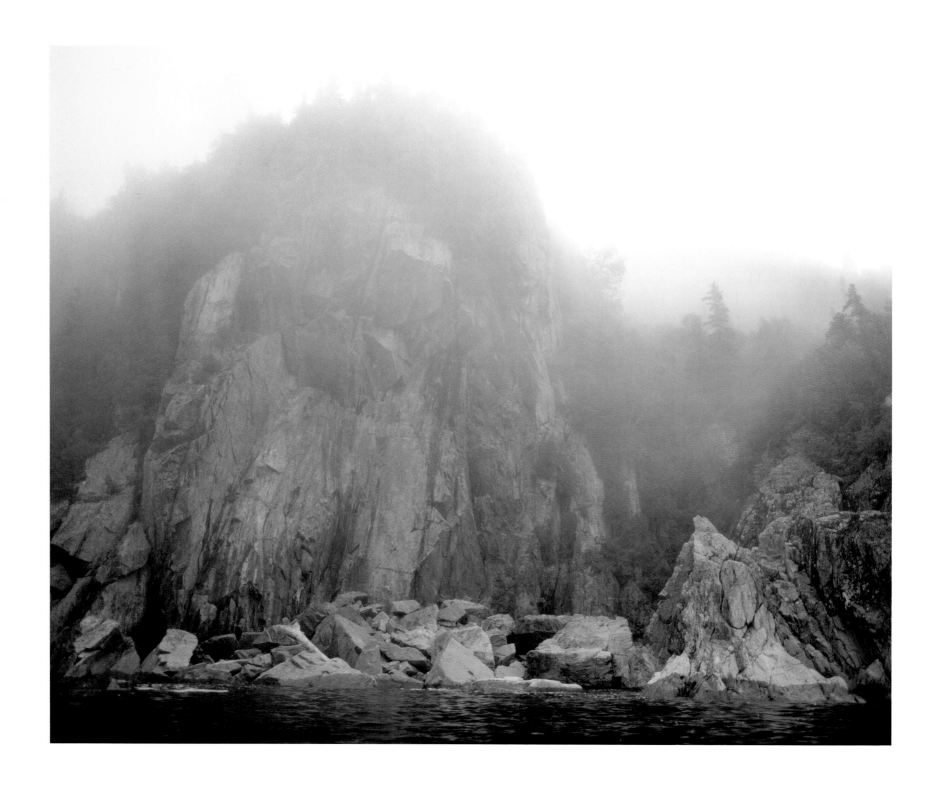

Plate 105

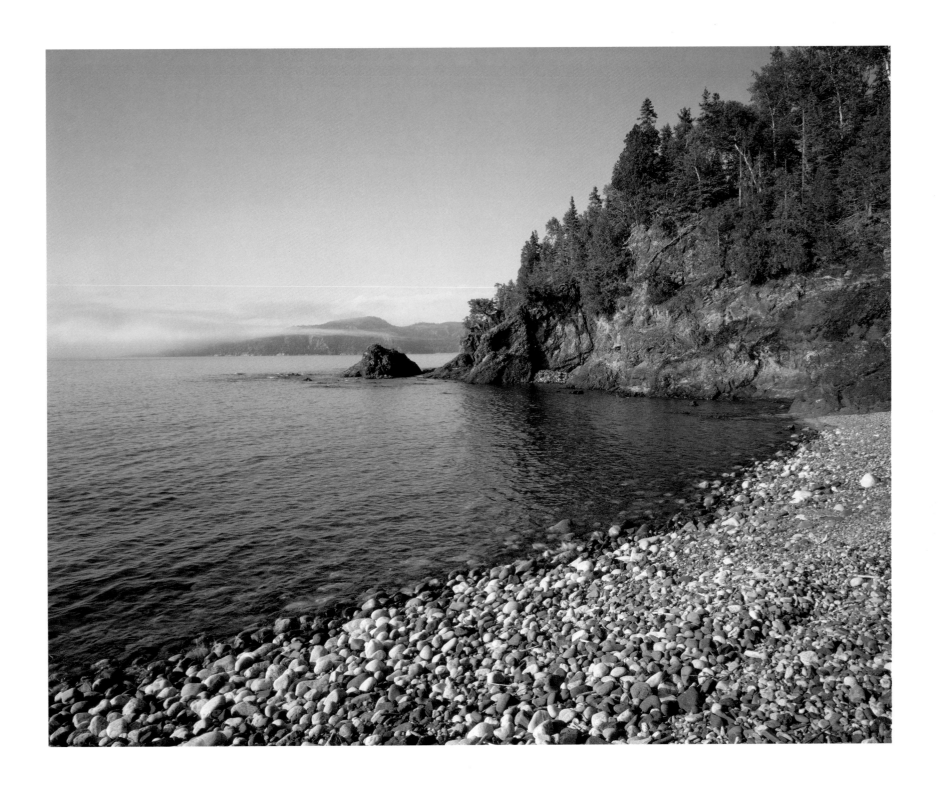

Plate 106

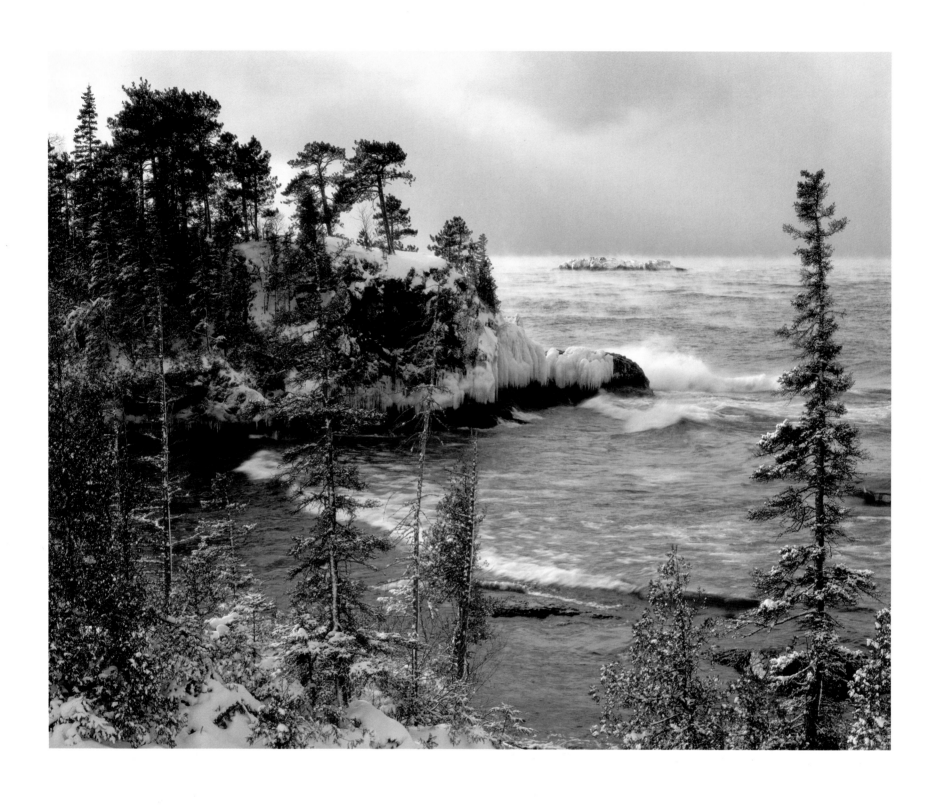

Plate 107

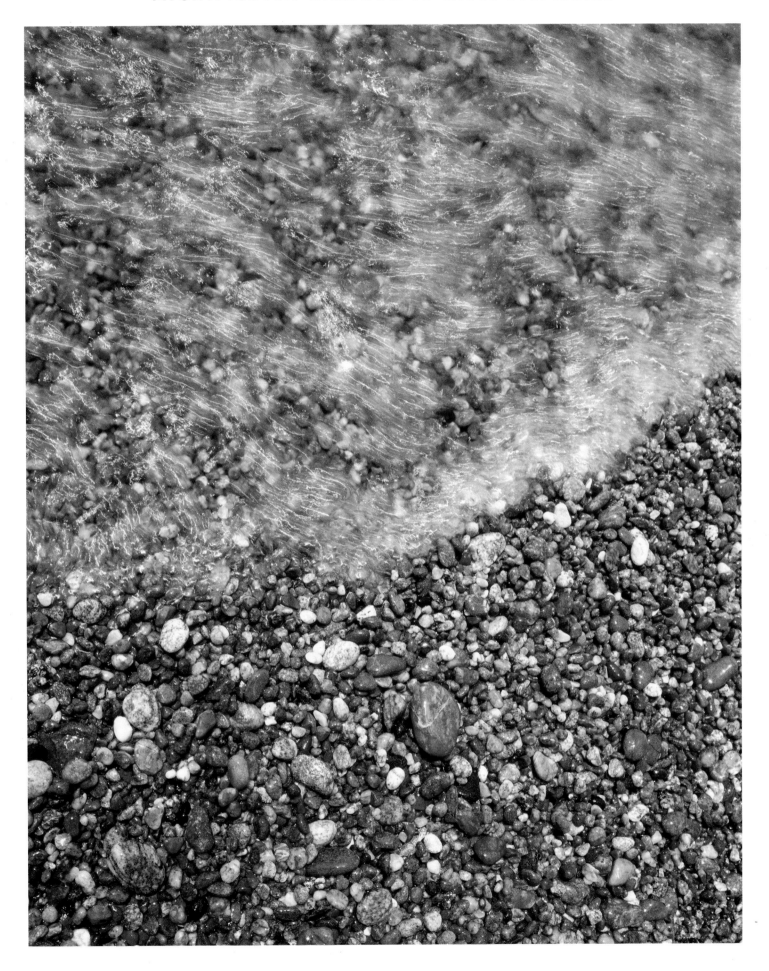

Plate 108

110
109, 122
117
114, 123
111, 112, 113
115, 116, 118
119, 120, 121

SAULT STE. MARIE TO GRAND ISLAND

Plate 109 Grand Sable Banks and Dunes, Pictured Rocks National Lakeshore. June, 1990
Plate 110 Great blue heron tracks. July, 1991
Plate 111 Ripple marks in sandstone near Mosquito River, Pictured Rocks National Lakeshore. September, 1989
Plate 112 Mud cracks in sandstone, Pictured Rocks National Lakeshore. September, 1989
Plate 113 Ice shards and leaf. December, 1985
Plate 114 Grand Portal Point, Pictured Rocks National Lakeshore. July, 1991
Plate 115 Sandstone cliff, Pictured Rocks National Lakeshore. July, 1991
Plate 116 Sandstone near Miners Beach, Pictured Rocks National Lakeshore. June, 1990
Plate 117 Twelve Mile Beach, Pictured Rocks National Lakeshore. June, 1990
Plate 118 Sandstone cliff, Pictured Rocks National Lakeshore. July, 1991
Plate 119 Azurite mineral seep, Pictured Rocks National Lakeshore. September, 1989
Plate 120 Sandstone cliff, Pictured Rocks National Lakeshore. July, 1991
Plate 121 Sandstone cliff, Pictured Rocks National Lakeshore. July, 1991
Plate 122 Coyote tracks, Grand Sable Dunes, Pictured Rocks National Lakeshore. June, 1990
Plate 123 Chapel Beach, Pictured Rocks National Lakeshore. September, 1989

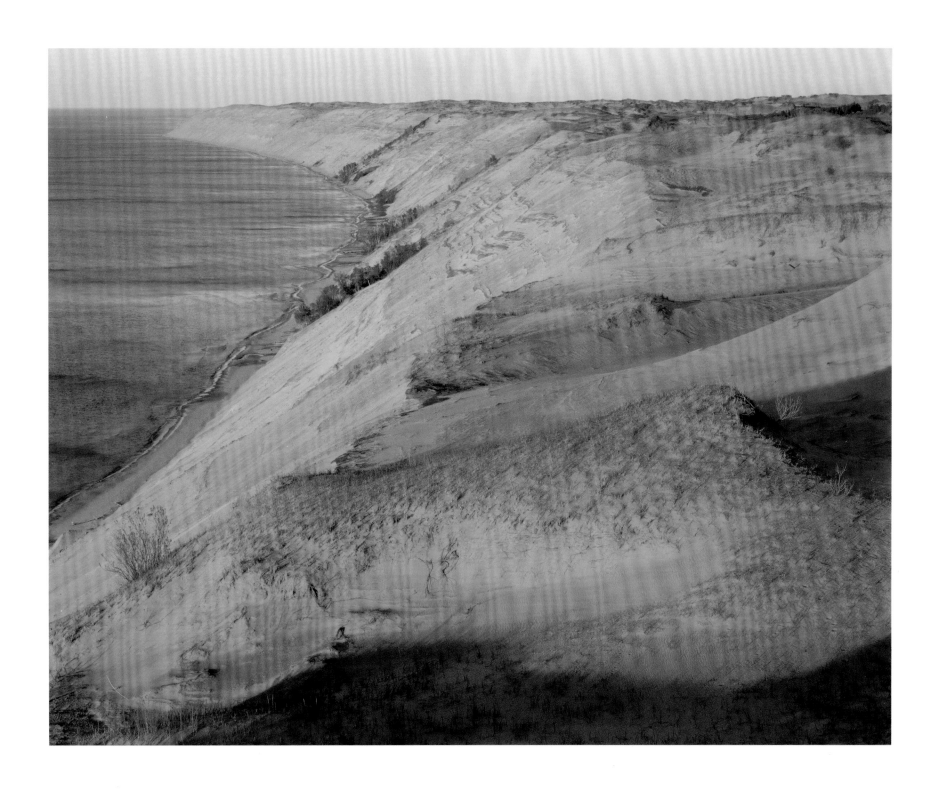

Plate 109

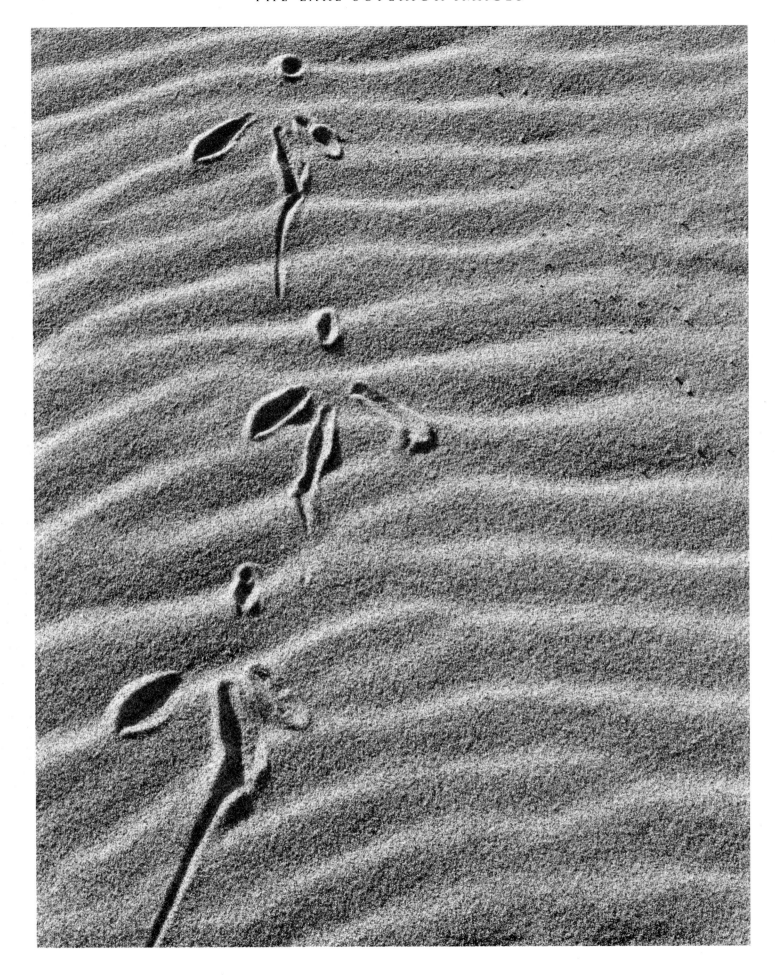

Plate 110

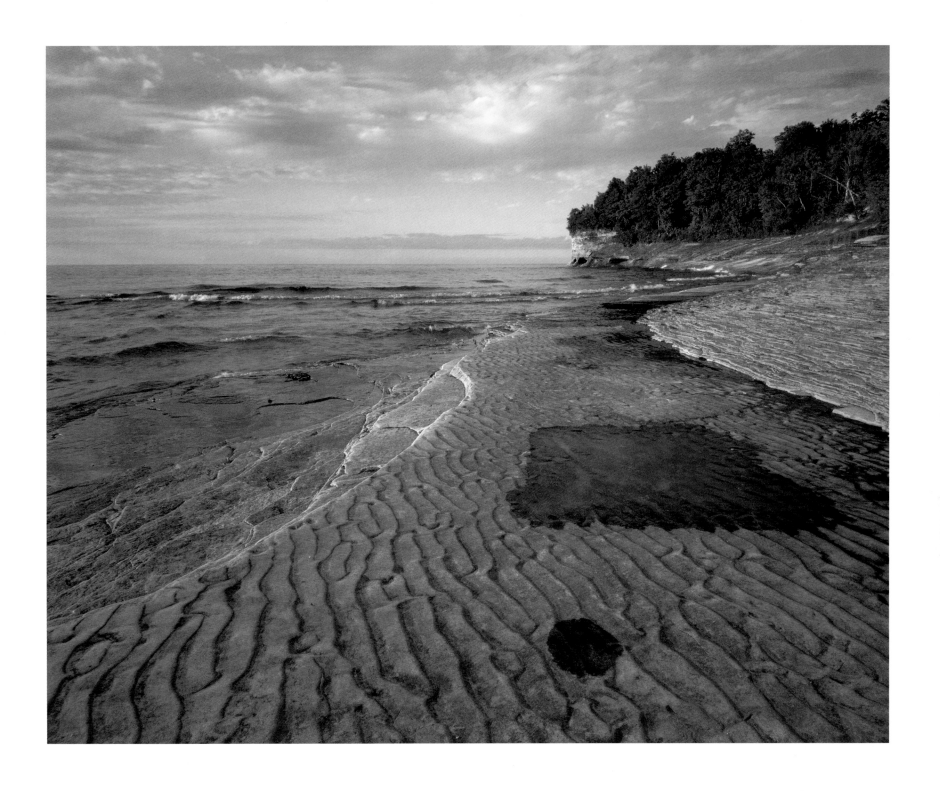

Plate 111

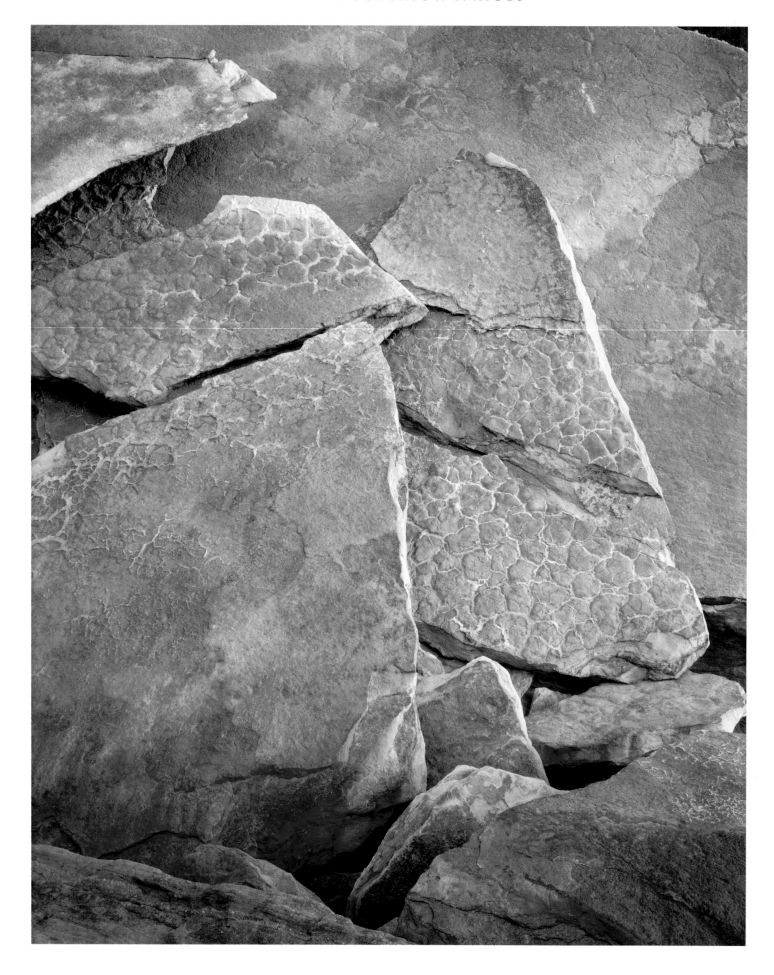

Plate 112

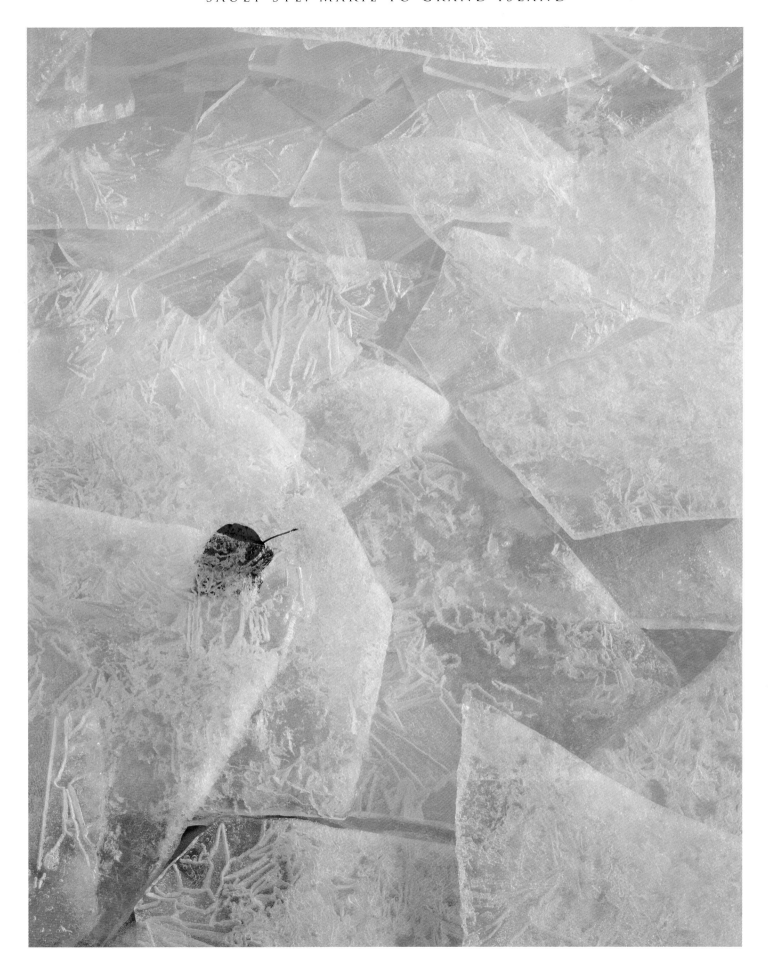

Plate 113

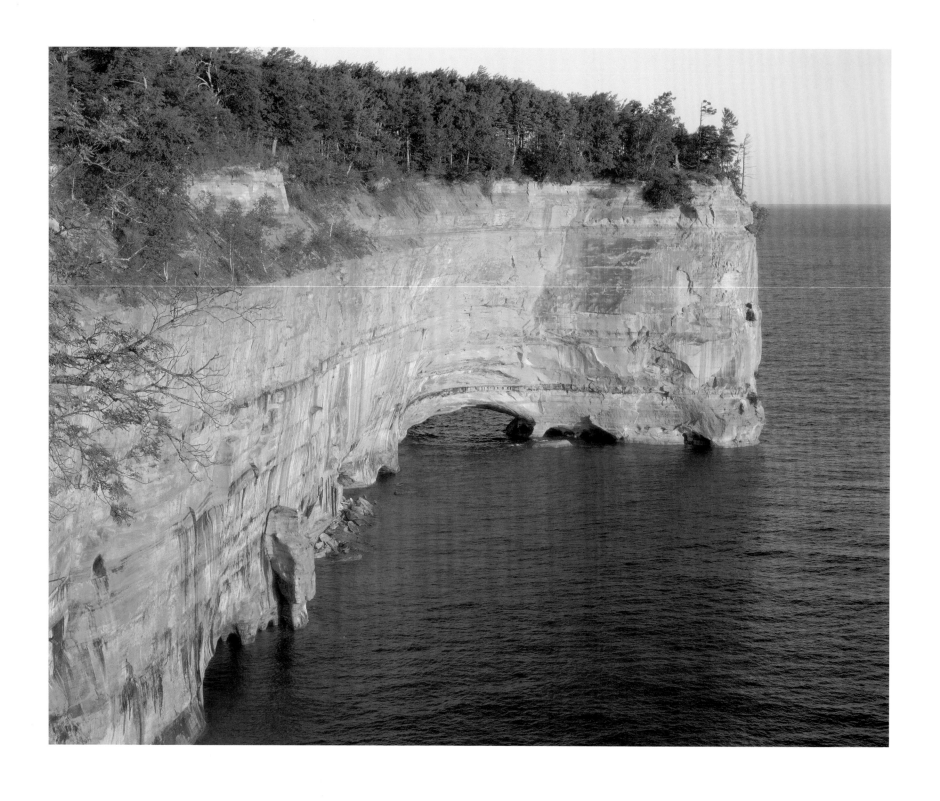

Plate 114

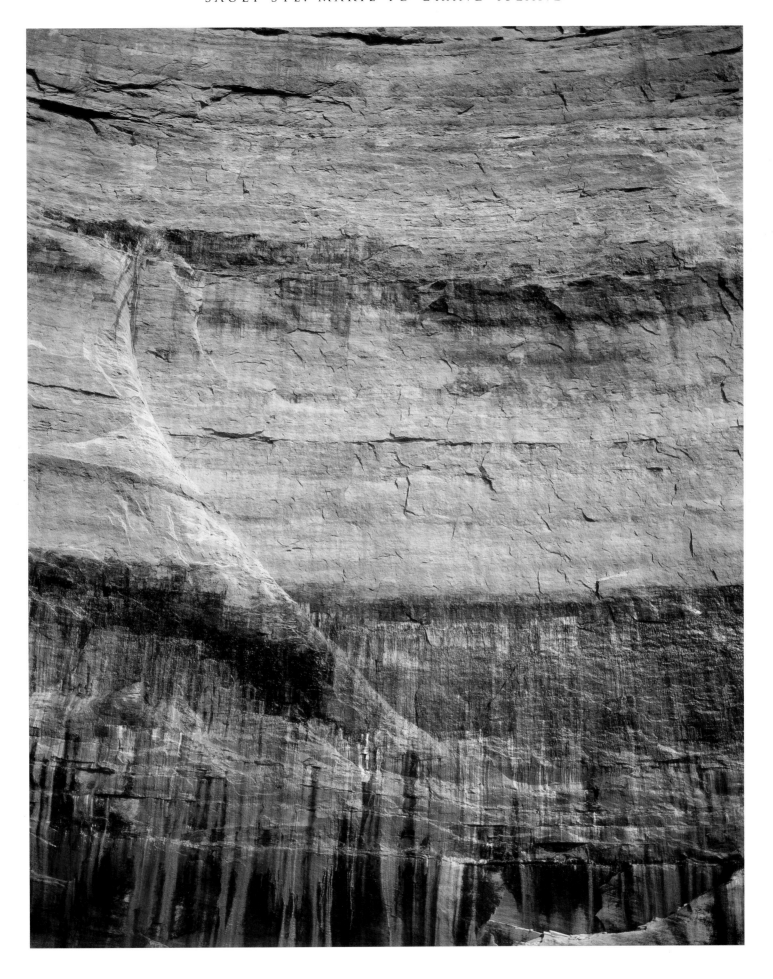

Plate 115

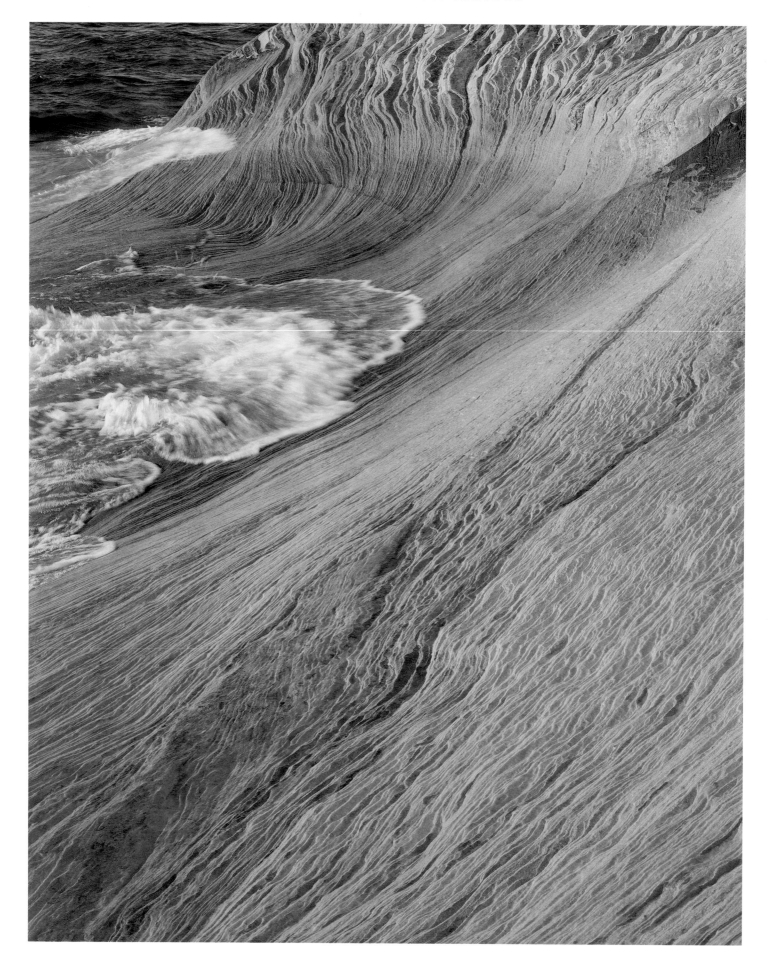

Plate 116

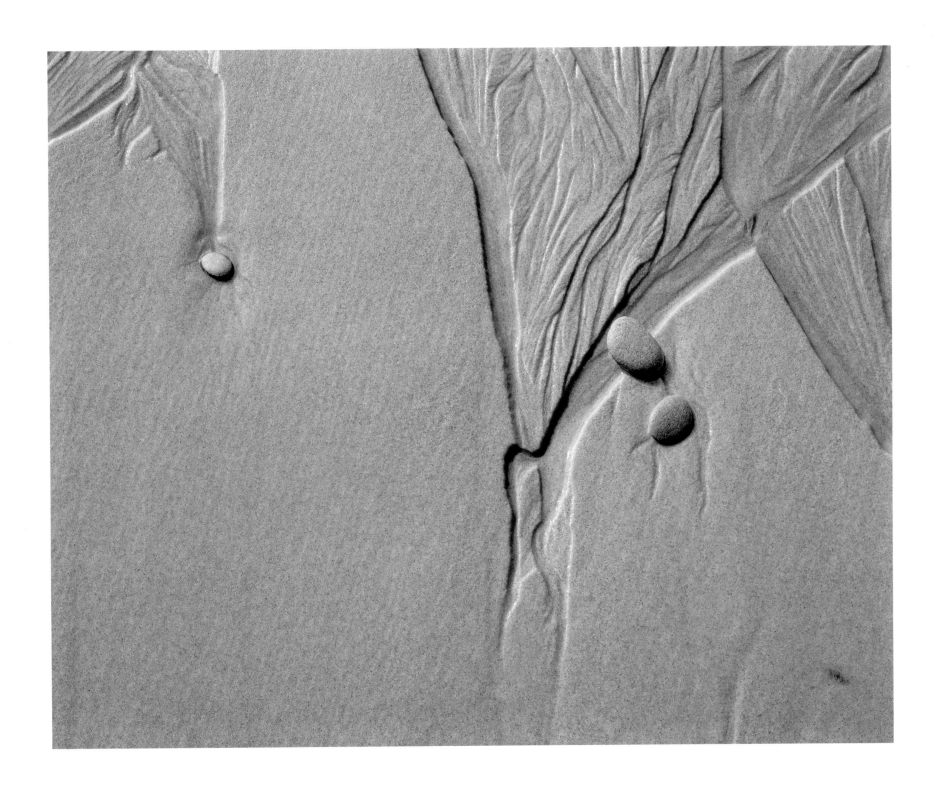

Plate 117

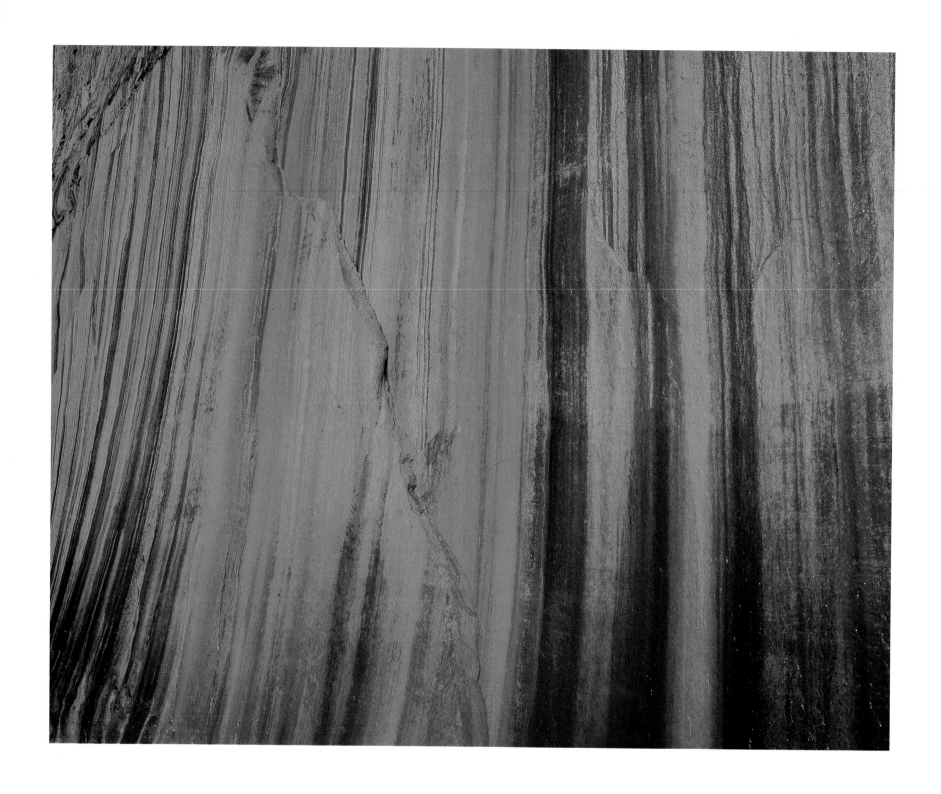

Plate 118

Plate 119

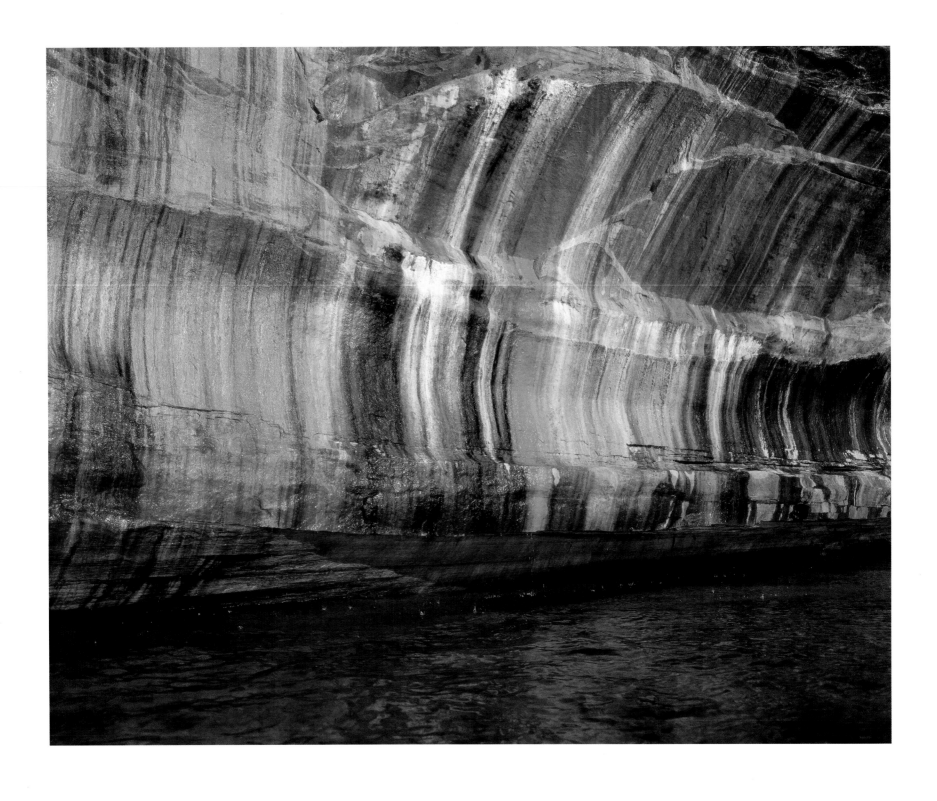

Plate 120

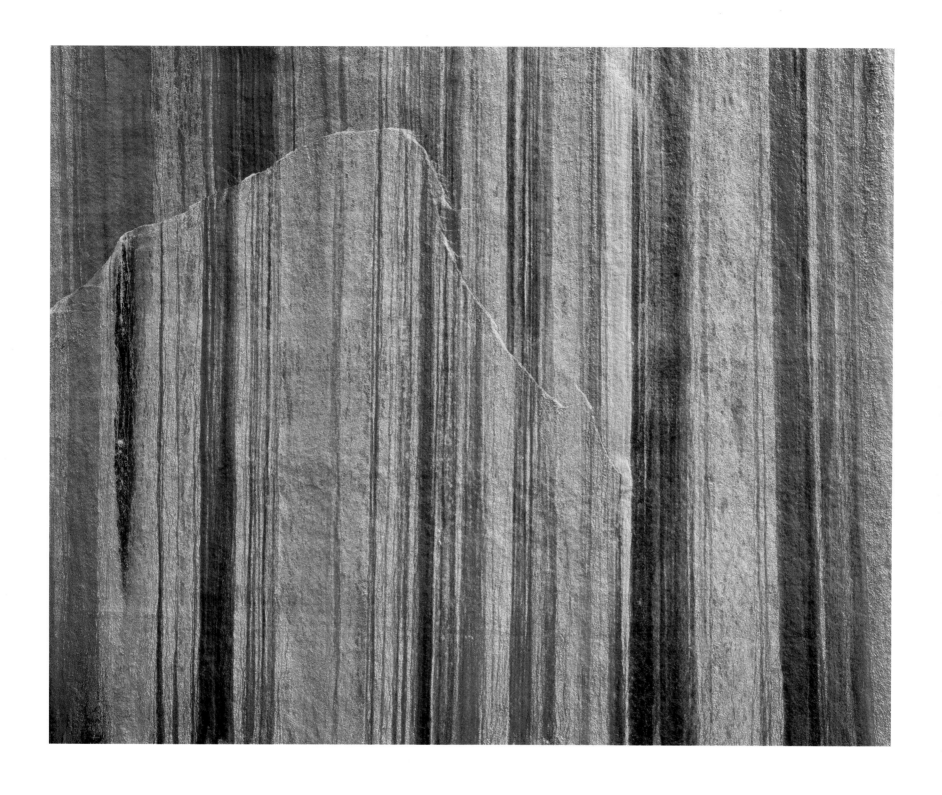

Plate 121

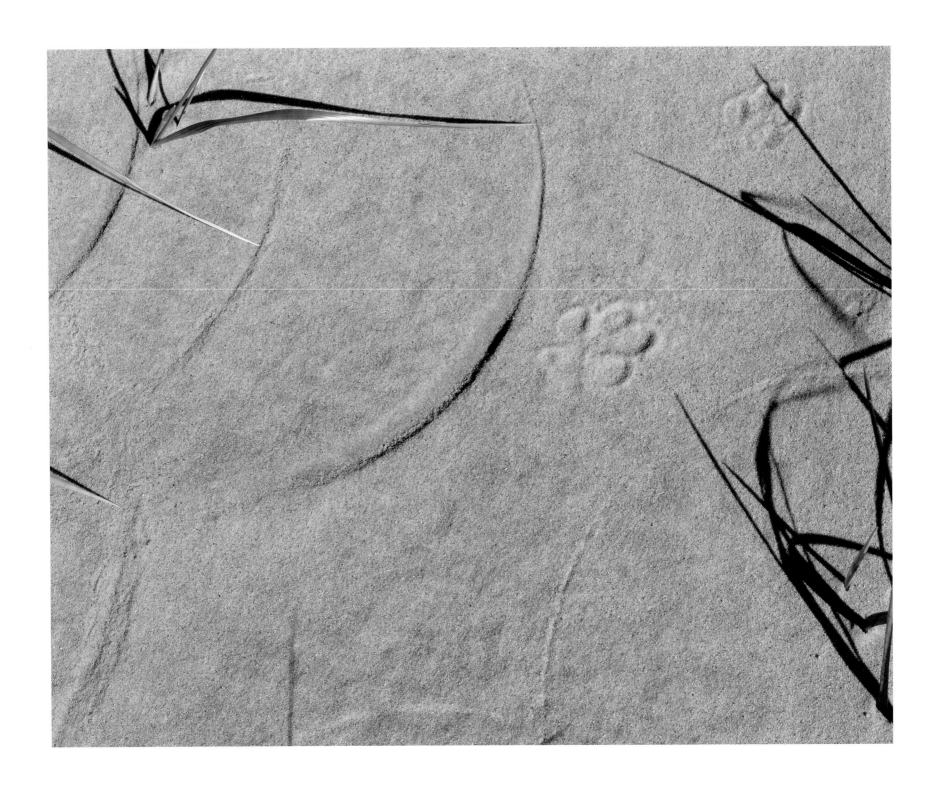

Plate 122

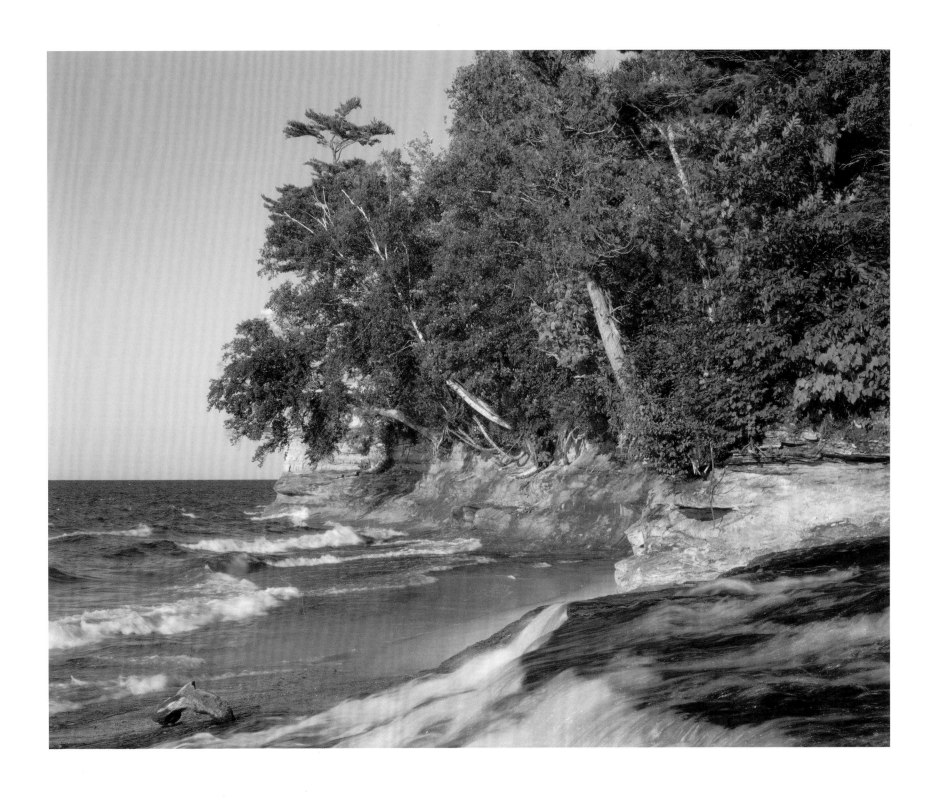

Plate 123

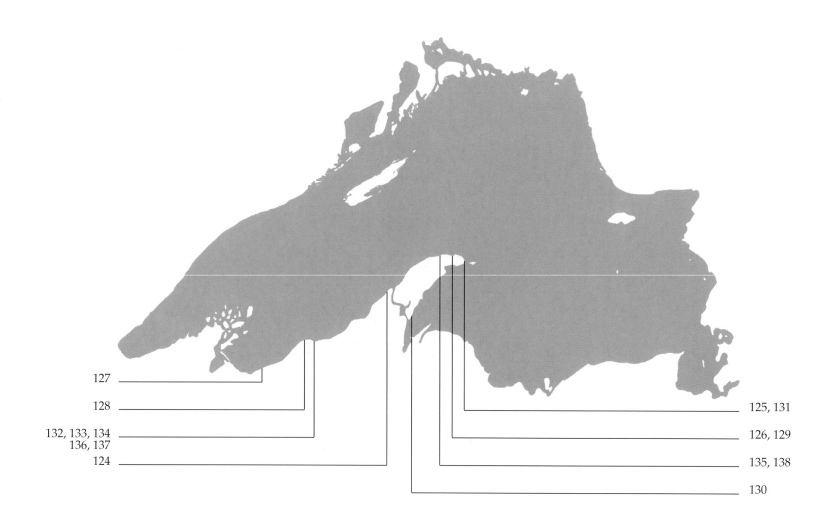

127
128
132, 133, 134
136, 137
124
125, 131
126, 129
135, 138
130

Grand Island To Little Girls Point

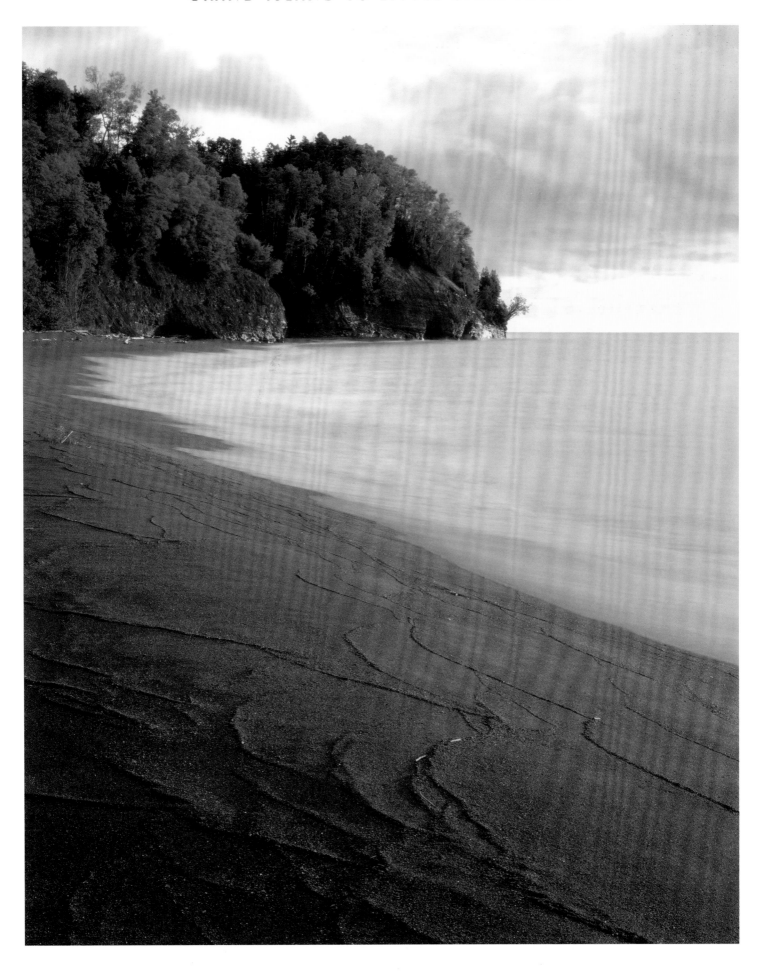

Plate 124

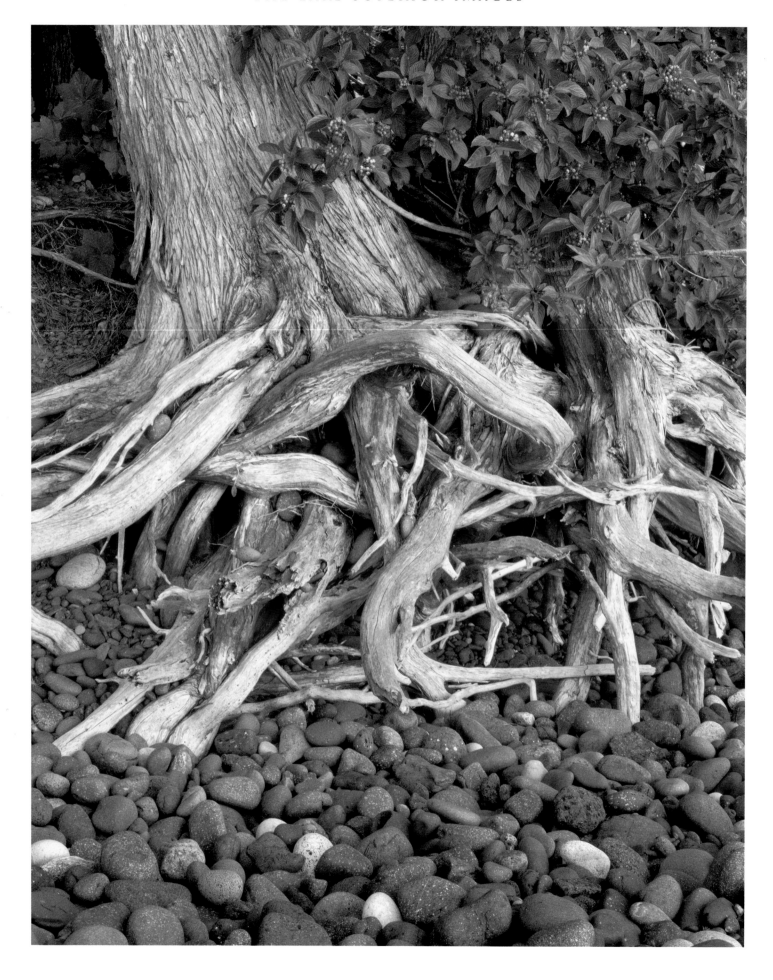

Plate 125

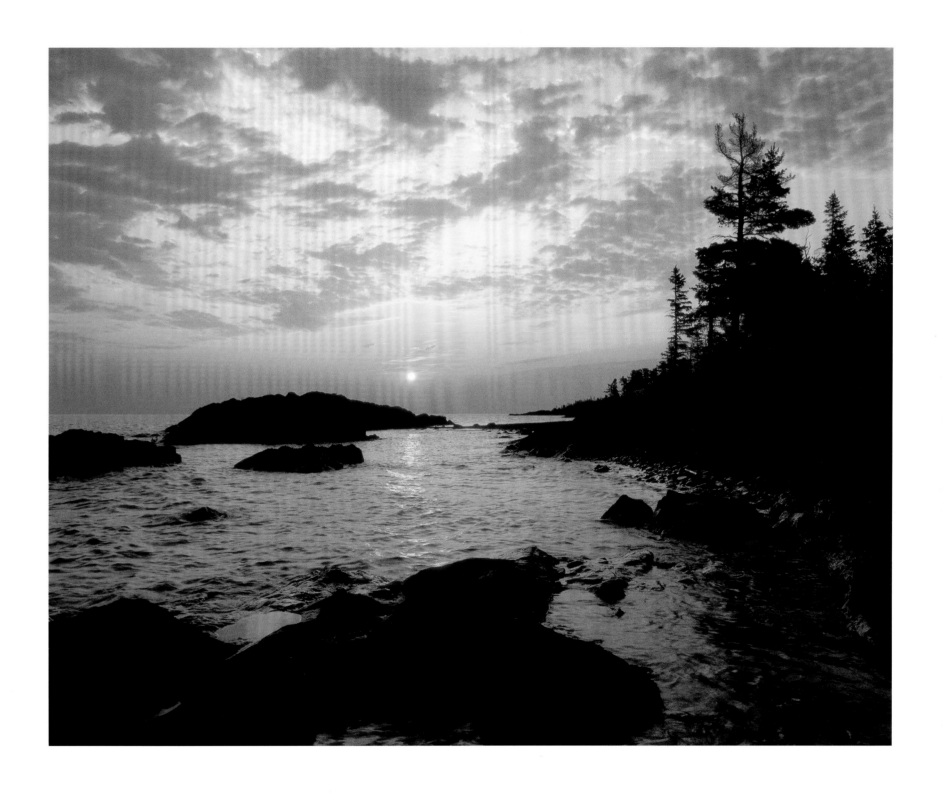

Plate 126

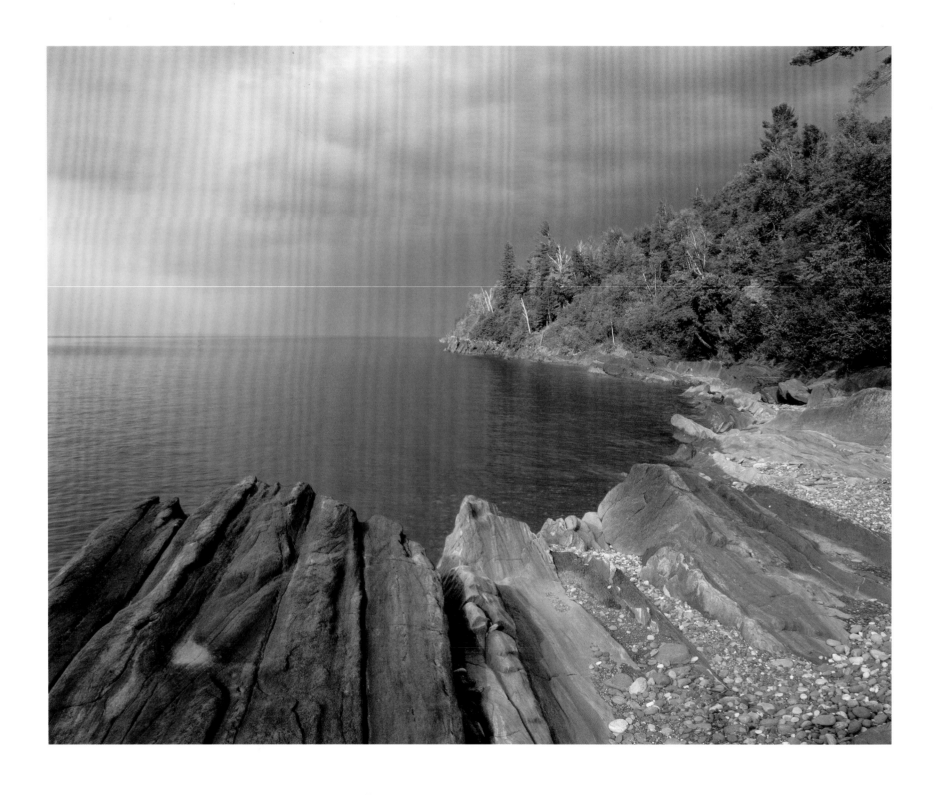

Plate 127

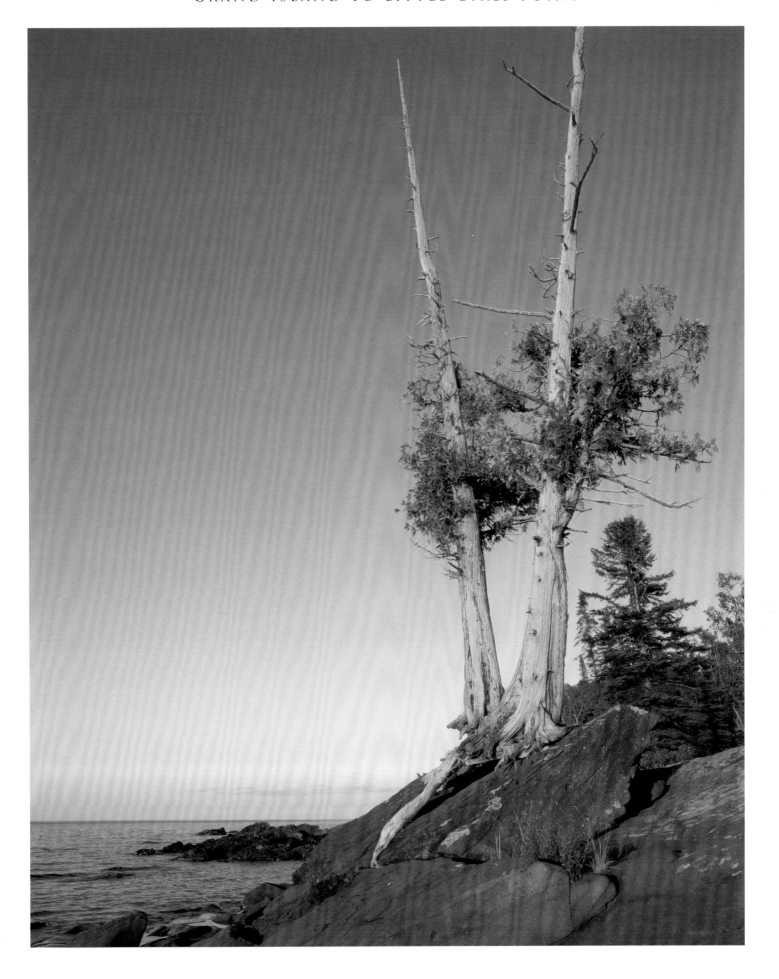

Plate 128

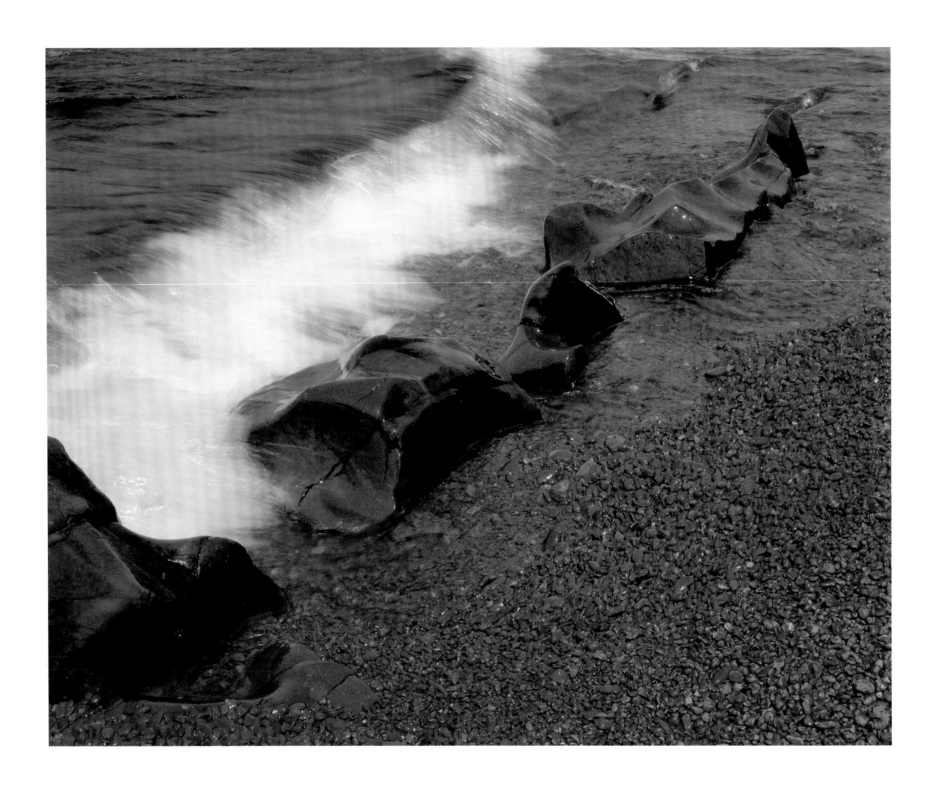

Plate 129

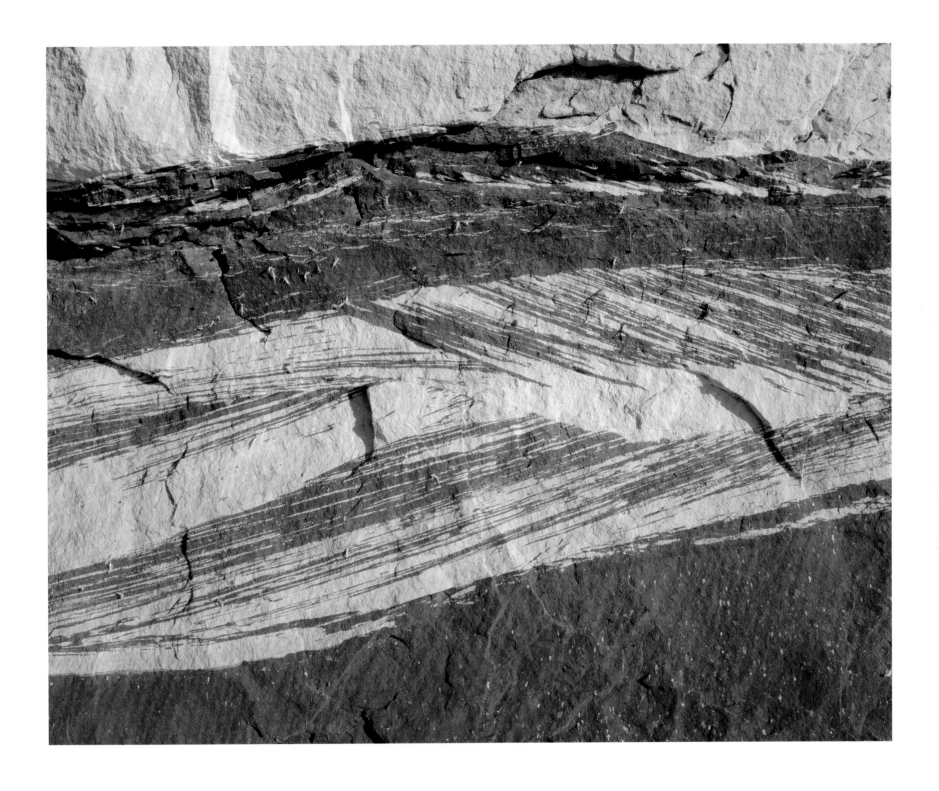

Plate 1 3 0

Plate 131

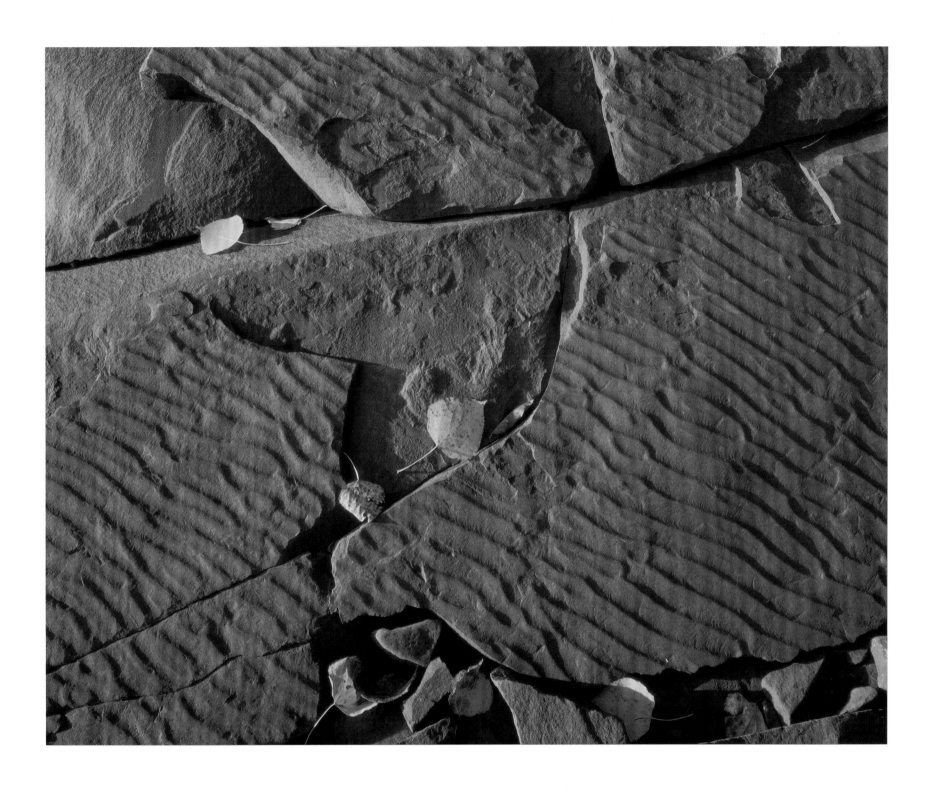

Plate 132

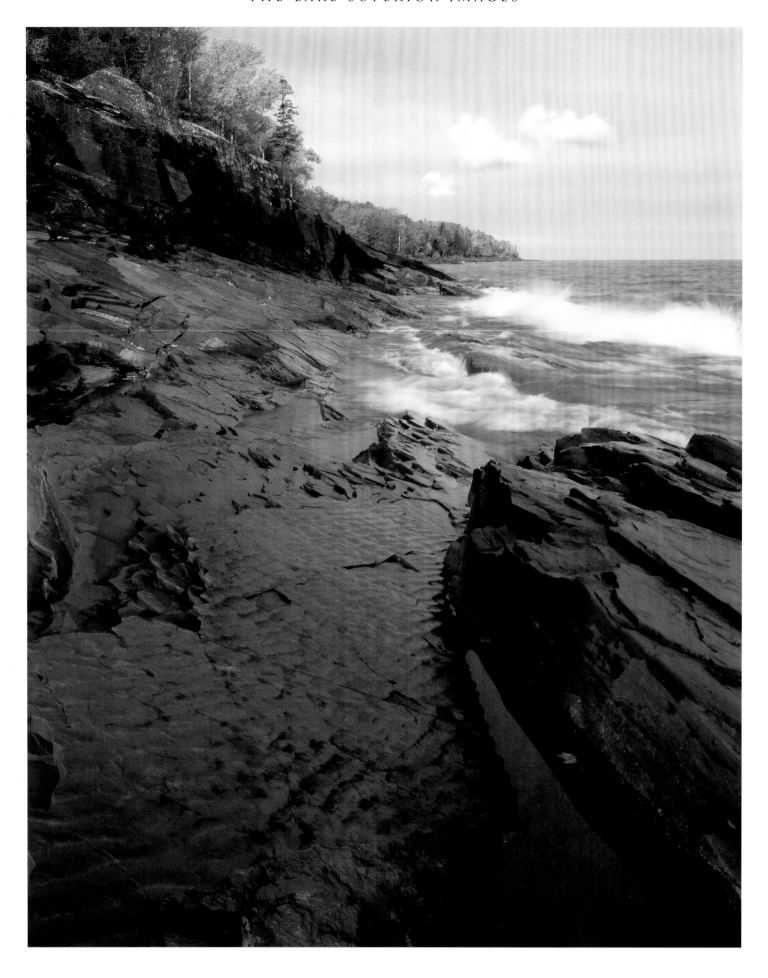

Plate 133

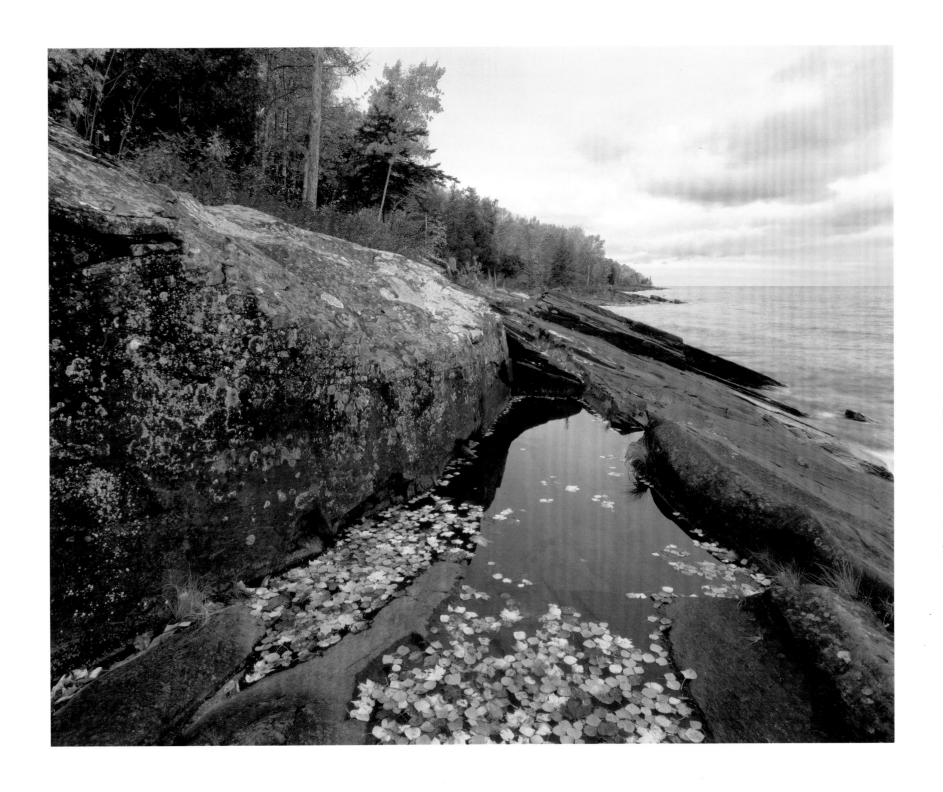

Plate 134

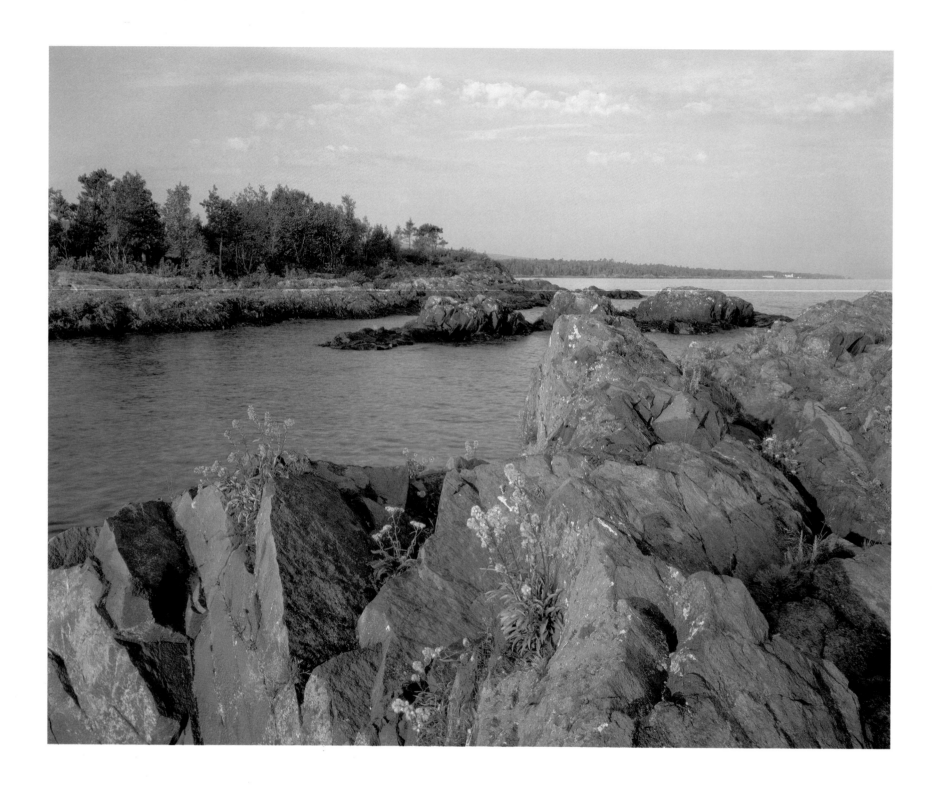

Plate 135

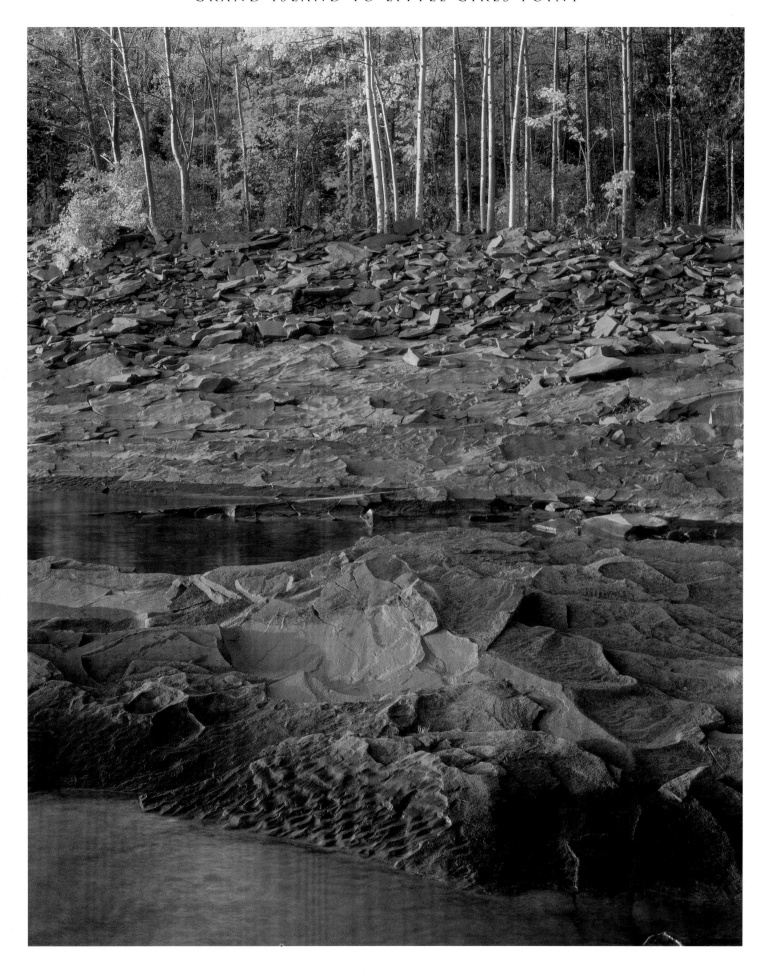

Plate 136

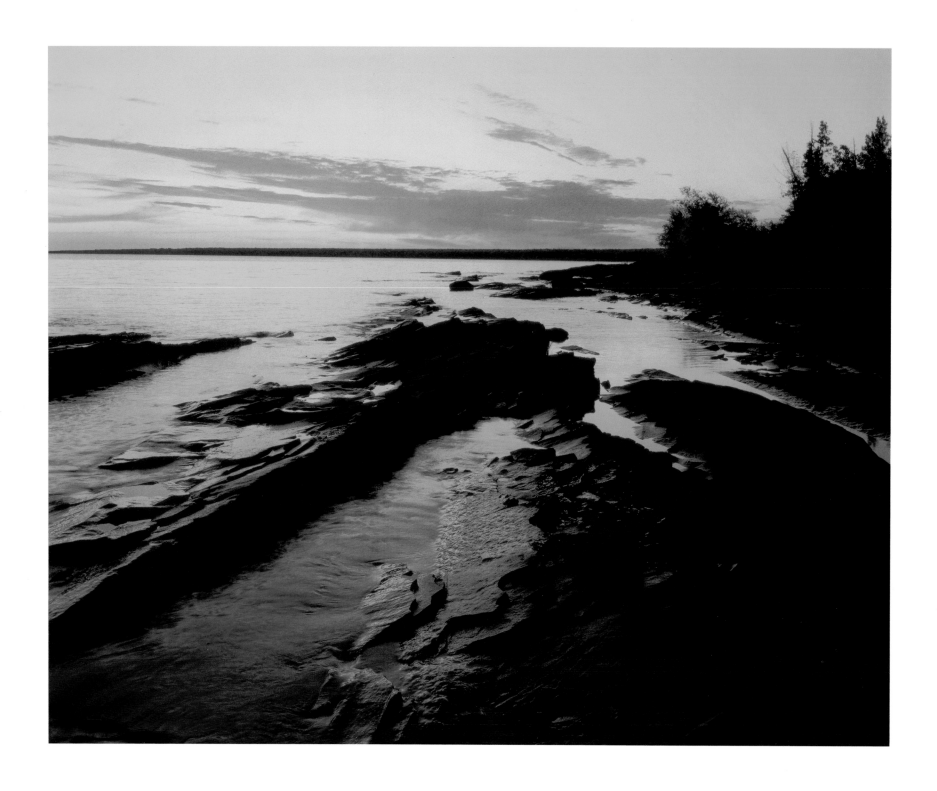

Plate 137

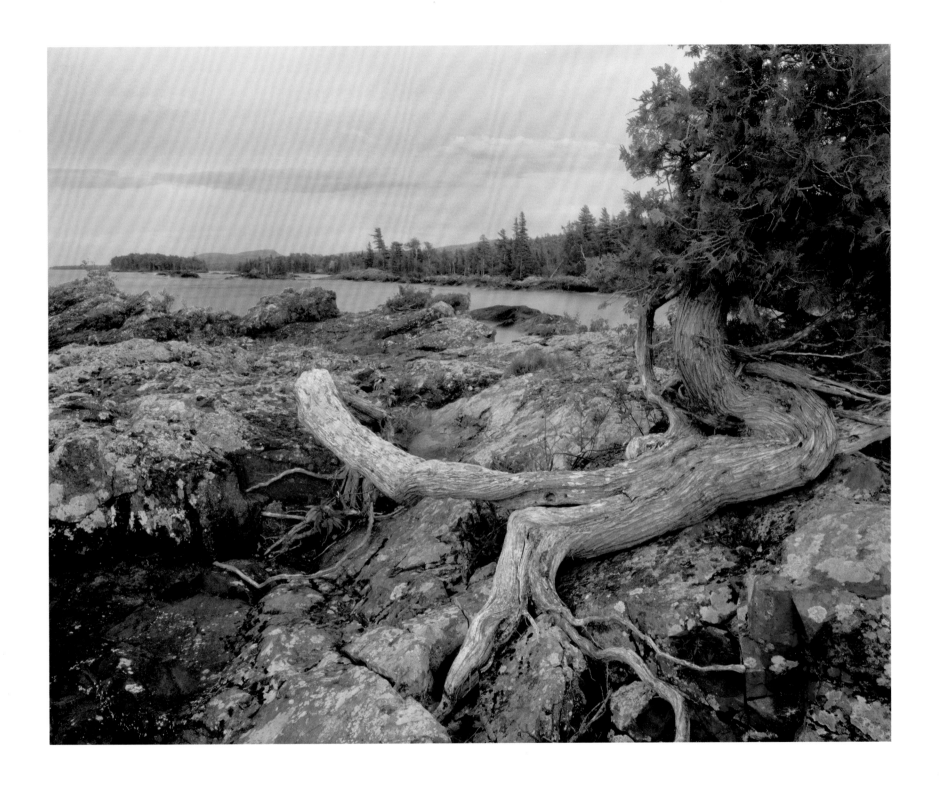

Plate 138

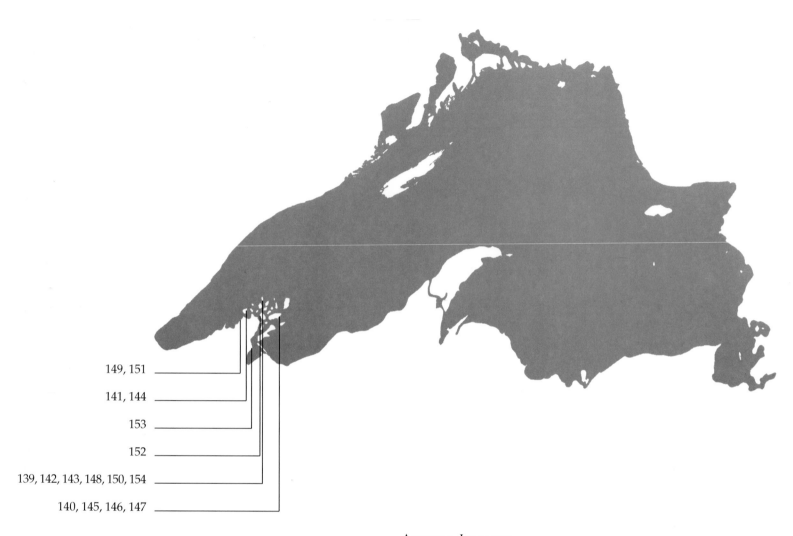

149, 151

141, 144

153

152

139, 142, 143, 148, 150, 154

140, 145, 146, 147

APOSTLE ISLANDS

Plate 139	Devil's Island, Apostle Islands National Lakeshore. July, 1989
Plate 140	Stockton Island, Apostle Islands National Lakeshore. September, 1988
Plate 141	Sand Island, Apostle Islands National Lakeshore. June, 1989
Plate 142	Devil's Island, Apostle Islands National Lakeshore. July, 1989
Plate 143	Devil's Island, Apostle Islands National Lakeshore. July, 1989
Plate 144	Sand Island, Apostle Islands National Lakeshore. June, 1989
Plate 145	Stockton Island, Apostle Islands National Lakeshore. September, 1988
Plate 146	Moonrise and Balancing Rock, Stockton Island, Apostle Islands National Lakeshore. September, 1988
Plate 147	Julian Bay, Stockton Island, Apostle Islands National Lakeshore. September, 1989
Plate 148	Devil's Island, Apostle Islands National Lakeshore. July, 1989
Plate 149	Squaw Bay, Apostle Islands National Lakeshore. February, 1986
Plate 150	Devil's Island, Apostle Islands National Lakeshore. July, 1989
Plate 151	Squaw Bay, Apostle Islands National Lakeshore. February, 1986
Plate 152	Oak Island, Apostle Islands National Lakeshore. August, 1988
Plate 153	Houghton Point. February, 1986
Plate 154	Devil's Island, Apostle Islands National Lakeshore. July, 1989

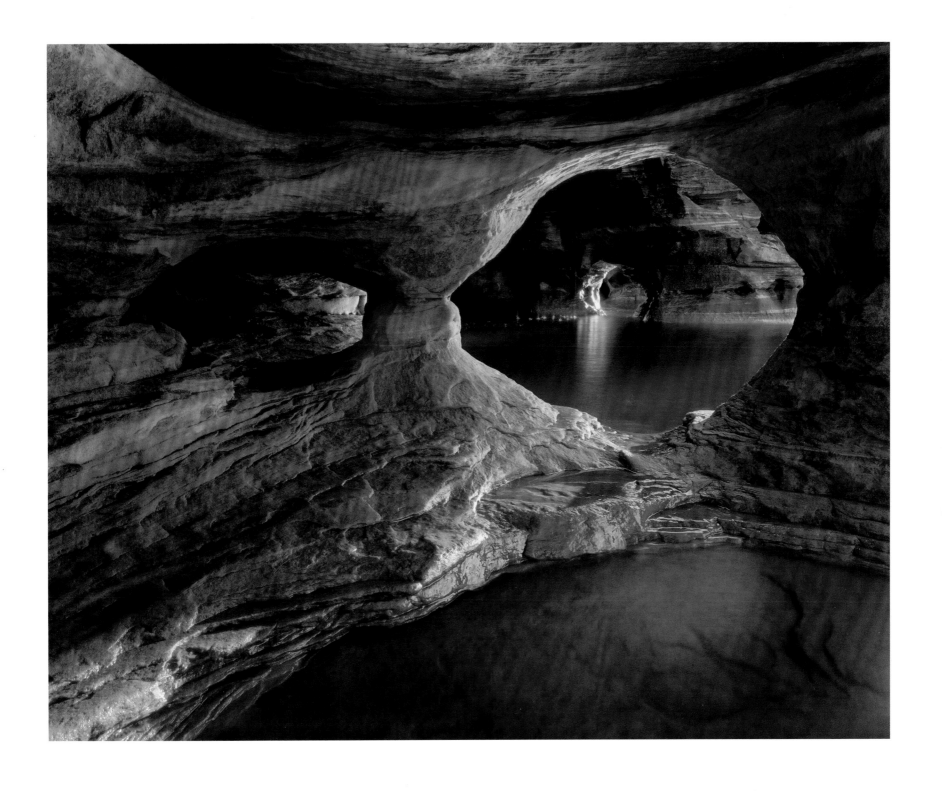

APOSTLE ISLANDS

Plate 139

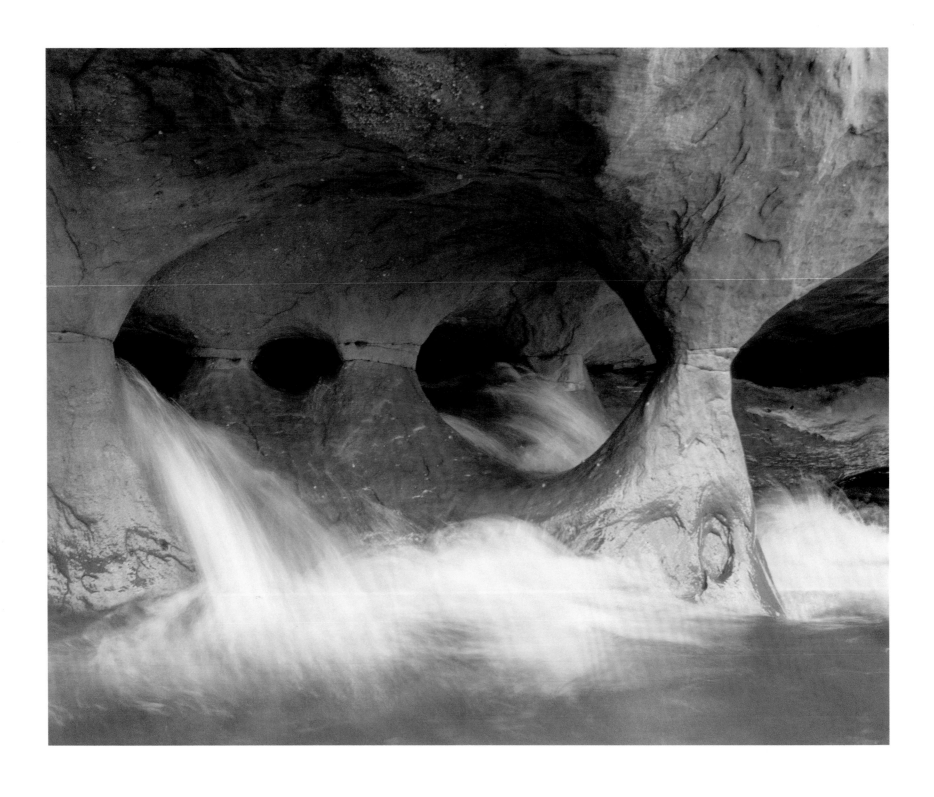

Plate 140

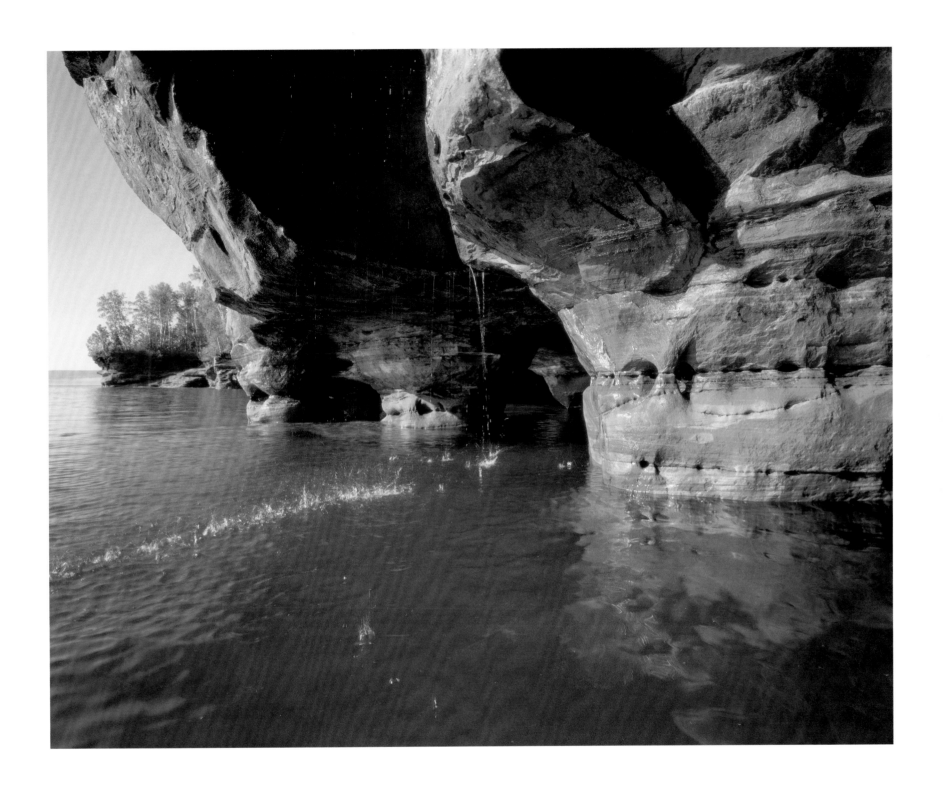

Plate 141

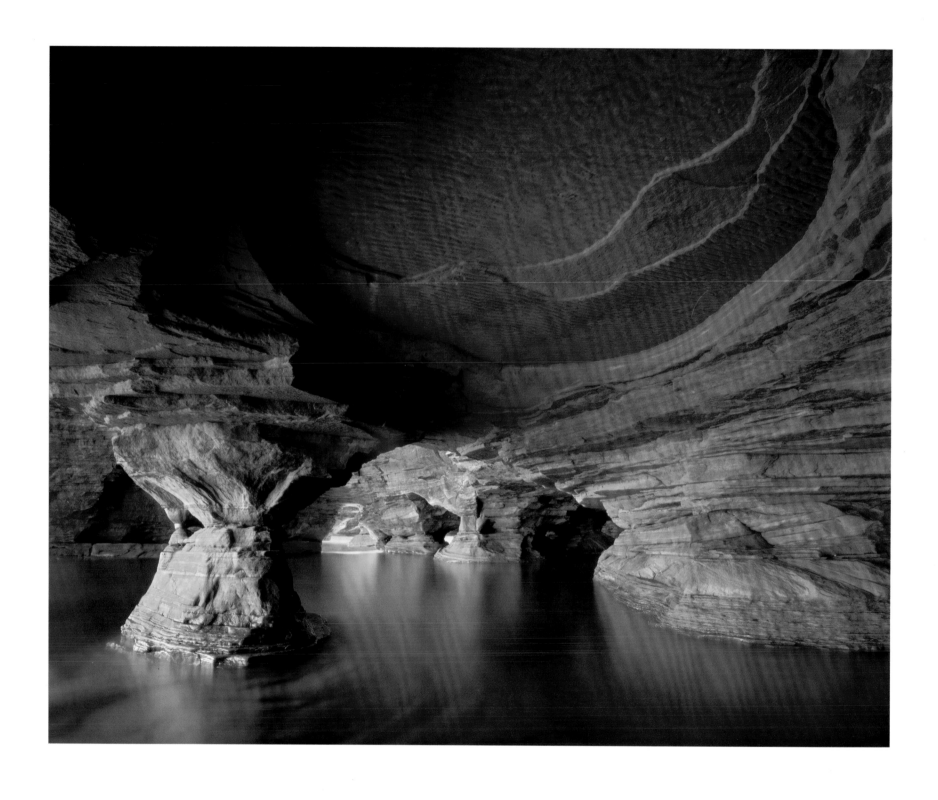

Plate 142

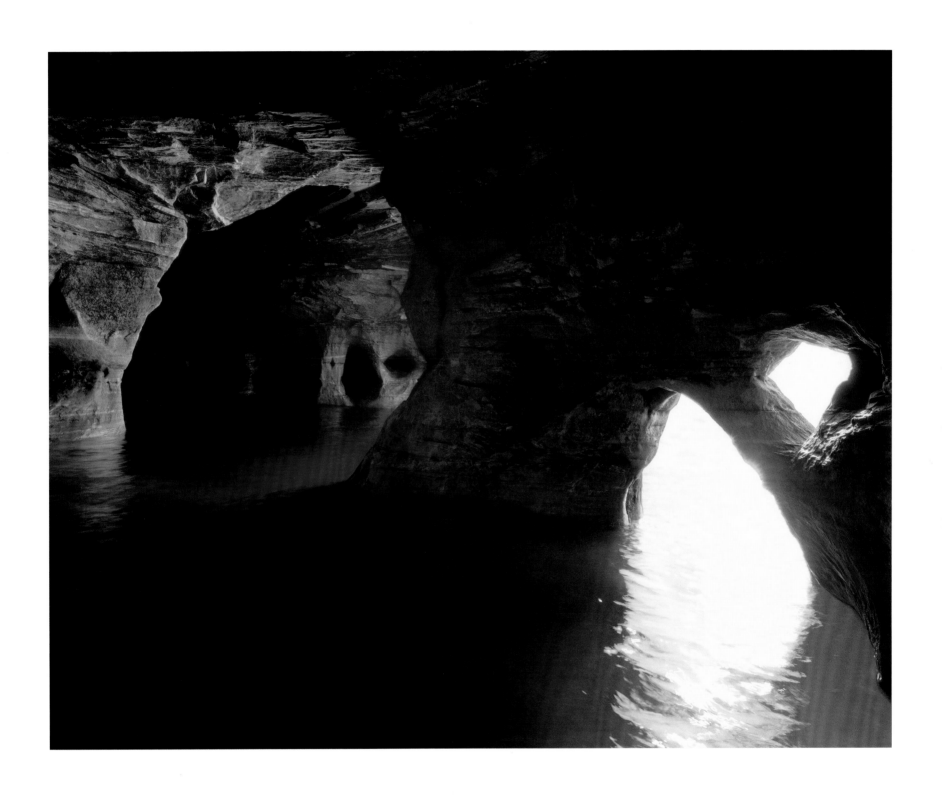

Plate 143

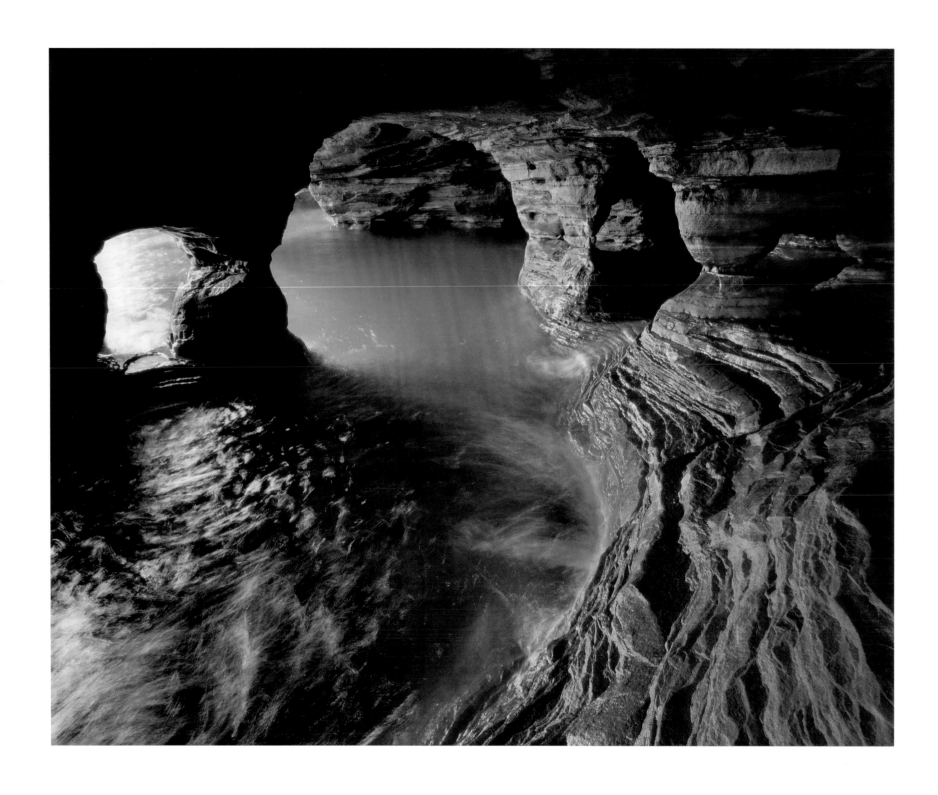

Plate 144

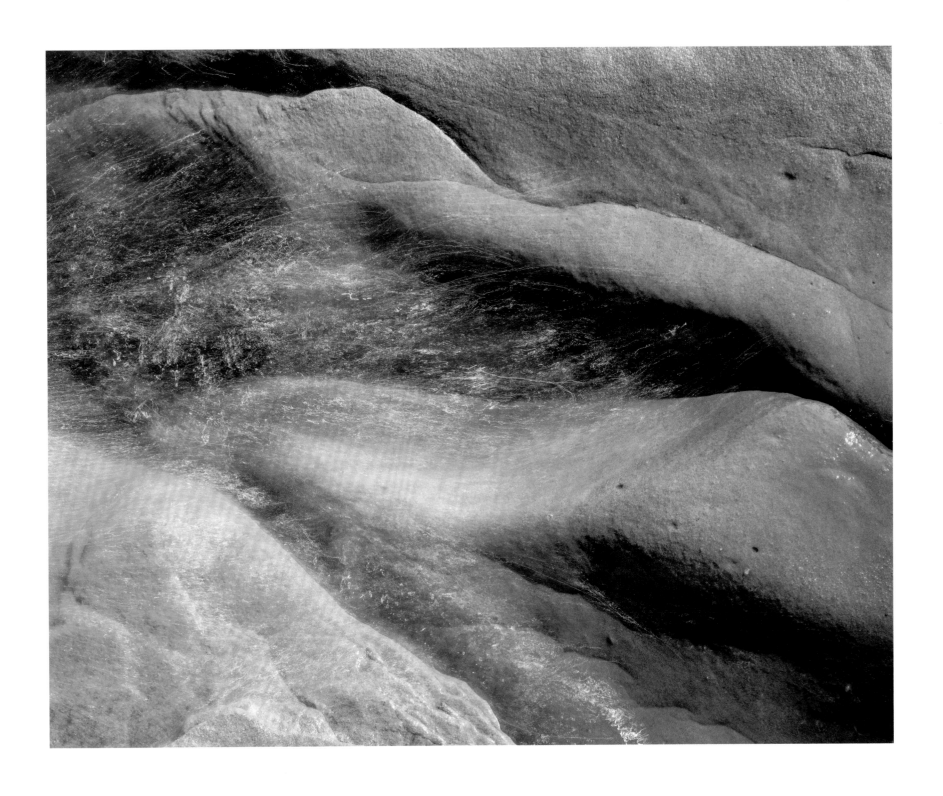

Plate 145

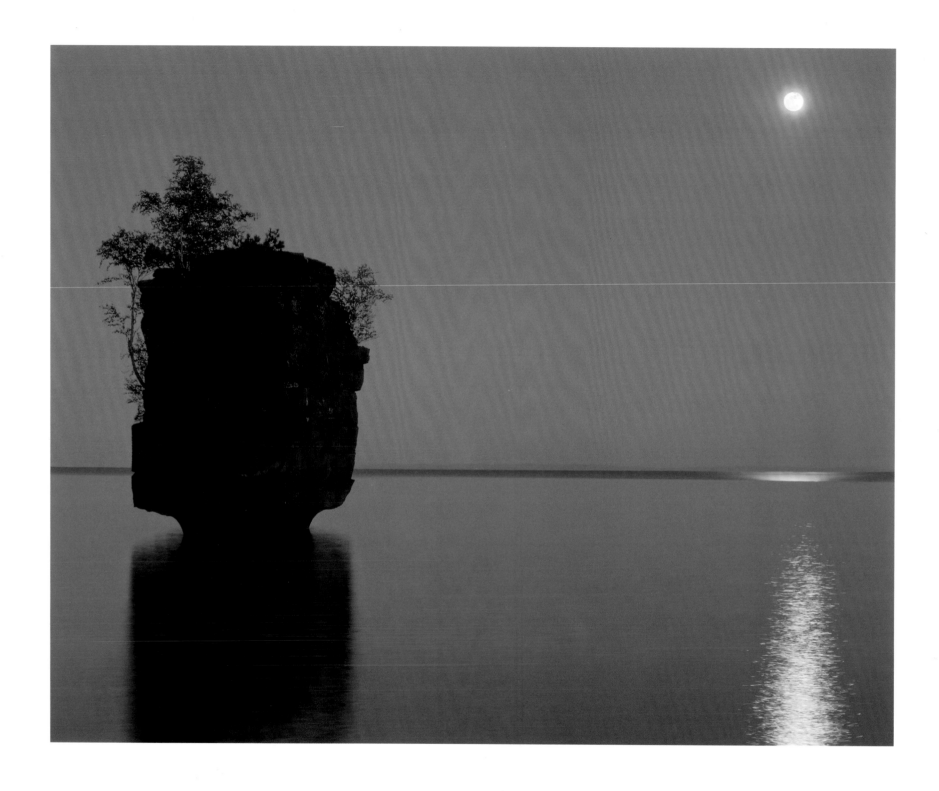

Plate 146

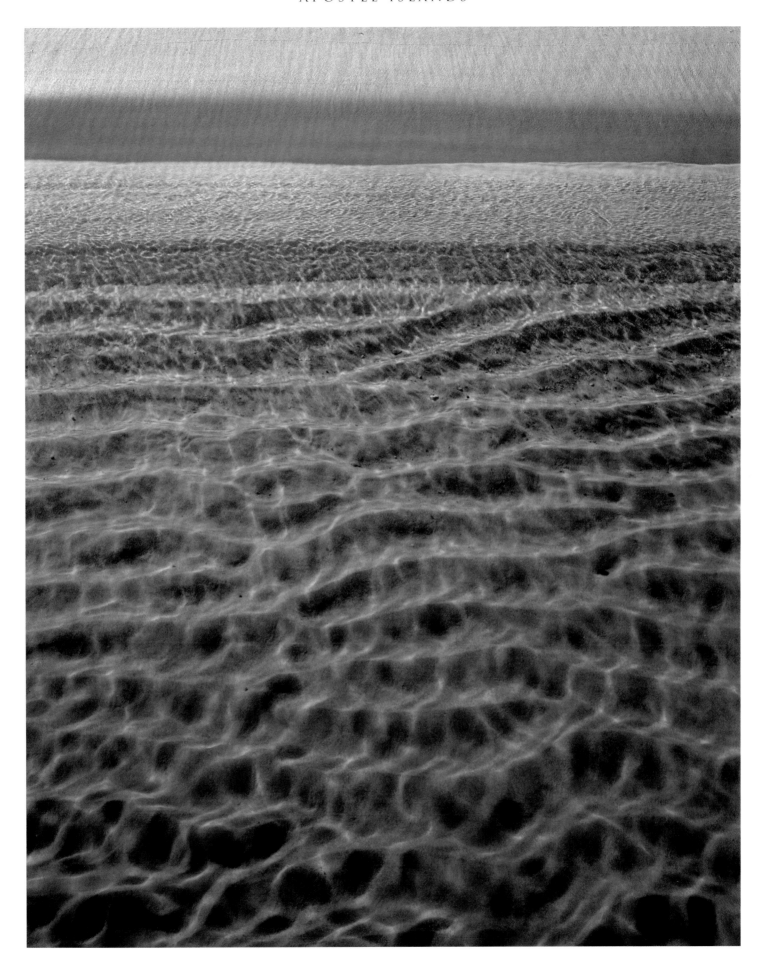

Plate 147

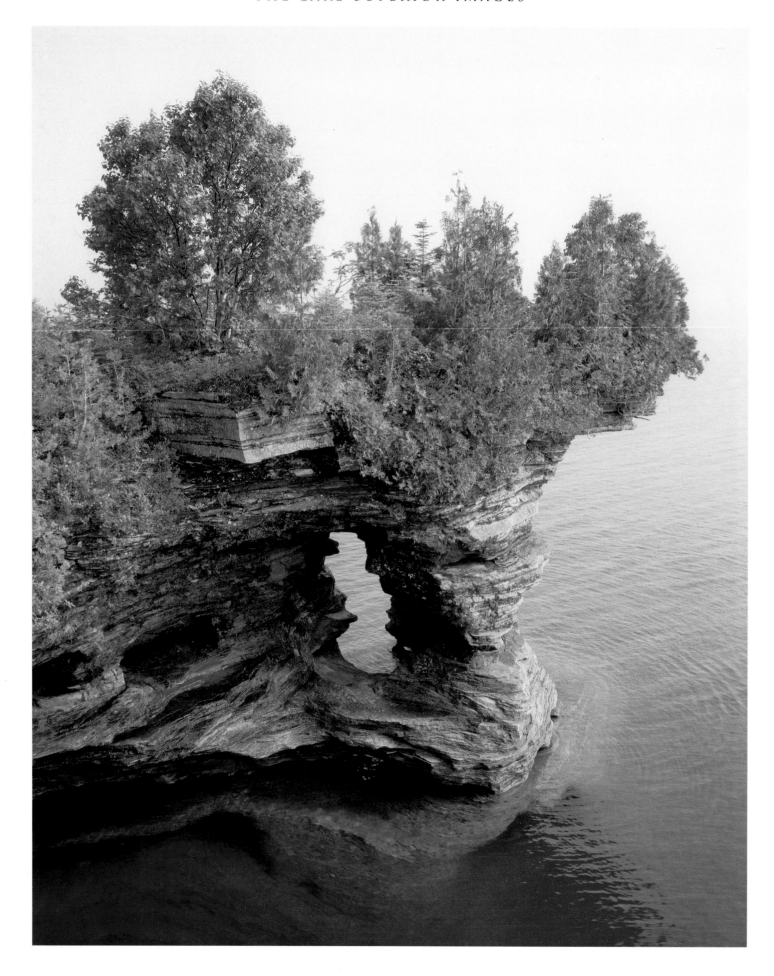

Plate 148

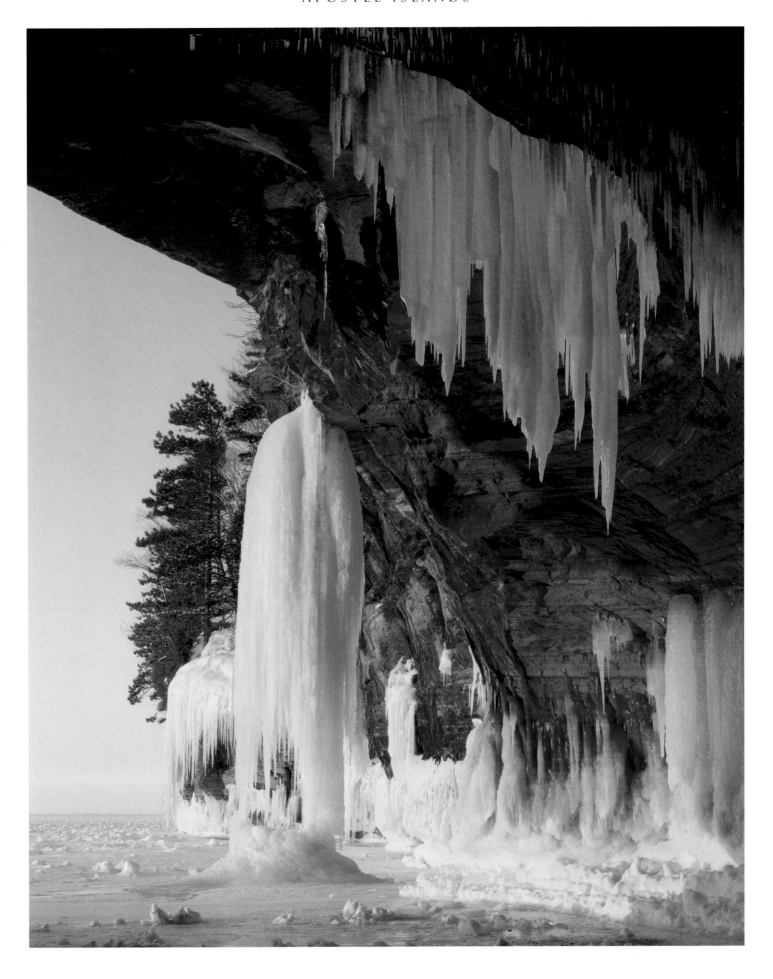

Plate 149

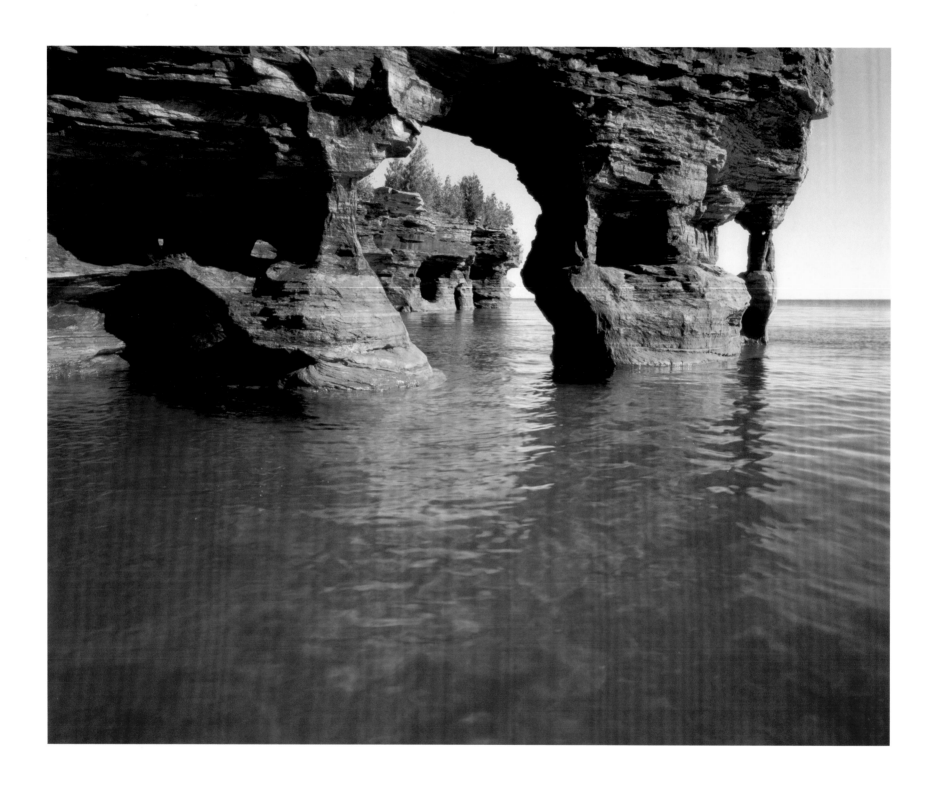

Plate 150

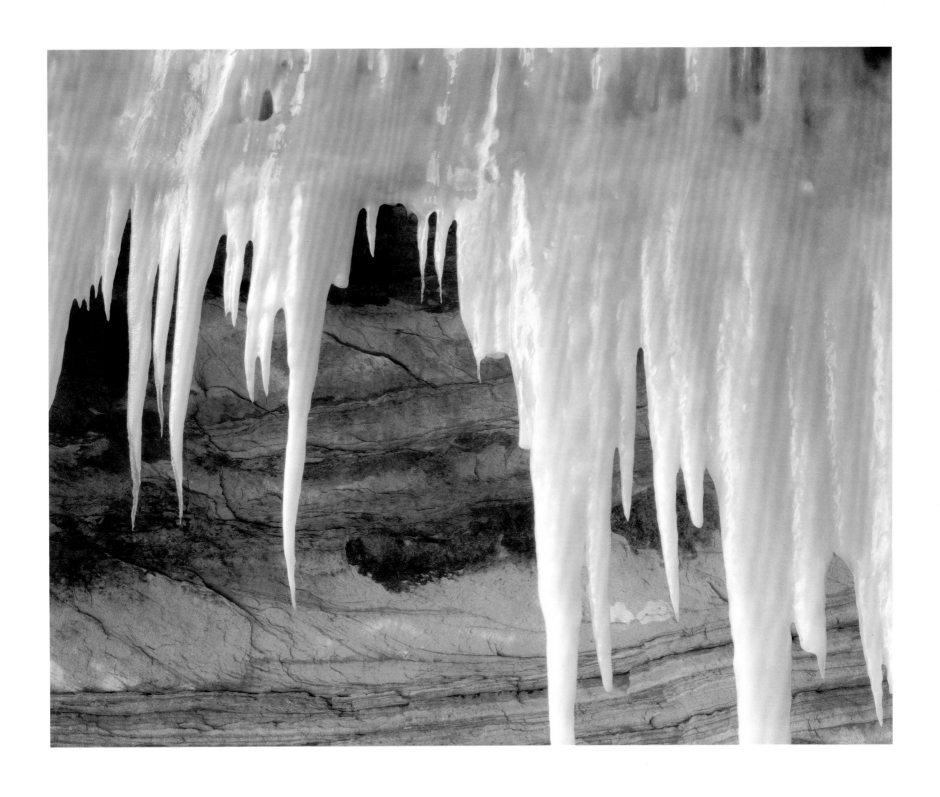

Plate 151

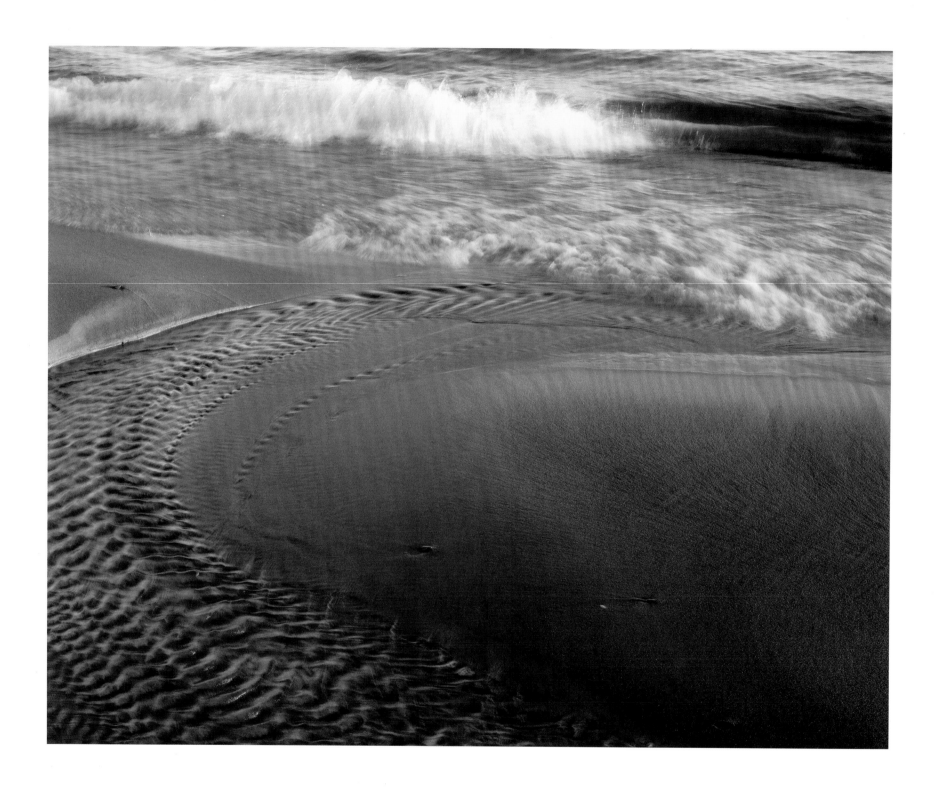

Plate 152

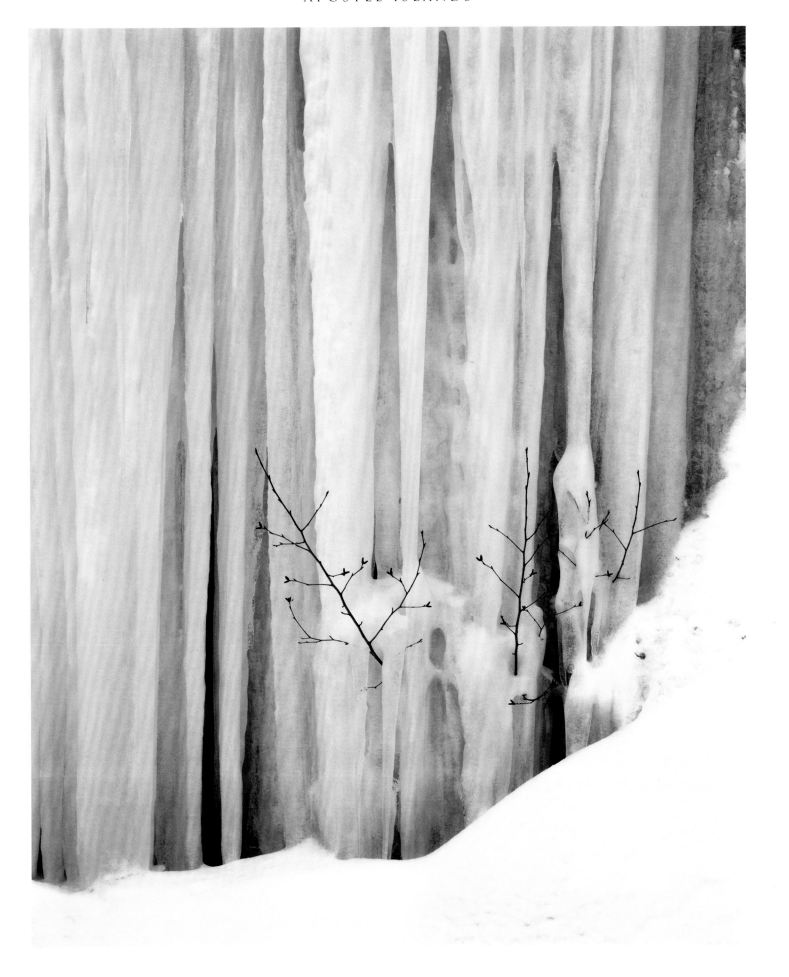

Plate 153

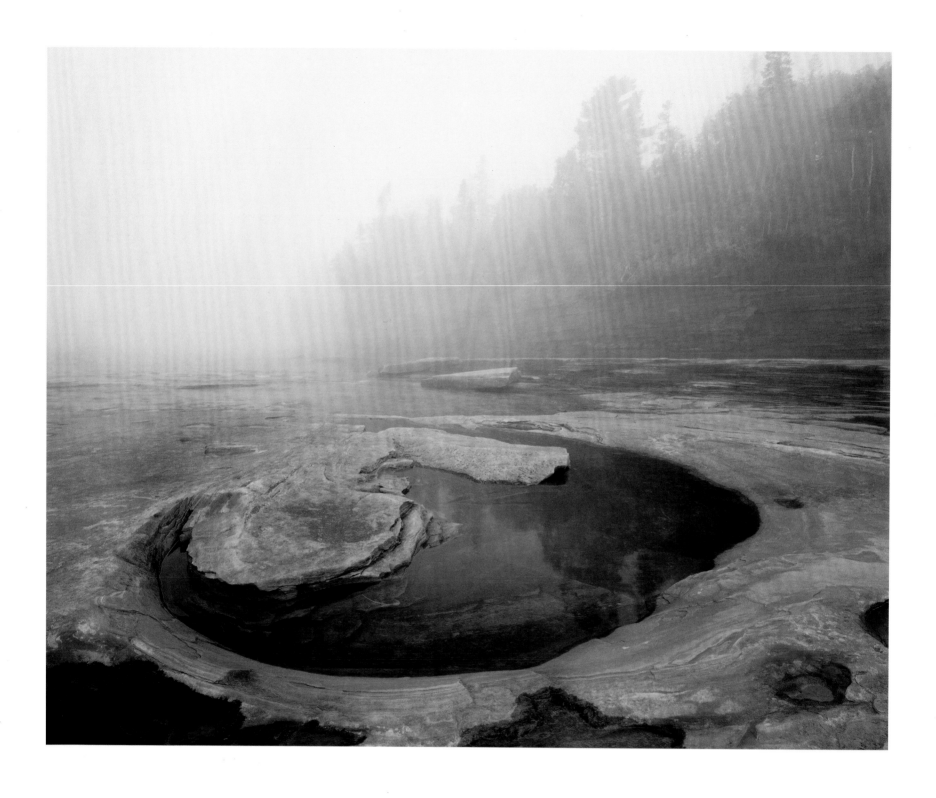

Plate 154

EPILOGUE

Spiral: *of or relating to the advancement to higher levels through cyclical movements.*

We often describe the changing of the seasons or other natural rhythms in terms of circles. In the preceding text, however, Craig uses the geometric shape of a spiral to help describe his reflections on Lake Superior and to illustrate the profound connections between Superior's many shores. Within a spiral everything is linked, and all motion is circular. The circle, however, is never quite complete. You never end up in exactly the same place you started when traveling in a spiral. Whether kayaking around Lake Superior, or whether driving the popular "Circle Tour", you realize that the lake is a constant, circular force forged of natural rhythms, and each new encounter with Superior results in elevated insight and respect for the collection of rock, water, plants and animals that make up Superior. Connected, continuous and ever-changing. That is the shape of a spiral, and that is the spirit of Superior.

Because everyone views Superior's broad horizons and profound depths with different mind and eye, the lake defies easy definition or categorization. Yet one of the first things you feel when traveling Superior's spiral, or in viewing this book's photographs, is continuity and connectedness. The ancient igneous cliffs of the North Shore reach back to a geologic time long past. The Pukaskwa pits and lake's pictographs bring you closer to the indigenous peoples that once inhabited this continent. And though the virgin timber along Superior's shores fell to lumberjacks' axes over a century ago, in many places you feel as though you are one of the few to ever encounter this rustic landscape.

Along with linking the ages, Superior connects the many people and places around the basin. Marathon and Marquette are more than two different communities in two different countries. They are bonded together through their interaction with the lake, both in their past cultural histories and their present environmental states. From Pictured Rocks to Pukaskwa, from Duluth to Devil's Chair, the cross-lake connections run deep.

Lake Superior's interactions also extend far beyond its shores. As with all larger ecosystems, the lake is intricately tied to the global biosphere. In a mere matter of days, atmospheric emissions from Moscow, Madrid or Mexico City can circle the globe and be absorbed into the prodigious surface of Superior. The majority of the lake's water supply comes through precipitation, and, ironically, the life-giving moisture can also carry unknown quantities of contaminants that are life-threatening when introduced into the food chain. Because it requires several centuries for water to cycle through Lake Superior, these contaminants will remain in the basin far beyond our lifetimes, making our decisions today truly the reality of tomorrow. For better and for worse, Superior is forever linked to the rest of the world.

Aside from maintaining its own aesthetic and ecologic importance, the spiral of Superior's influence twists into the economic realm as well. The region's resources (including minerals, timber and fish) and its essential waterways provide for the livelihoods of hundreds of thousands of people around the basin and around the globe. Resting in the heart of the continent and at the head of the Great Lakes, Superior initiates a priceless transportation network that funnels grain, paper, steel, and other goods to markets worldwide.

Because of these social, ecologic and economic connections, Superior represents an essential model for choices - and for changes - that will have to be made around the earth in the not-too-distant future. Due to its relatively pristine state, Superior remains an indicator of how well we are living - and will live - in balance with our environment. Over the past century, we have slowly acknowledged that the scale has too long been tipped in favor of short-term economic gain, coming at the expense of long-term ecologic health. Gene Stratton-Porter, a turn-of-the-century nature writer, declared in 1910, "Pity of pities it is, but man [sic] can change and is changing the forces of nature. I never told a sadder truth, but it is truth that man can 'cut down clouds'. In utter disregard or ignorance of what he will do to himself, his children, and his country he persists in doing it wherever he can see a few cents in the sacrifice."

While we have made some substantial strides since Stratton-Porter's time, we continue cutting down the clouds, or at least the cloud forests, pursuing a better life for our burgeoning population. As far as Superior is concerned we have yet to answer the crucial question: Can we develop sustainable activities that provide a healthy balance between economy and ecology in Superior's basin? More importantly, will we try?

Fortunately, alternative ways of thinking are re-emerging that applaud this balance and reward cooperation instead of cut-throat competition. The concept of harmonic balance has actually been spiraling throughout our human consciousness for centuries. From Taoism's Yin and Yang to the Christian Golden Rule and to the multitude of indigenous mythologies, most religions and philosophies have at some time recognized life's

cyclical patterns and the need for balance in our giving and taking, even if they did not come true in practice. If we are to answer the above questions of sustainability, these ideals need to once again be heeded and turned into action.

Although the circular relationships of an ecosystem are extremely intricate and complex, the overall message is relatively simple: all our actions have effects that ripple through the environment. To accept this truth requires profound responsibility. As the fox in Saint Exupery's *The Little Prince* explains, "You become responsible, forever, for what you have tamed." Over the centuries, we have tamed and altered the wilderness, hopefully as much as we ever will, and now we must be responsible for it. For it and for ourselves. For its future and for our own.

To be responsible in our relationship with the environment - to strike a balance between human endeavors and a healthy ecosystem - first requires an underlying sense of appreciation and respect. To this end, the photographs found in *The Lake Superior Images* help us visualize and value both the broad vistas and the hidden intricacies of the natural world. These carefully selected pieces of time and place speak to a personal journey, one of deep respect, and one of necessity. We cannot all paddle around the expanse of Lake Superior, yet with these photographs, we can envision ourselves within these extraordinary places, and more importantly, we can envision these extraordinary places within ourselves. Only then will we truly embrace the necessary truths of balance and responsibility. Only then will we truly love both the natural world and ourselves, which are forever connected in our lives of continuity and change.

Kris Aas-Larson

PHOTOGRAPHIC INFORMATION

Most of the photographs in this book were made using 4x5 inch view cameras, with occasional use of a 5x7 inch back. When I was working within walking distance of my car, I used a Wista monorail camera. When traveling by kayak, I took a Calumet Woodfield camera which folds down quite small and is a fraction of the weight of the Wista. Lenses used on the large-format cameras ranged from a 75mm wide-angle to a 300mm, which produces only a two power magnification on the 4x5 film. I used Ektachrome transparency film until 1987 when I switched to Polaroid Professional Chrome. The Polaroid film produces good color with fine grain, and comes packaged in a way that eliminates the need to carry cut film holders and a changing bag. When packing gear into the limited cargo space of a kayak, this advantage is tremendous! I also used Polaroid Type 54 black-and-white instant print film for test prints, which was particularly important when photographing moving water. I also wrote location notes on the back of the prints. These notes were essential when making file cards for the transparencies.

At times I photographed from the kayak in water too deep to set up a tripod even with leg extensions. For this reason I kept a Pentax 6x7cm camera with a 55mm wide-angle lens in a dry bag between my feet in the kayak. I used Fujichrome Velvia for all my 6x7cm work.

The one 35mm photograph in the book, on Plate 140, was made on Kodachrome 64 using a Nikkormat camera and a 28mm lens.

All of the E6 transparency film was processed by Linhoff Corporate Color in Minneapolis.

Except when hand-holding the Pentax in the kayak, the cameras were mounted on a Bogen 3021 tripod with a 3028 head. The tripod is small enough to store in the cockpit of my kayak, yet sturdy enough to hold even the big Wista.

Exposures were figured using a Pentax digital spot meter and the Zone System. In cases where extreme contrast existed, I used a zone II pre-exposure to raise the lower values and, when possible, bounced light into shadow areas with a mylar reflector.

I seldom used filters. When I did, it was to cut glare or alter contrast with a polarizing filter, or to balance the blue light in sea caves with color-correcting filters. I weighed many considerations when selecting shutter speeds to photograph waves. Often the faster shutter speeds were ruled out by the need to use a small aperture to obtain sufficient depth-of-field. I used various speeds in different situations to obtain desired effects. A speed of 1/30th of a second records motion as it looks to our eyes, but I often prefer the look of 1/4 of a second or even slower. The close-up of a wave washing over sandstone on Stockton Island (Plate 145) was exposed for a full second. The shutter was opened just before the wave entered the frame, allowing me to photograph both the rocks and the scintillations on the wave that covered them.

With all the images in this collection, I reacted to what I saw and used my craft to bring my interpretation to the viewer. There is no proper, best, right or wrong way to photograph a subject like Lake Superior. I enjoy being able to share my view of the lake. I also delight in seeing how others react to the same subject matter in totally different, and equally viable, ways.

For information on ordering limited edition posters or original photographic prints of the images in this book, or on nature photography workshops taught by Craig Blacklock, write to:

BLACKLOCK NATURE PHOTOGRAPHY
P.O. BOX 560
MOOSE LAKE, MN 55767